Digital Masters:
Nature Photography

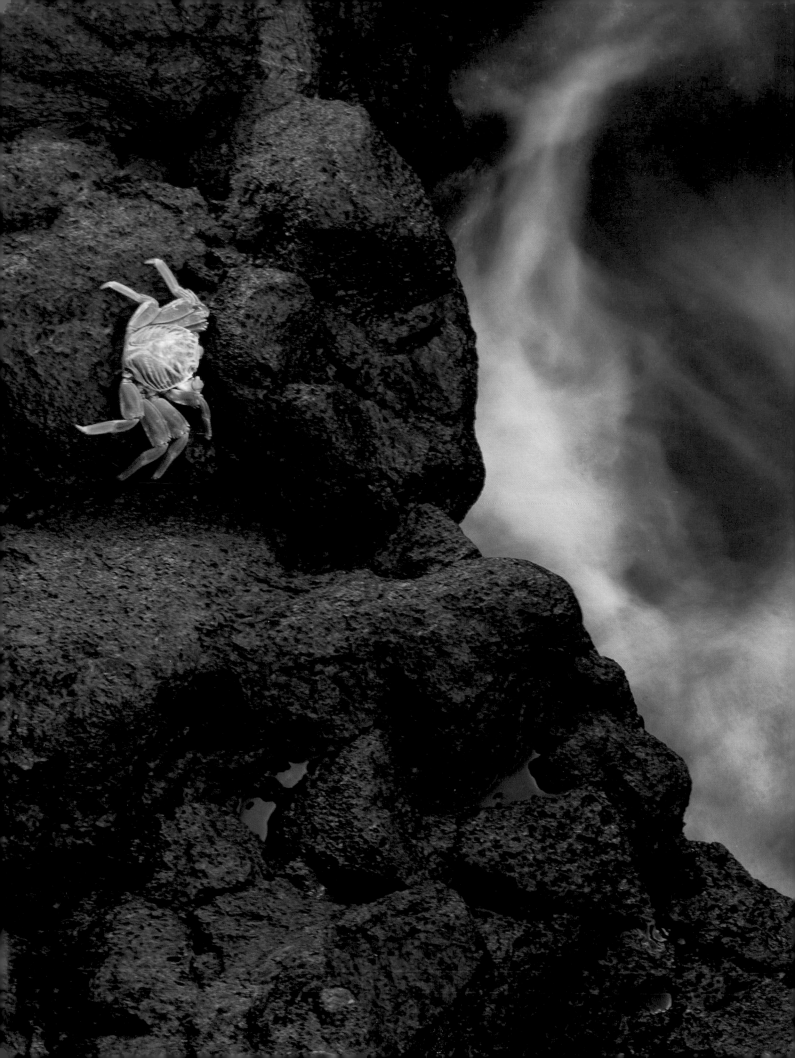

Digital Masters: Nature Photography

Documenting the Wild World

Ralph Lee Hopkins

LARK PHOTOGRAPHY BOOKS

A Division of Sterling Publishing Co., Inc.
New York / London

Editor: Kara Arndt
Book Design: Tom Metcalf
Cover Design: Thom Gaines

Library of Congress Cataloging-in-Publication Data

Hopkins, Ralph Lee.
 Digital masters. Nature photography / Ralph Lee Hopkins. -- 1st ed.
 p. cm.
 ISBN 978-1-60059-522-6
 1. Nature photography. 2. Landscape photography. 3. Photography--Digital techniques. I. Title.
 TR721.H645 2010
 778.9'36--dc22

 2010000298

10 9 8 7 6 5 4 3 2 1

First Edition

Published by Lark Photography Books, A Division of
Sterling Publishing Co., Inc.
387 Park Avenue South, New York, N.Y. 10016

Distributed in Canada by Sterling Publishing,
c/o Canadian Manda Group, 165 Dufferin Street
Toronto, Ontario, Canada M6K 3H6

Distributed in the United Kingdom by GMC Distribution Services,
Castle Place, 166 High Street, Lewes, East Sussex, England BN7 1XU

Distributed in Australia by Capricorn Link (Australia) Pty Ltd.,
P.O. Box 704, Windsor, NSW 2756 Australia

If you have questions or comments about this book, please contact:
Lark Books
67 Broadway
Asheville, NC 28801
(828) 253-0467

Manufactured in China

ISBN 13: 978-1-60059-522-6

For information about custom editions, special sales, premium and corporate purchases, please contact Sterling Special Sales
Department at 800-805-5489 or specialsales@sterlingpub.com.

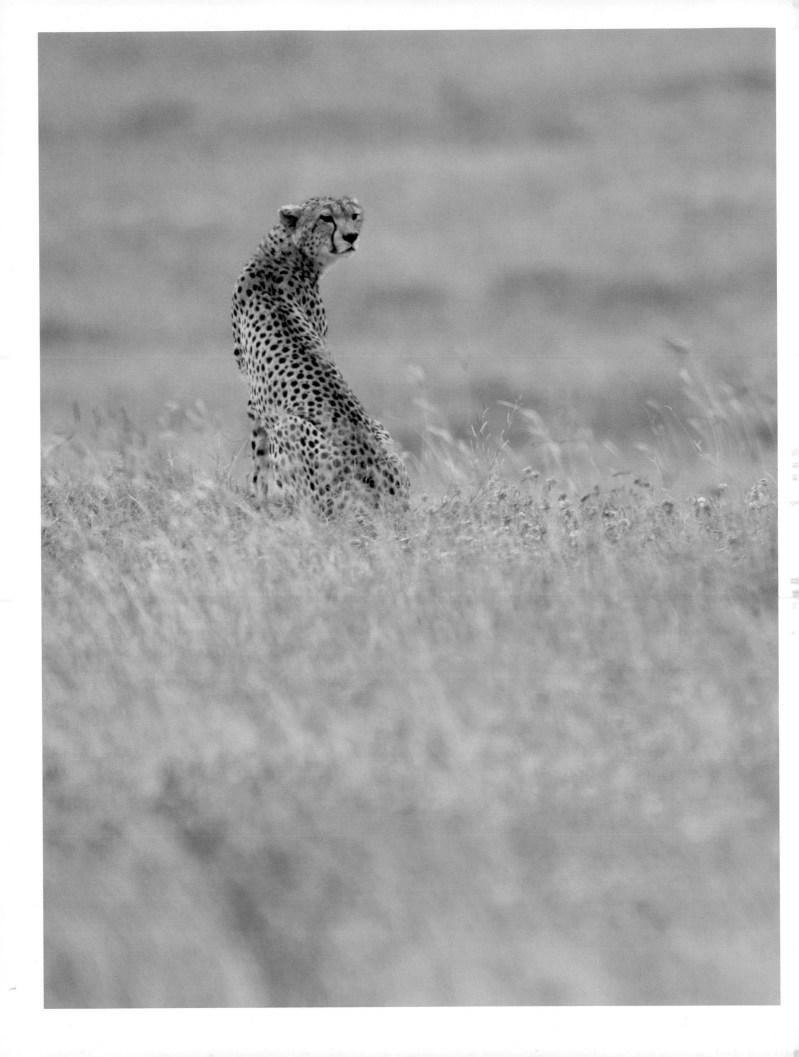

Contents

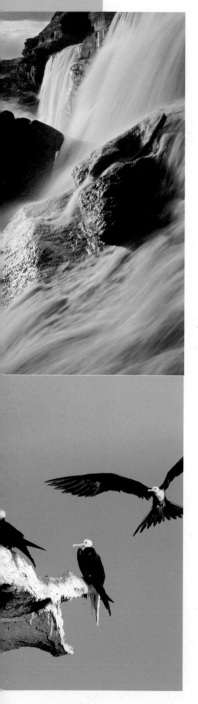

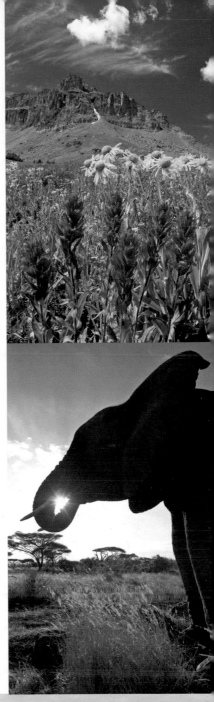

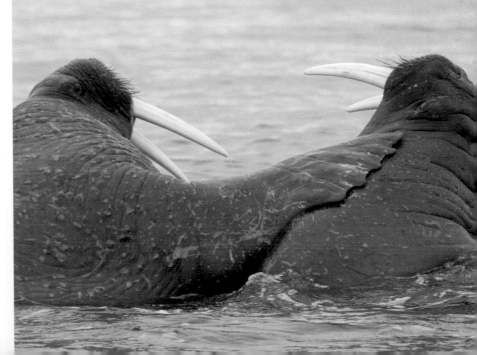

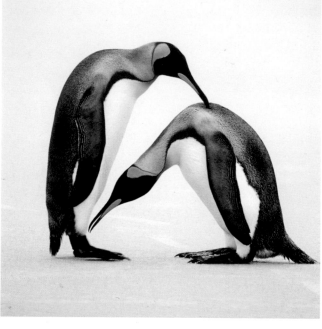

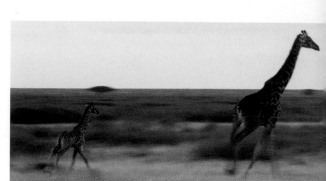

preface

"Creativity is allowing yourself the freedom to make mistakes, art is knowing which ones to keep." — From an anonymous refrigerator magnet

Photography is experiencing a renaissance in a world where the lines between creativity, art, and technology are disappearing. This book is intended to help lead you into this digital world, while remaining true to nature photography's artistic side.

For more than 20 years I've been exploring wild places with my camera. My career spans three different camera systems, from large- and medium-format to 35mm SLRs, and from 4 X 5 sheet film, 645 transparencies, and 35mm slides, to digital capture.

This book is about sharing the story of how I approach nature photography. It's what works for me, a compilation of things that I've learned over the years. I take no credit for any of the ideas or useful tips. Consider them all borrowed and intended to help you know your equipment just a little better, so you can get beyond the technical, away from your computer, and back to the creative side of making pictures.

This is a workbook that you can return to again and again as you develop your own workflow. Chapters don't have to be read in any particular order. We all approach things differently. There's not one right way, or even a best way, to take your image from capture to print. Hopefully, it will help you along the way to expanding your own unique photographic vision of the world's wild places.

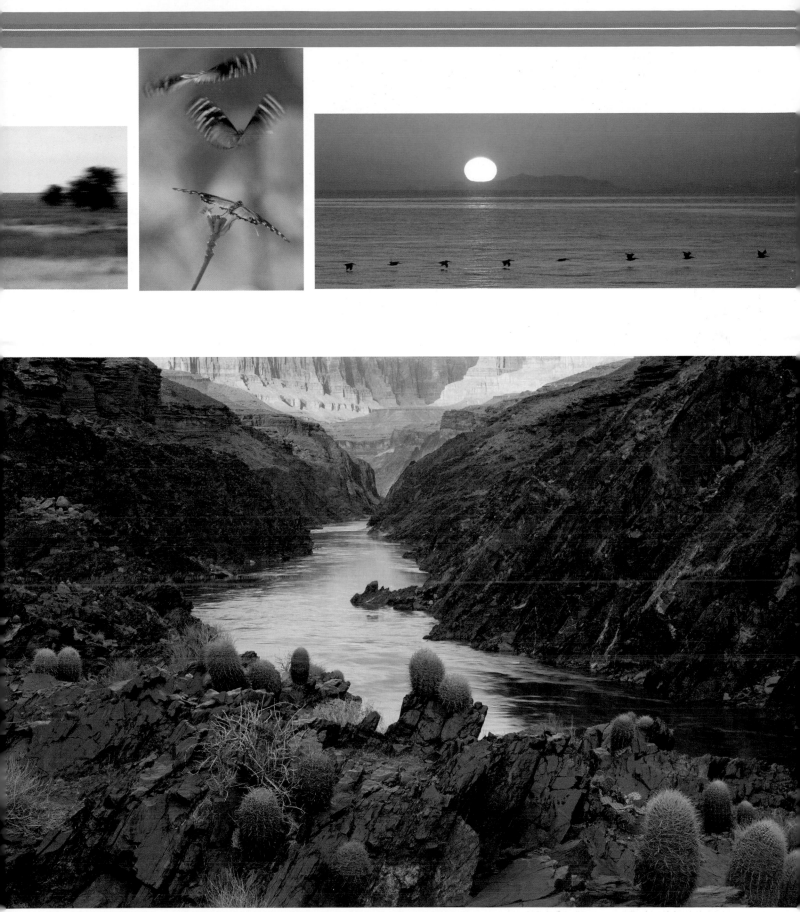

Barrel Cactus and Colorado River in Lower Granite Gorge, Grand Canyon National Park, Arizona

(Linhof 4 X 5, Fujichrome 100, exposure unrecorded, warming filter)

This downstream view was made in February 1990 on a river trip with the US Geological Survey matching historical photos from the 1890 Stanton Expedition. Broken clouds and the low-angle of the winter light created interesting warm light that was enhanced with a warming filter.

introduction

"Life is either a daring adventure or nothing." – Helen Keller

I didn't set out to be a photographer. I didn't have a Kodak Brownie camera when I was a kid, or work on the school newspaper in high school. While growing up, we did have a darkroom in the basement, but it was my younger brother's. He was the photographer in the family.

It was a strange twist of fate that photography found me later in life, a consequence of my background in geology and affinity for nature and wild places. Travel and nature photography go together, and I was lucky to discover that this was my path. I found that wherever you are in the world, the quest to make nature images requires you seek the wild places.

What captivates me about nature photography is the act of being in the moment with my camera in a natural setting. For nature photographers, working with a camera intensifies the experience. Being with our camera helps us slow down and look at the world in a different way. The act of searching for the perfect branch to frame a composition, or waiting patiently for the light, the sweet light, or anticipating wildlife behavior keeps me grounded in the moment.

My travels may indeed be defined by the images I make, but my experiences are rooted in nature. For me, nature photography is not just an art—it's also a way of being in and connecting with the natural world. It's an endless cycle. I have to photograph to live, to be who I am.

I've been extremely fortunate in my career. Nature photography has taken me by raft down the Colorado River, by foot to the highest peaks in Colorado's Rocky Mountains, and by ship to the Polar Regions of the Arctic and Antarctic. My work with Lindblad Expeditions has been central to my photographic life, and I appreciate greatly that Sven Lindblad entrusted me the freedom to help integrate photography into the core of our expeditions. The alliance between Lindblad Expeditions and National Geographic has provided opportunities that I could never have dreamed. And I've benefitted greatly from teaching with Arizona Highways and at Santa Fe Photographic Workshops and being around motivated photographers on the cutting edge.

This book is a success if you find just one or two nuggets that will help you be in the right place at the right time, and also in the right frame of mind. Remember that the essence of nature photography is about making the best possible picture in the moment. Approach your subjects with respect, and strive to shoot it right the first time. By sharing my approach to nature photography, my hope is that you will care about the places you travel, and return home with a renewed commitment to help protect the world's wild places and the animals that thrive there.

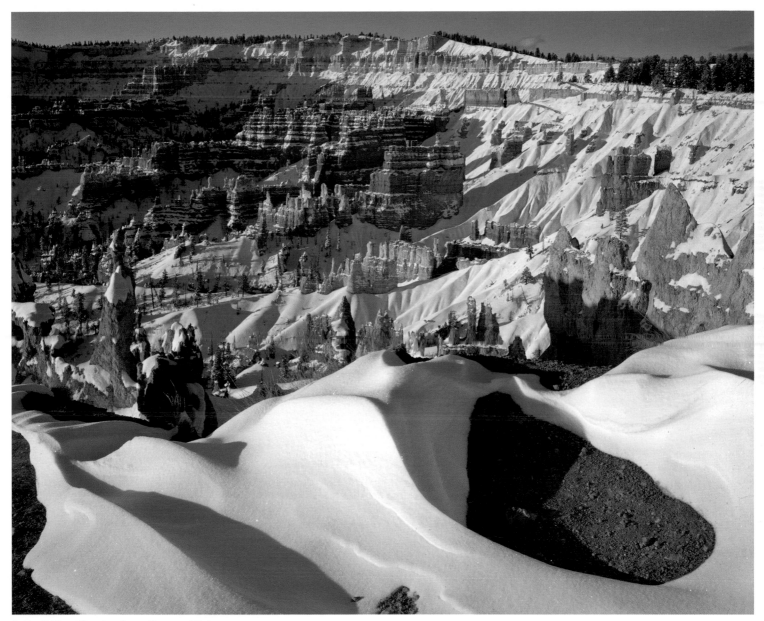

Snow Drifts at Sunrise, Bryce Canyon, Utah

(Graflex Crown Graphic 4 x 5, Schneider 135mm, Kodak
Ecktachrome, exposure unrecorded, no filter)

This winter shot was the first image I ever had published,
by the Utah Travel Council in their 1982 calendar.

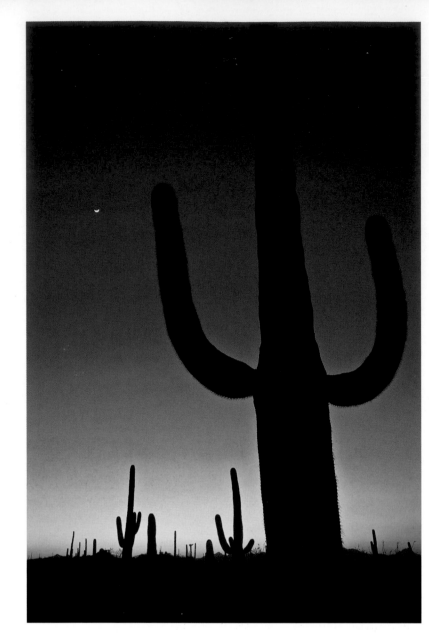

Saguaro Cactus at Twilight, Saguaro National Park, Arizona

(Pentax 645, 35mm, Fujichrome Velvia, exposure unrecorded, no filter)

I'd been searching for a perfect saguaro cactus to frame against the twilight sky back when ash from Japan's Mt. Pinatubo volcano colored the sky. It became a cover for Lonely Planet's Southwest guidebook.

My horizons expanded on family camping trips to Lake George in upstate New York's Adirondack Mountains. For two weeks each summer, I explored the rocky islands where we camped. It was a whole new universe, and it seemed so wild. A turning point for me was on our big family trip "out west" when I was twelve years old. From the time we hit the New Jersey Turnpike, with every soaring bird I saw I'd ask, "Is that an eagle?" To me, an eagle symbolized the wildness, and I was so excited I couldn't stand it. Pulling a tent-trailer with our 1964 avocado-green Impala station wagon, we headed west toward the legendary Rocky Mountains, the famous bears of Yellowstone, and the Grand Canyon—the biggest canyon of them all. It was an epic trip full of adventure. We hid from tornadoes in Kansas, escaped serious car trouble in Colorado, and survived the heat in Zion Canyon in July.

We camped on the North Rim. Alone, I walked through the ponderosa forest to the rim. The towering trees ended abruptly at a sheer cliff of gray rock. Before me was a canyon so deep that I could not see the bottom. I finally got to see my eagle that summer; a bald eagle, with its white head perched like a golf ball high in a nest along the Snake River. Although I wasn't conscious of it at the time, it was the Grand Canyon that changed me forever.

EXPLORING
WILD PLACES

My connection with wild places dates back to childhood experiences growing up in Long Island, New York. The first wild place I ever knew was the forest around our house. I cared for the "woods," as my brothers and I called it, and spent a lot of time climbing trees, making secret trails, and digging foxholes to hide in. Although maybe just an acre or two, as a small child the woods seemed so huge and mysterious.

It wasn't until earth science class my senior year in high school that I thought much about the Grand Canyon again. Memories from our family trip "out west" came flooding back in earth science class. I recalled seeing the layered rocks of the Canyon walls, the distant mountains like sailing ships on the horizon, and the mighty Colorado River that carved the landscape.

These memories began to make sense. Geology was the unifying concept that not only explained my backyard, but also the wild places "out west" I experienced as a kid. I knew then, while still in high school, that I wanted to be a geologist. I went on to study geology in college and viewed my degree as my ticket west. After graduation, I packed everything I owned in our Volkswagen camper and left in search of solitude and wild places. I backpacked in Colorado's Rocky Mountain National Park, got lost for a while scrambling in Utah's Canyonlands, and challenged myself climbing the steep trails in Wyoming's Grand Tetons. Although I had a camera then, my Dad's old Konica rangefinder, photography was not yet important in my life. Taking pictures was simply a way of recording experiences. All that changed when I first saw the tilted red-rock landscapes of southern Utah's Capitol Reef National Park.

During the summer of 1979, I was working as a field geologist traveling around the western US. I was seeing landscapes I had never seen in photographs; not even by Ansel Adams, whose work profoundly influenced me. I was blown away, both by the spectacular scenery, and the powerful geologic and erosional forces that created the landforms. Something "clicked" inside me seeing the tilted rocks along Waterpocket Fold in Capitol Reef. At that time, all I had was an all-manual Pentax SLR with two lenses. I attempted to photograph the landscapes I was seeing, but the images could not match the impact this had on me. This inspired me to learn how to take better photos.

The next summer, I took a job working with the Fishlake National Forest based in Richfield, Utah, only 90 miles from Capitol Reef National Park. I had the late afternoon and twilight hours to explore the alpine meadows with my camera. Although I don't recall making any memorable images, once, a young mule deer permitted me to approach at close range. It was a gift that taught me about patience; something until that point in my life I did not know I had. By the end of the summer, I purchased an old Graflex Crown Graphic 4 X 5 view camera with a 135 Schneider lens. Using only that one lens for over a year, I taught myself about light and composition, lugging my view camera around even when backpacking. Sheet film was expensive in those days; every shot cost $4 for film and processing. This taught me to be selective about clicking the shutter. I learned the difference between just "taking" a photo and "making" a photograph.

Another turning point came when I decided to attend graduate school for my master's degree. Naturally, I chose Northern Arizona University in Flagstaff, Arizona, near the Grand Canyon. I had only published a handful of photos and still had no intentions of being a full-time photographer, but I photographed my way through my thesis, and many of the images would later be published with Arizona Highways magazine.

If it weren't for my geology background, I probably never would have discovered photography. And if I weren't a geologist, the tilted layers at Capitol Reef would not have had any meaning to me. After graduate school, I worked for 2 years, 3 months, and 12 days as a geologist in Midland, Texas (I'm joking, but I did add up all my days once!). Although I escaped to the Guadalupe Mountains and Big Bend on the weekends, being exiled in the lonely expanses of Texas forced me to ask, "What do I really want to do with my life?"

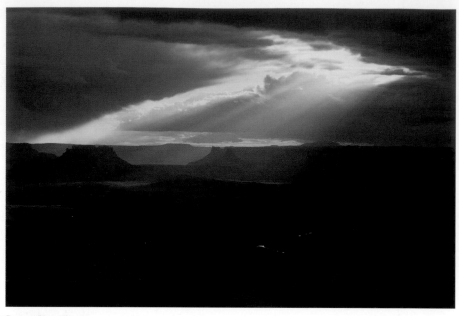

Green River Basin,
Canyonlands National
Park, Utah

(Pentax 645, 45mm
f/2.8, Fujichrome Velvia,
exposure unrecorded,
warming filter)

The answer was clear: I wanted to be a photographer. Nature photography was my true passion, and I was determined to pursue it. But I had no clue as to how I would make a living. I always figured I would photograph while doing other things.

My first big break was when I was selected as a photographer on a Colorado River expedition with the US Geological Survey, matching historical photos from the 1889-90 Stanton Expedition through the Grand Canyon. My next big break was being hired by Lindblad Expeditions, an expedition travel company that takes travelers to the world's wild places. Although my job was to interpret the geology of our destinations, I soon found myself learning about marine life, rainforests, and the fauna and flora of different ecosystems. Obviously, exploring and photographing wild places, while learning to be a naturalist, was a dream job.

My first book projects also came out of my geology/photography connection. I spent the better part of three years hiking over 100 trails in the Four Corner States for "Hiking Colorado's Geology" (co-authored with my wife, Lindy) and "Hiking the Southwest's Geology" (The Mountaineers Books, 2000 and 2002). Producing both the words and photos for these two guidebooks was a profound experience that finally brought me full circle.

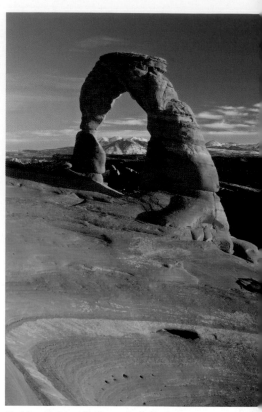

Golden Light at Delicate Arch, Arches
National Park, Utah

(Pentax 645, 45mm f/2.8, Fujichrome Velvia,
exposure unrecorded, polarizing filter)

The digital revolution was just gearing up in 2000 when we launched Lindblad Photo Expeditions. Like many photographers, I resisted making the switch to digital until the quality of digital images equaled what I could do on film. It didn't take long, and I was hooked. With digital, I'm much more creative and productive in my work, and the instant feedback of digital is a great teaching tool and has added greatly to the popularity of photo expeditions and digital photographic workshops.

But even with all the rapid advances in digital technology, it all comes back to making pictures in the moment. My early mistakes and struggles behind the 4 X 5 camera still help define my approach to making images today. I'm still careful about my compositions and selective with the subjects I choose.

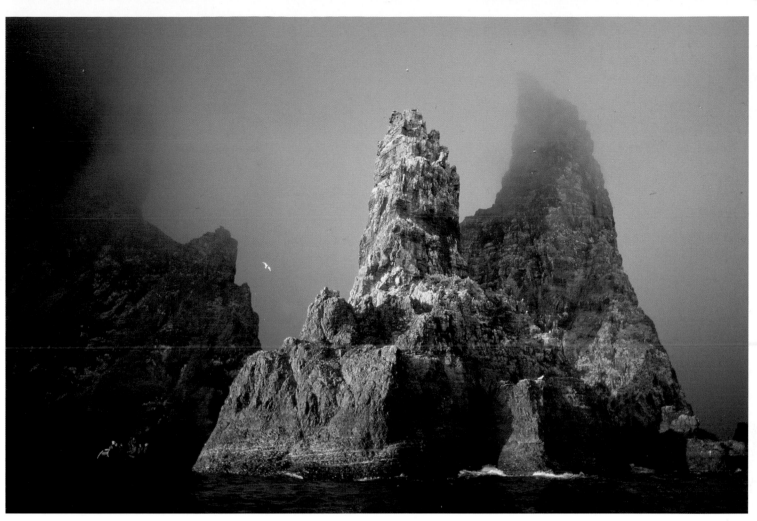

Exploring Sea Stacks at Bear Island, Svalbard Archipelago, Norway

(Pentax 645, 45mm f/2.8, Fujichrome Velvia, exposure unrecorded, no filter)

What started as a part-time job has now lasted over 20 years. Somehow, somewhere along the way, I stumbled into a career. Who could have dreamed that one day I'd be making images with digital cameras, seeing the results instantly, and uploading images wirelessly through space over the internet. It still seems like magic to me. The digital revolution has opened whole new world to explore, a world I call the "World Wild Web."

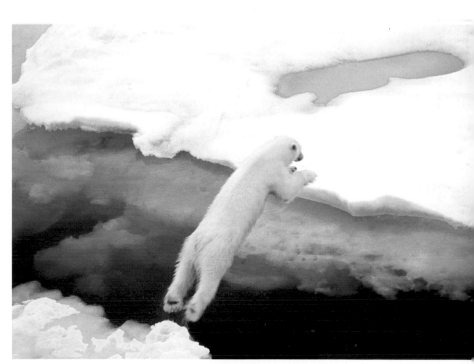

Polar Bear Jumps between ice Floes. Svalbard Archipelago, Norway

(Nikon F4, 70-200mm f/4, Fujichrome Velvia, exposure unrecorded, no filter)

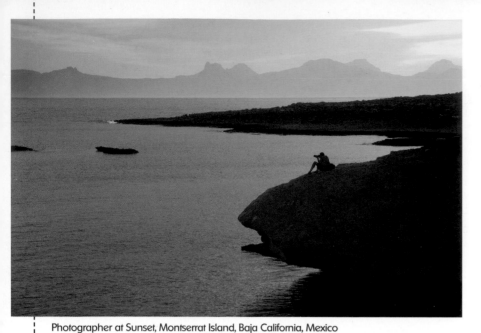

Photographer at Sunset, Montserrat Island, Baja California, Mexico

(Canon EOS 5D, Canon EF 70-200mm f/2.8L IS USM, 1/500 second @ f/5.6, ISO 200, -0.33 EV, no filter)

I look to include people in the frame to draw the eye and provide a sense of scale.

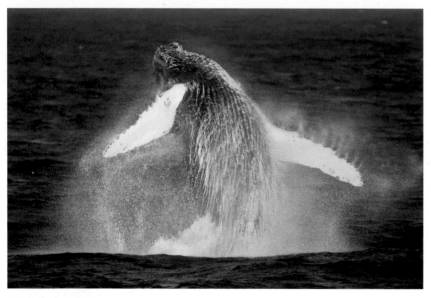

Humpback Whale Breaches, Baja California, Mexico

(Canon EOS 1D, Canon EF 70-200mm f/2.8L IS USM, 1/5000 second @ f/2.8, ISO 200, -0.67 EV, no filter)

learn your camera's features and limitations. Don't be afraid to actually read and study the camera manual or, better yet, get one of the many books on the market that deal specifically with your make and model (such as the Magic Lantern Guide series). The sooner you master the technical aspects of your equipment, the faster you will grow as a photographer, and the more creative you will become.

Be in the Moment: Being in the moment is about learning a personal approach to the art of nature photography. For me, it's a process that goes beyond the search for the perfect image, to a more mindful way of being in nature.

When I'm outdoors in search of a composition, I try to be as open as possible to what nature presents. This approach brings about a sense of freedom where the technical side of photography merges with the creative side. I explore with patience, moving on until I find a composition that works photographically. The composition can be as subtle as water drops on a flower petal, or as dramatic as the splash of a breaching humpback whale. Being mindful keeps me ready to click the shutter at the decisive moment, the moment it all comes together in the viewfinder. If there's one goal in nature photography, it's to always be ready for the spontaneous while staying open to serendipity.

Right Place at the Right Time: Developing a knack for being in the right place at the right time is where practice and preparation pay off. Like the big fish that got away, missed moments haunt nature photographers. To consistently find yourself in good situations requires homework. Once in the field, it then takes effort to scout locations, and experience to pre-visualize what will work and what won't. And then it takes a little bit of luck for something to happen while you're there.

GETTING STARTED

Great nature photographs do not happen by chance alone. Sure, there is the "lucky" shot from time to time, but it's really a matter of being prepared, being in the moment, and being in the right place at the right time.

Know your Equipment: Being prepared starts with knowing your equipment. A good understanding of your camera, lenses, and accessories will help you respond quickly to the fast changing photo opportunities that happen in nature. Take time to

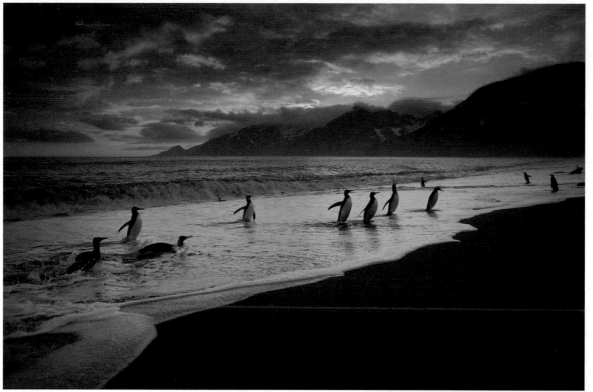

King Penguins coming Ashore at Sunrise, St. Andrews Bay, South Georgia

(Canon EOS 5D, Canon EF 16-35mm f/2.8L II USM, 1/250 second @ f/2.8, ISO 200, -0.33 EV, grad-ND)

Knowing when to walk away is just as important as having patience to shoot up to the bitter end. Tired, hungry, and cold, I've seen countless amazing sunsets in the rearview mirror after giving up and heading for camp, the café, or the bar. But I've also been rewarded for slogging through the rain. Waiting on the weather to break is key to finding drama in landscapes. With wildlife, learn about animal behavior so you can anticipate the action. Turn your back on the humpback whale, and it will breach.

Taking the next step in your photography is not about what's convenient or comfortable. Nature photographers get up early and stay out late. Once in South Georgia, we landed at 4:00 A.M. to catch the light. It was one of the best couple of hours I've ever had in photography. The light was incredible, and there were hundreds of thousands of king penguins in every direction. I filled every memory card I had with me before breakfast!

When the magic happens, the hardships suddenly become worthwhile. It's a special feeling when it all comes together in the viewfinder with a strong composition, great light, and the magic of the moment.

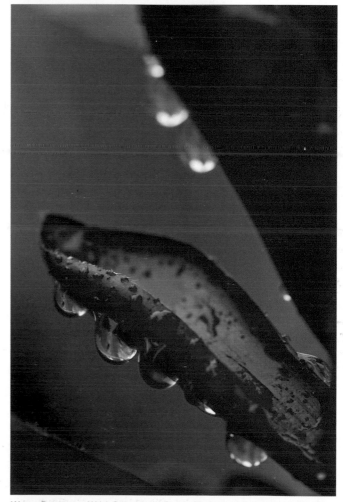

Water Drops on Wild Ginger, La Selva Biological Reserve, Costa Rica

(Canon EOS 1D, Canon EF 100mm f/2.8 Macro USM, 1/40 second @ f/8, ISO 200, -0.67 EV, no filter)

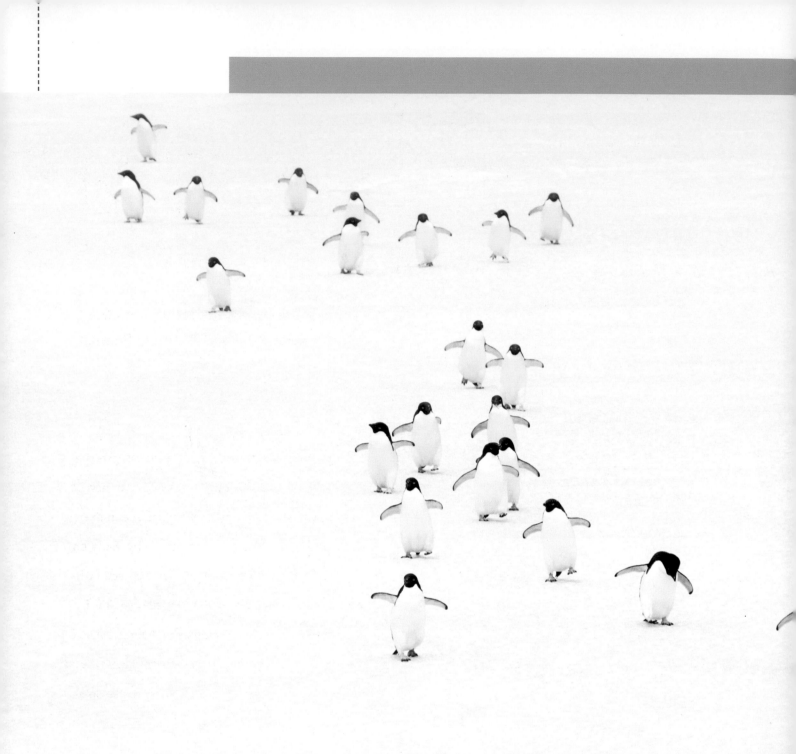

A Parade of Adelie Penguins Crossing the Pack Ice, Antarctica

(Canon EOS 1D Mark II, Canon EF 70-200mm f/2.8L IS USM
w/1.4x, 1/400 second @ f/8, ISO 100, +1.66 EV, no filter)

Chapter 1: Preparation

"Funny thing, the more I practice the luckier I get." – Arnold Palmer

While we all learn from our mistakes, preparation can help you avoid mistakes. I can honestly say that I've made every mistake in the book when in comes to photography. Early on, I once forgot to pack film for an important trip and, more recently, I erased memory cards by mistake. Once I even missed a flight because I nodded off while sitting at the gate! Please, learn from my mistakes. Make preparation a key part of your approach to nature photography.

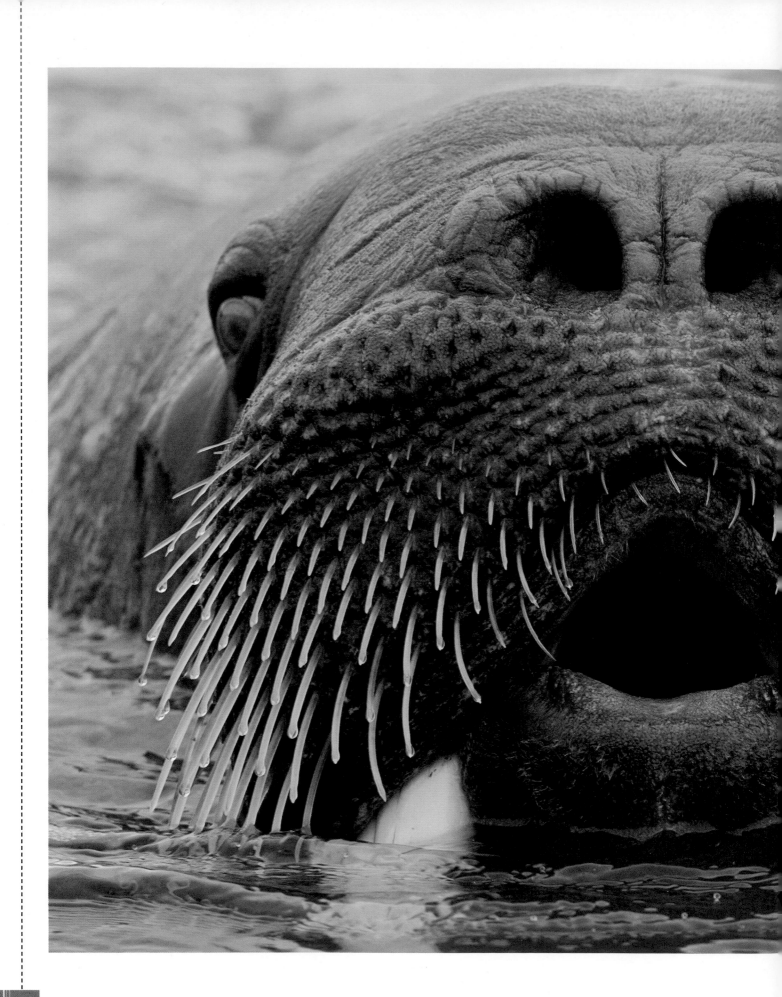

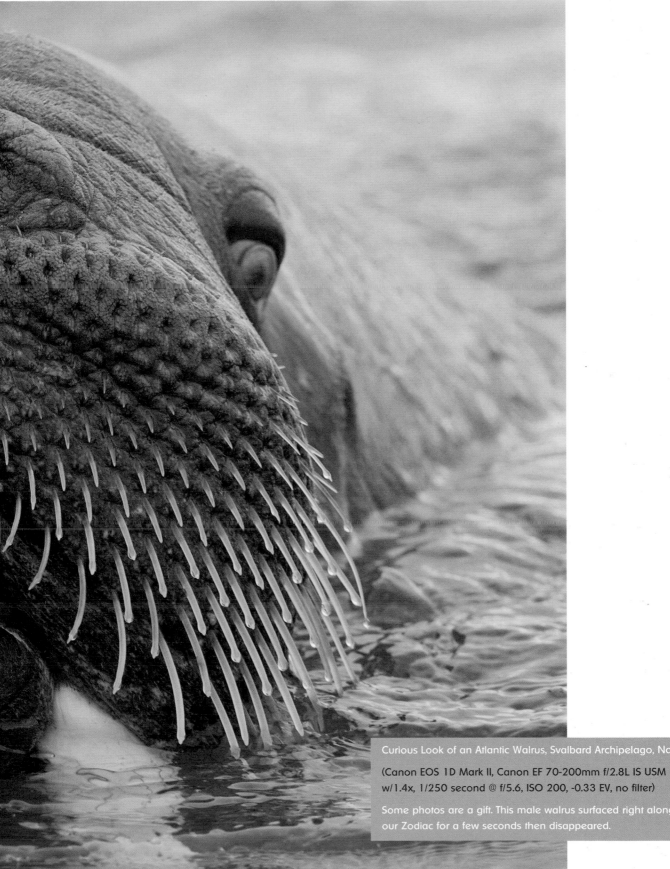

Curious Look of an Atlantic Walrus, Svalbard Archipelago, Norway

(Canon EOS 1D Mark II, Canon EF 70-200mm f/2.8L IS USM w/1.4x, 1/250 second @ f/5.6, ISO 200, -0.33 EV, no filter)

Some photos are a gift. This male walrus surfaced right alongside our Zodiac for a few seconds then disappeared.

DISCOVER YOUR PASSION

To be a successful nature photographer, it's important to discover your passion. Do you love photographing the grand landscape, or capturing wildlife portraits and behavior? Or do you enjoy making intimate close-up pictures of wildflowers?

To help in the process of discovering what really motivates you, take extra time to explore the natural world with your camera. Hike a trail, investigate a pond, or simply visit your own back yard. Then spend time with your images, editing and creating collections. Make prints or create slideshows to share with friends. Or even try your hand at designing an online book. All these creative tasks will help you narrow your focus.

Everyone loves to be outdoors clicking the shutter, but when it comes to the time-consuming tasks of organizing, processing, and outputting your images, that's when you realize what really interests you. Do you want to spend time working on your flower images, or are you really more interested in making a large print of one of your polar bear photos?

When the day comes that you discover your passion, you will know it. It may be a "Eureka!" moment, or perhaps a quiet realization. Trust in the process and know that it will find you one day. It may be an over-used cliché, but there's truth in the old saying, "Shoot what you love and the rest will follow." Begin by finding what it is that you love the most.

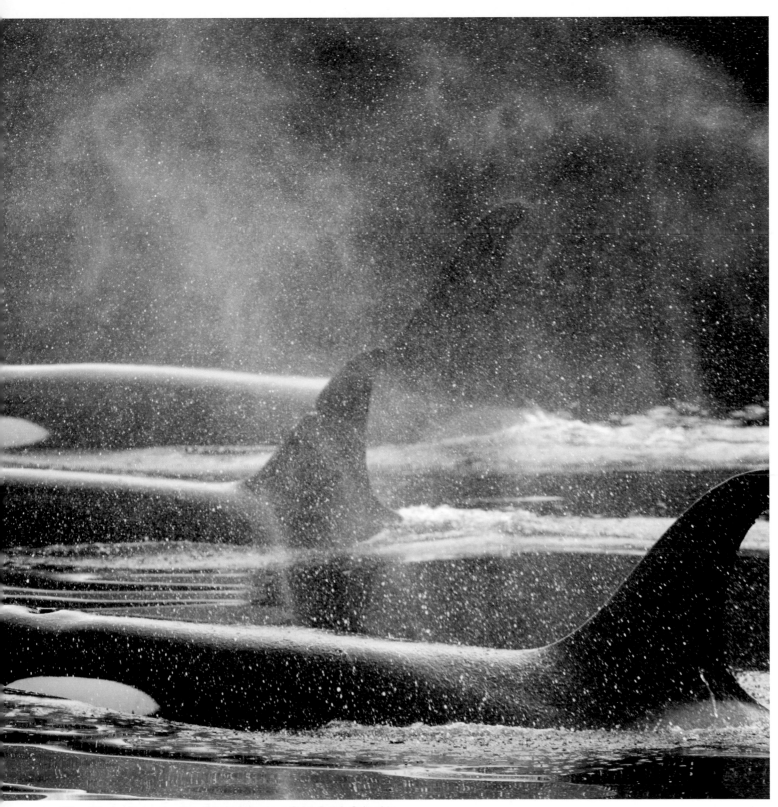

Killers Whales Swimming Together in Johnstone Strait, British Columbia

(Canon EOS 1D Mark II, Canon EF 300mm f/2.8L IS USM w/1.4x, 1/500
second @ f/5.6, ISO 200, -0.67 EV, no filter)

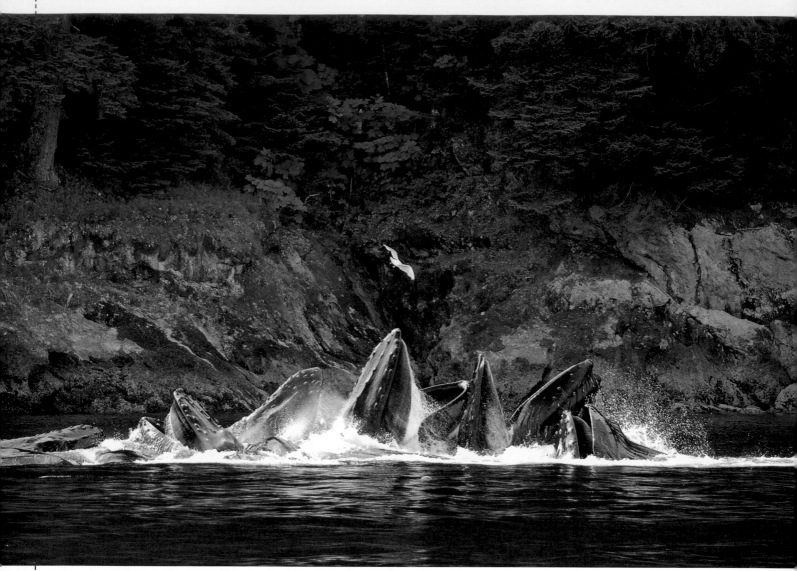

Humpback Whales Bubble-Net feeding, Chatham Strait, Southeast Alaska

(Canon EOS 1D Mark II, Canon EF 70-200mm f/2.8L IS USM w/1.4x, 1/250 second @ f/8, ISO 200, -0.33 EV, no filter)

DO YOUR HOMEWORK

Once you have discovered your passion and what it is you love to photograph, the next step is learning to be in the right place at the right time. This requires homework, with lots of research and planning before you start making pictures.

The best approach to research is to make research and planning part of the fun of nature photography. I love to plan; to spread out a map on the floor and daydream about the next, new place. The more homework you do before hitting the road or the trail, the more productive your trip will be. Research your destination thoroughly. Motivate yourself to become an expert.

Naturally, before you can plan, you need to choose a destination, or perhaps a specific animal or habitat to explore. Start by going to the library, or visiting a local bookstore. I still enjoy the feel of having a real book in my hands, thumbing through the pages and looking at pictures. My bookshelves are filled with guidebooks and nature guides; there's a stack on my desk as I write this.

However, in today's world, I find I'm much more productive using the Internet. Google has forever changed the way we do research. I begin by making a destination folder on my computer. I search the web to gather key links and drag them to my destination folder, organized into subfolders by topics of interest.

As my focus narrows, I perform an image search to identify the most photographed spots. In my industry, a fresh perspective is important, so I strive to capture a new look. It helps to know what's already been done. For years I avoided hiking up to Delicate Arch in Arches National Park because it was so well photographed. But on the flip side, you learn there's always another angle.

As the research continues, I narrow the scope even more, choosing specific locations and determining the best time of year. Identifying target locations and planning for the peak times of year requires digging a little deeper.

If it's landscapes you're after, be aware of the seasons. Investigate the timing of wildflower blooms in spring and summer, or locations for the most vivid fall color displays. Remember that elevation plays a big role in the timing of events. Wildflowers peak in the Arizona desert as early as February. The aspens may be spent in the Colorado Rockies by mid-October, but the cottonwoods are still blazing in the valleys of New Mexico.

For wildlife, consider the seasonal migrations and behavior of the animals of interest. You're not going to find Yellowstone grizzly bears in winter, but it's a great time for elk and bison. The snow geese don't arrive along the Rio Grande until late November and they're gone by mid-March. And you'll miss the gray whales in Baja California's San Ignacio lagoon if you get there in May.

Once you've settled on your locations and subjects, reach out to people you know who may have been there. When I was planning a trip to South Africa, I picked the brains of my Seattle friends who had been there. Though they weren't serious photographers, they had lots of good information about the advantages and disadvantages of certain lodges and national parks. They encouraged me to visit a private reserve because you can drive off road, stay out past sunset, and even do game drives at night with spotlights. In contrast, Kruger National Park limits travel to established roads, and you need to be inside the camp gate by sundown. I still visited Kruger and made some nice images, but I took into account the limitations in my planning.

When it comes to hitting the ground running, there's no substitute for inside knowledge. As nature photographers, we are always looking for the hidden gems, the off- the-beaten-path waterfall, a hidden wildflower meadow, or a unique angle on a classic scene that only locals would know. Ideally, find a local who is willing to share information. This may be a local outfitter or a more specialized guide. Even if they are not photographers, their expertise can be very helpful. An email inquiry can establish contact, but it's more helpful to make a phone call. A phone conversation can lead to questions you never thought to ask and may result in helpful recommendations that you did not anticipate.

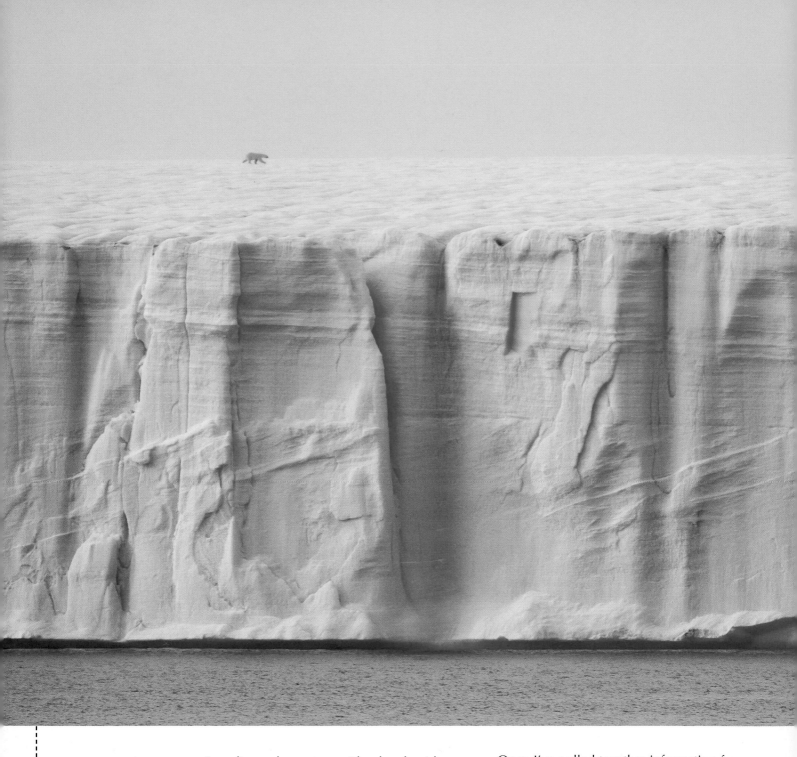

Spending a day or two with a local guide who knows the lay of the land can jumpstart your explorations and save you precious time. Make plans to meet within a day or two of your arrival. To get oriented, have your guide show you the most obvious locations first, then branch out to the more hidden spots. Take into account the time of day when you scout. No sense visiting a morning location in the afternoon when the sun is already behind the mountain.

Once I've pulled together information from many sources, I create hard-copy folders of the most important maps and information. I also get an all-weather notebook for listing important contacts, reservation information, and taking notes in the field. The real fun starts when I get to the point of booking reservations and making travel arrangements. The homework is done and plans are becoming a reality, but I still haven't even snapped a picture!

Resources for Research

- Travel Guidebooks: Lonely Planet (lonelyplant.com)

- National Park information and permits (nps.gov)

- National Wildlife Refuge information (fws.gov)

- National Park topographic maps: National Geographic Maps (natgeomaps.com)

- US Geological Survey topographic maps (topomaps.usgs.gov)

- Satellite Maps: Google Earth (earth.google.com)

- Information about wildlife: Audubon Online Guides (audubonguides.com)

- Information about the night sky: SkyGazer software (carinasoft.com)

- International travel updates: US Department of State (travel.state.gov)

- Weather and forecasts: National Weather Service (weather.gov)

Lone Polar Bear Crossing Northeastland Ice Cap, Svalbard Archipelago, Norway

(Canon EOS 1D Mark II, Canon EF 300mm f/2.8L IS USM w/2x, 1/1250 second @ f/5.6, ISO 200, +1.0 EV, no filter)

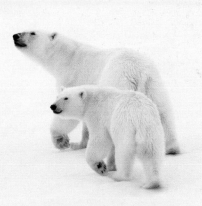

Following Mom, Polar Bears on Pack Ice, Svalbard Archipelago, Norway

(Canon EOS 1D Mark II, Canon EF 70-200mm f/2.8L IS USM, 1/400 second @ f/8, ISO 200, +0.67 EV, no filter)

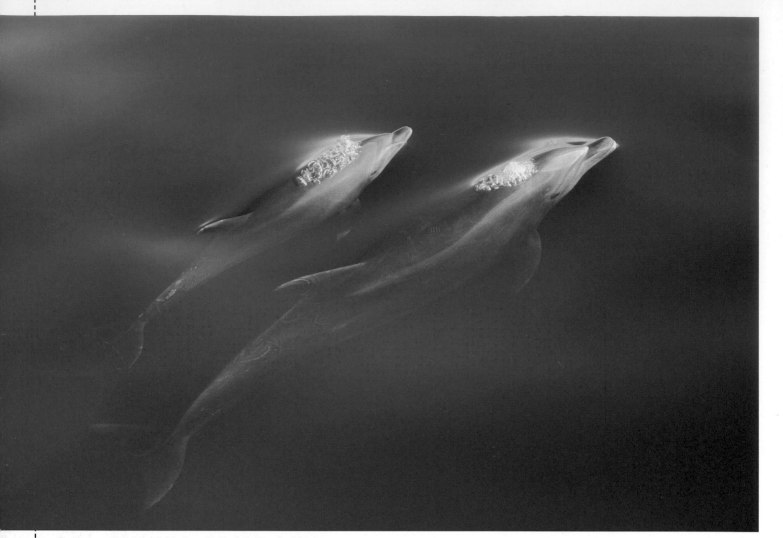

Bottlenose Dolphins Surfacing, Gulf of California, Mexico

(Canon EOS 1D Mark II, Canon EF 70-200mm f/2.8L IS
USM w/1.4x, 1/500 second @ f/5.6, ISO 200, -0.67 EV,
polarizing filter)

STUDY THE MASTERS

I'm always surprised at how little photographers of today know about the roots of their craft. When I was teaching myself to be a landscape photographer using a large format 4 X 5 camera, naturally I studied the black-and-white portfolios of Ansel Adams. I was drawn to the clouds and quality of light of "Clearing Winter Storm, Yosemite," puzzled by the extreme depth of field of "Mt. Williamson, Sierra Nevada," and in awe of the jet-black sky in "Moonrise, Hernandez, New Mexico." His work taught me to be mindful of my compositions and to "pre-visualize" what the final images will look like.

Later, I discovered the color photography of Elliot Porter. In the landmark Sierra Club book, "In Wildness Is the Preservation of the World," I was struck by his use of color, pattern, and texture. Rarely did his compositions include sky, and many of the images were made on overcast days. His work taught me about the soft qualities of diffused light and looking for beauty in the smallest details of the overall landscape.

Influences

I learned a great deal by studying the work of master photographers and wildlife artists:

- Ansel Adams: black-and-white landscapes
- Elliott Porter: color landscapes and nature details
- Phillip Hyde: color landscapes of the American Southwest
- David Muench: color landscapes
- Galen Rowell: wilderness and adventure
- Boyd Norton: wilderness and conservation
- Tom Mangelsen: wildlife in their natural habitat
- Flip Nicklin: marine mammals
- Robert Bateman: wildlife painter

Today, I also admire the work of:

- Jack Dykinga: color landscapes and details of nature
- Patrico Robles Gil: wildlife and conservation issues
- Bob Krist: worldwide travel destinations
- Paul Nicklen: polar wildlife and climate change
- Jim Richardson: environmental issues
- Joel Sartore: environmental issues and endangered species

For wildlife, I looked up to the work of Tom Mangelsen, which I first came across in the Denver airport. What I found intriguing in his images was the use of the landscape as context for the animal's habitat. The lone polar bear and arctic fox crossing the wind-swept Arctic pack ice, or an Alaskan bull moose engulfed in a forest, ablaze with fall color. I learned from Mangelsen that there is more to a good wildlife photo than the tight portrait—the environmental portrait is just as important. It can give context to an issue, such as showing the animal's vulnerability or the risks of shrinking habitat.

I also studied the wildlife paintings of Robert Bateman, who uses every inch of the canvas to convey an animal's habitat, and creates tension by having the animals looking out of the frame, or by painting a branch in front of the subject. His paintings taught me "emptiness is not nothing," a quote I learned from him while traveling together on a Lindblad trip in Baja California. He taught me to leave space in my wildlife images and to create tension, rather than perfection.

Fall Color at its Peak, Sangre de Cristo Mountains, New Mexico

(Canon EOS 5D Mark II, Canon EF 70-200mm f/2.8L IS USM, 1/500 second @ f/5.6, ISO 200, -0.33 EV, no filter)

Workshop Student Photographing Wildflowers, Jemez Mountains, New Mexico

(Canon EOS 5D Mark II, Canon EF 100mm f/2.8 Macro USM, 1/4000 second @ f/2.8, ISO 100, 0.00 EV, no filter)

WORKSHOPS

Nothing helps boost your technical and creative skills like taking a photographic workshop. When I was starting out, workshops were few and far between. In fact, I never had the luxury of taking one. Today, with the explosion in digital technology and the need to stay current, the workshop business is booming. Workshops help you become a better photographer faster.

When considering a workshop class, it's important to choose the right instructor. Do some basic fact-finding by visiting the instructor's website or contacting a couple of past students. The title of the workshop is not as important as the instructor's style and the type of work they do.

The number one challenge in a workshop is facing the fear factor. You can't hide in the workshop environment. The intent of a workshop is to get you out of your comfort zone. If you always approach image making in the same old familiar way, you won't grow as a photographer. Workshops push your boundaries by presenting challenges that may be unfamiliar to you. Each day, your images are edited with the help of the instructor. Then, your selections are projected on the screen, along with the other students', and critiqued by the instructor. This daily image critique pushes students to work harder than ever before.

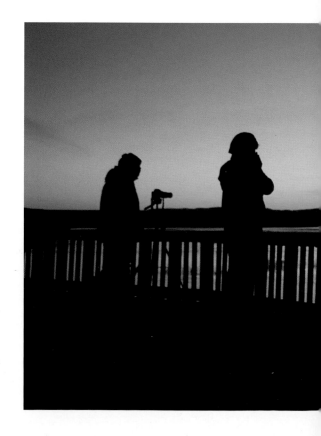

In my own workshops, I concentrate on teaching the creative side of photography. Daily assignments force students to experiment with exposure and depth of field, which helps them understand the camera's controls. On the first day, I typically ask them to use only a wide-angle lens on manual shooting mode and shoot the same composition while dialing through the aperture settings (f/2.8 to f/22). This exercise teaches them how the camera sees the world, and the relationship between aperture and shutter speed for determining exposure. This loosens everyone up and encourages experimentation, and everyone's photographs make a quantum leap. Subsequent assignments encourage students to find strong foreground elements and to shoot in different kinds of light. I love watching their growth in confidence and willingness to try new things.

There is also the "cross-pollination" effect of seeing the other students' work. It's inspirational to see how differently the photographer next to you captured a similar scene or subject, and it's amazing when a student discovers a unique approach and we all say, "Why didn't I think of that?" It just takes one image to ignite the creative spark that propels student photographers to get out on their own and make great images, and that is the most rewarding of all.

Workshop students waiting for the light at dawn, Bosque del Apache, New Mexico

(Canon EOS 5D Mark II, Canon EF 16-35mm f/2.8L II USM, 1/250 second @ f/2.8, ISO 200, -0.67 EV, no filter)

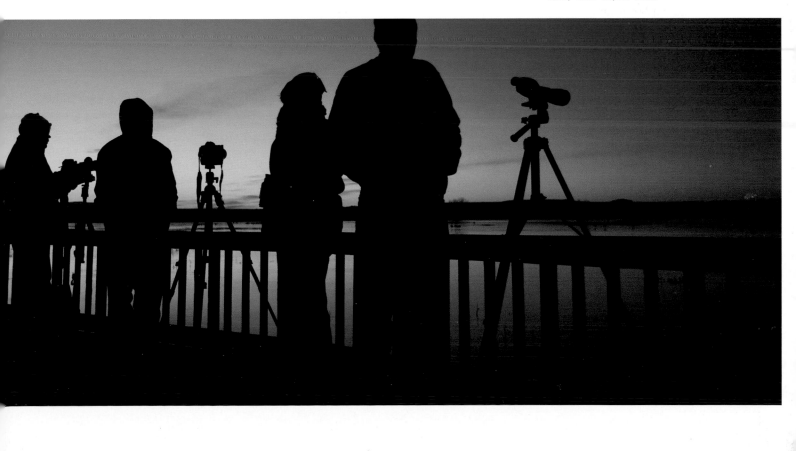

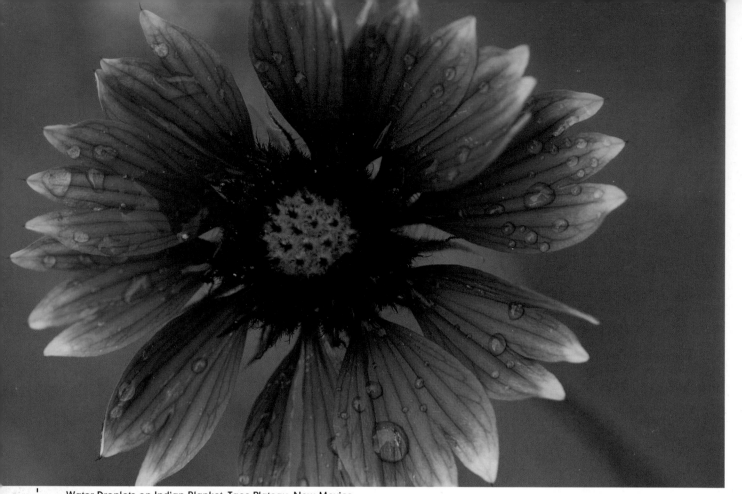

Water Droplets on Indian Blanket, Taos Plateau, New Mexico

(Canon EOS 5D Mark II, Canon EF 100mm f/2.8 Macro USM,
1/500 second @ f/5.6, ISO 200, -0.33 EV, no filter)

ADOPT A PROJECT

Another way to improve your photographic skills is to adopt a project close to home. Your own backyard is the best place to start. As nature photographers, we all want to travel to wild and exotic destinations; there seems to be a direct relationship between how long it takes to get somewhere and how much we appreciate it. A place is more special the further we fly, drive, or hike. It always seems that our best pictures are the ones we worked the hardest to get.

But this kind of thinking can limit our creativity. You can make great pictures anywhere. Photographic projects naturally present themselves once you discover where your passion lies. It could be as simple as photographing your neighbor's rose garden or working with an organization trying to preserve a local wetland.

Adopting a project helps you focus on your photography. It motivates you to take breaks from the everyday grind. The goal is to stay in practice with your camera and to see the project through. Give yourself a deadline, make contacts, and search for venues to present or display your work. Challenge yourself, make mistakes, and learn to see something new in the ordinary.

Develop Your Own Project

- Photograph the birds coming to your birdfeeder (from a blind or nearby window)

- Create a print exhibit of flowers and plants in your own backyard or local park (public libraries often have a public art space)

- Photograph endangered or threatened plants, animals, or lands for local conservation organizations

- Document hiking trails for city, state, or local land trusts

- Help experts develop field guides for the local botanical garden or native plant society

- Partner with international conservation organizations to document issues and projects in other countries

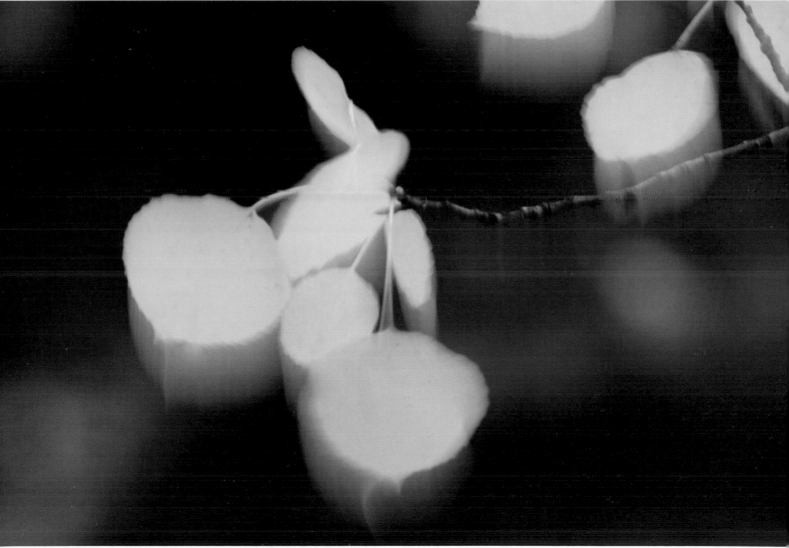

Wind Blown Aspen Leaves, Sangre de Cristo Mountains, New Mexico

(Canon EOS 1D Mark III, Canon EF 70-200mm f/2.8L IS USM, 1/3 second @ f/8, ISO 200, -0.33 EV, no filter)

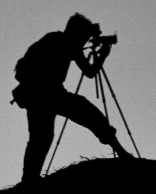

Photographer at Twilight, Baja California, Mexico

(Canon EOS 5D, Canon EF 70-200mm f/2.8L IS USM,
1/125 second @ f/2.8, ISO 400, +1.0 EV, no filter)

Chapter 2: Gearing Up

"How do you know when more is too much." – from the movie, *Taos*

I entered the world of digital photography cautiously. My first foray to the "digital dark side" came after one of my students wrote on his class evaluation, "Will someone please give Ralph a digital camera?!" Turns out, he just happened to have the original Canon EOS D30 digital single-lens-reflex (D-SLR) at the time to sell me. With its whopping 3-megapixel (MP) sensor, it's hard to believe now that this camera was once cutting edge, state-of-the art technology. We are truly entering the golden age of digital photography. I can only imagine what amazing technological advances are coming down the line in the future.

What's in the Bag?

Here's my standard gear for nature photography:

- 2 D-SLR camera bodies (full-frame and APS)

- Compact digital camera and underwater housing

- Lenses: 16-35mm f/2.8, 24-105mm f/4, 70-200mm f/2.8, 100-400mm f/4-5.6, 500mm f/4, 100mm f/2.8 macro, fisheye

- Lensbaby

- 1.4x tele-extender, extension tubes

- Off-camera flash, cords, wireless transmitter

- Remote shutter release

- Filters: polarizer, 2-stop and 3-stop graduated neutral density (grad-ND), fixed 5-stop ND, variable neutral density (vari-ND)

- Memory cards (as many as possible)

- Batteries and chargers for cameras and flash units

- Tripod with ballhead and quick-releases plates

- Laptop computer w/external hard drives for back-up

- Back-up digital storage device

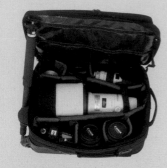

Rolling camera case

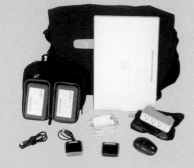

Computer bag with laptop and external hard drives

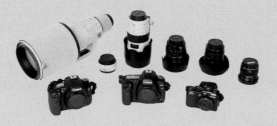

Camera and lens arsenal

GEAR

With so many digital cameras flooding the market, it's understandable to be confused by all the choices, and it's hard to keep up with the rapid pace of technological advances rendering new cameras obsolete in a matter of months, not years.

Choosing a camera depends on several things: what kind of photography you like best, how much gear you can carry, and how much money you want to spend. For example, wildlife photography requires big glass and D-SLR cameras with high burst rates. In this case, APS sensor D-SLRs work well because they give an added boost to the lens length with the cropping factor (see page 38). Landscape photography, on the other hand, employs deep, wide-angle views, with depth of field (DOF) being more important than shutter speed and frames per second (fps). A full-frame D-SLR makes more sense for this kind of work because it does not crop the digital image.

Whatever your needs may be, the most important thing is to choose a camera that you'll actually use. There is no sense in buying one of the heavier professional models if you don't want to carry the extra weight. Be sure the camera fits ergonomically in your hands, and that the controls make sense.

CAMERAS

Digital cameras come in all shapes and sizes. Unfortunately, there is not one camera or system that is good for everyone. When it comes to camera types, I divide them into three basic categories.

Digital Single-Lens Reflex (D-SLR) Cameras:

The digital single-lens-reflex, or D-SLR, is the camera of choice for serious nature photographers. These cameras have interchangeable lenses, through-the-lens viewfinders, and offer the most versatility for nature photography. Today's full-frame D-SLRs rival the resolution and quality of the medium-format transparencies I shot on film a decade ago. D-SLRs have no perceptible shutter lag (the time delay after pressing the shutter button until the camera fires), in-camera processors are faster, and these cameras can shoot at capture rates exceeding 10 fps. All D-SLRs can shoot either RAW or JPEG capture formats.

D-SLRs offer a range of shooting modes that give the photographer complete control over exposure, shutter speed, and DOF. These cameras use interchangeable lenses ranging from wide-angle zooms to extreme telephotos that provide focal length combinations for every possible scenario, from macro to bird photography.

D-SLRs utilize several different sensor sizes, from the smaller APS size sensor to the full-frame 35mm size sensor at the high end. In general terms, physically larger sensors render higher quality colors and contrast and less digital noise, so full-frame D-SLRs are the way to go for top-quality digital images. D-SLRs range greatly in price and available features: lower-end, consumer level D-SLRs are not as heavy-duty and usually come with a smaller array of features; higher-end models are typically magnesium alloy, able to withstand some of the most extreme weather conditions, and come with a huge range of pro-level features.

In general, the primary advantages of D-SLR cameras are image quality, a rapid burst rate (from 5 – 11 fps), and autofocus performance. The faster models are the favorites among wildlife photographers. The major downsides to D-SLRs are the larger size, added weight, increased vulnerability to sensor dust (from changing lenses), and higher cost.

Advantages of Digital

- Instant feedback on a large LCD monitor
- Ability to change ISO from shot to shot
- High ISO and long exposure capabilities with lower noise
- No processing cost (once you invest in the gear, you're done)
- Unlimited images per shoot (with enough memory cards)
- Encourages experimentation
- More sharing via email, online, and slideshows
- Making prints in your own digital darkroom

D-SLR Sensors:
Full Frame vs. APS

Hopefully, it's not news to you that digital camera sensors differ. In addition to the number of pixels packed onto the sensor, the actual physical size of the sensor varies. And not all pixels are made the same either. Larger sensors accept more pixels, but the actual photo sites are larger. The bottom line is that larger pixels gather more light and produce a higher quality digital image.

High-end D-SLRs have full frame image sensors that are the same size as a traditional 35mm film frame (24 x 36 mm). Full frame sensors have larger pixels, or more correctly, larger photo sites, that translate into pixels that render better color and contrast information and have less digital noise. Full frame D-SLRs yield the best image quality with today's high-resolution sensors topping out at over 24MPs.

Most D-SLRs are not full frame, and have smaller APS size sensors. These APS sensors are a little more than half the size of a full frame sensor, creating an effective focal length magnification or "cropping" factor. This magnification factor varies with sensor size, ranging from 1.3x to 1.6x (all other variables being equal). This is why a 16-35mm zoom lens acts more like a 24-50mm zoom on an APS D-SLR, all things being equal. To balance the magnifying factor, many camera manufacturers make specialized, digital wide-angle lenses that start at a lower focal length range. At the other end of the spectrum, your 100-400mm zoom acts like a 150-600mm zoom—an added boost for wildlife.

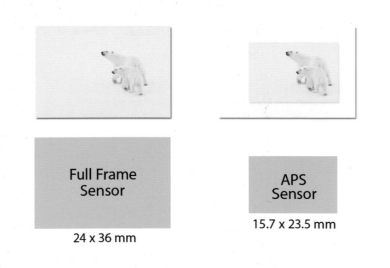

Full Frame
Sensor

24 x 36 mm

APS
Sensor

15.7 x 23.5 mm

Advanced Compact Cameras:

Not all nature photographers need to use D-SLRs, which are larger, heavier, and more expensive than most cameras. Advanced digital cameras offer a wide range of styles, with the major differences being they do not have interchangeable lenses or true through-the-lens viewfinders. Instead, lenses are built into the camera and they utilize LCD screens as live-view electronic viewfinders.

The high-end models offer all the same shooting modes and controls as D-SLRs and a choice of shooting RAW or JPEG. However, they tend to suffer from shutter lag and slower burst rates, both of which are big drawbacks for wildlife photography. Some models have a zoom range from medium wide-angle to extreme telephoto, and they do an amazing job for macro shots as well. Plus, certain models have an articulating LCD screen that rotates for composing at difficult angles, offering new and creative ways of shooting.

Advanced compact digital cameras have smaller sensors—about the size of your thumbnail. Smaller sensors cram the same number of pixels into a smaller space, so the pixel sites are even smaller. These smaller pixels can't capture as much light, once again limiting image quality and adding more digital noise because the sensitivity of the sensor is amplified electronically.

Still, despite their limitations, advanced digital cameras have a place in nature photography, especially where weight and accessibility are concerned. In some instances they can have advantages—for example, underwater housings are far less expensive for these cameras than for D-SLRs and can yield amazing results.

Photographer Working in Hunt's Mesa, Monument Valley, Arizona

(Canon EOS 5D Mark II, Canon EF 24-70mm f/2.8L USM, 1/60 second
@ f/11, ISO 100, -0.33 EV, polarizing filter)

Live View and HD Video

In today's digital world it's now possible to compose and focus using the D-SLRs live view mode. In live view mode, you can see on the camera's LCD exactly what the digital sensor is seeing. It's realtime, through-the-lens (TTL) viewing like you get with a video camera. Advanced compact digital cameras have used live view for some time, but now most high-end D-SLRs have live view as well. Using live view not only helps with fine-tuning your compositions, but also helps you nail the critical focus point within the images.

Sensor Dust:
Digital's Dirty Little Secret

Digital's dirty little secret is the fact that the image sensor is particularly susceptible to dust. This is because the sensor is a charged surface that attracts particles—a law of physics hard to defeat. Many D-SLR cameras have an ultrasonic dust removal function that shakes the dust off; this helps but does not eliminate the dust. After all, where can it go inside the camera?

The reality is that you have to regularly clean your sensor if you want to avoid long Photoshop sessions removing dust spots from images with the healing brush. In landscape photography, we often shoot with a deep depth of field, which exasperates the problem because the dust is more visible in the frame.

Everyone tells you not to touch your sensor; you'll void warranty and can damage your camera. But you are not really touching the sensor exactly, rather just the protective high-pass filter. With the right tools and proper care, it's possible to clean the sensor. (Warning: Proceed at your own risk! You will void the warranty on your camera and risk damaging the sensor if you don't clean the sensor correctly.)

For nature photographers working outdoors in a variety of harsh environments, it's almost impossible to keep your camera's sensor completely free of dust. However, there are steps that will help minimize the problem.

As a general practice, it's enough to simply use a rocket blower regularly, being sure to use the camera's sensor cleaning function, which turns the power off to the sensor during cleaning. If you notice sensor spots that won't go away, then use the specialized sensor pen to remove stubborn dust. Only as a last resort do I use a liquid cleaner and Pec-Pads, but it's good to have on hand just in case.

Tips for minimizing Sensor Dust:

- Use two camera bodies to reduce lens changes
- Turn off the camera when changing lenses
- Avoid windy or dusty conditions
- Keep the lens caps and camera bag clean
- Use a rocket blower often for loose dust
- Clean the sensor with a sensor pen for sticky dust

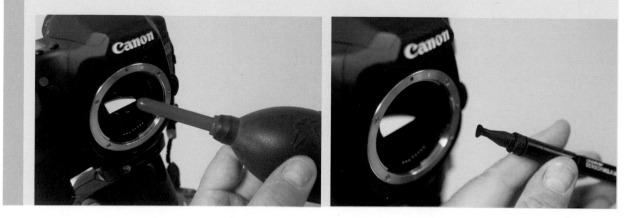

Sharing the instant feedback on a compact digital camera, Baja California, Mexico

(Canon EOS 5D, Canon EF 24-70mm f/2.8L USM, 1/125 second @ f/5.6, ISO 200, -0.33 EV, no filter)

Compact (Point-and-Shoot) Cameras: Everyone should have one of these small, compact cameras, affectionately known as a point and shoot. The simpler models are nearly fully automatic, while other, more sophisticated models allow some measure of control (exposure compensation, ISO, and color balance). Many are weatherproof and can be completely submerged in water.

Although severely limited, these fun little cameras are great for taking record shots that document the nature photographer's life and travels. A few even shoot RAW files!

Baja California, Mexico

(Canon EOS 5D, Canon
EF 24-70mm f/2.8L USM,
1/640 second @ f/2.8,
ISO 100, -0.33 EV, polar-
izing filter)

*If you are interested in
bird photography, bring
your big glass (and your
tripod).*

LENSES

In today's digital world there are more lens choices than just choosing between a fixed focal length and a zoom lens. With the extreme conditions we encounter as nature photographers, it's important to get image stabilized (IS) or vibration reduction (VR) lenses. I'm often shooting on moving boats, hand-holding in marginal conditions, and shooting in dark forests. When using my longer lenses, I even use IS when my camera is on a tripod and shutter speeds are slow.

So what lenses do you need? Do I stick with zoom lenses, or do I go for it and get the big glass? Again, the answer depends on how you're going to output your images. You don't need the sharpest optics unless you are blowing your images up to really large print sizes. Sure, you can buy and carry a huge, fixed telephoto, but unless you're a serious wildlife photographer, you won't want to carry it. There are other options for good image quality without going fixed, especially in the Antarctic and Galapagos, where the wildlife is close at hand. But I also have longer zooms and the 500mm for wildlife trips to places like Alaska or Svalbard.

Wide: Wide-angles are the lens of choice for emphasizing foreground elements and increased DOF, and are most effective when the lens is close to an interesting foreground subject. Placing the camera low to the ground greatly enhances the effect of the wide-angle perspective. Wide-angle lenses also help create a sense of space. Wide-angle lenses are great for landscape photography, creating interesting perspective effects, tight spaces with little room to move, and for capturing deep DOF.

Medium: Medium focal lengths see the world more like our eyes, and can result in very balanced images if used correctly. I use the 70-200mm f/2.8 with 1.4x option more then any other lens combo. Medium focal length lenses are good for "postcard" landscape photos, common wildlife encounters that don't require any great distance, and for some macro photography work.

Telephoto: Longer telephotos lenses—300mm and above—compress the perspective and make distant objects look bigger, adding drama to the scene. Wildlife photography requires big glass—industry jargon for high-end telephoto lenses—and D-SLR cameras with fast burst rates (preferably 6 fps and above). Even when you can get close to wildlife, it's still useful to have a longer lens so you can simplify the background with a shallow depth of field. I carry a 500mm (coupled with a 1.4x tele-extender) for wildlife work. Telephoto lenses are necessary for most wildlife photography, useful for macro photography, and can even be used to create interesting landscape photos due to the increased compression effects.

Macro: The advantage of macro lenses is the high-quality optics for making sharp pictures at close range and high magnification. Most allow for close focusing at magnifications up to 1:1 or "life size," where the subject is the same size on the sensor as in real life. Some zoom lenses also have "macro" settings, but they do not approach 1:1 magnification and the image quality often suffers. For the highest quality macro image possible, dedicated macro lenses are the way to go.

Extension Tubes: Extension tubes are essentially lens spacers that come in different widths (e.g.12mm or 25mm, the wider the extension the closer the focusing) and attach between the lens and the camera body. No optics (glass) is involved; the concept is that the farther the lens is from the digital sensor (film plain) the closer it will focus. Extension tubes are best used with fixed focal-length lenses, although I've had good results with the 70-200mm f/2.8 zoom. Chromatic aberration (color fringing along edges) is a troublesome issue when extension tubes are coupled with inexpensive lenses and shorter zooms. This may or may not be an issue to you, depending on the final output of your images. Extension tubes are primarily used in macro photography, but can be used with wildlife as well.

Tele-Extenders: Tele-extenders (1.4x, 1.7x, and 2x) can also be used in nature photography. Tele-extenders are optical accessories that also fit between the lens and the camera body. When used with fast zooms, like the 70-200mm f/2.8, the 1.4x and 1.7x tele-extenders magnify the image without degrading image quality (the 2x does result in loss of sharpness, allowing for a farther working distance, which is good for shooting lizards and butterflies, or anything that might be scarred away with a close approach. They don't, however, allow you to focus the lens closer to the camera as extension tubes do.

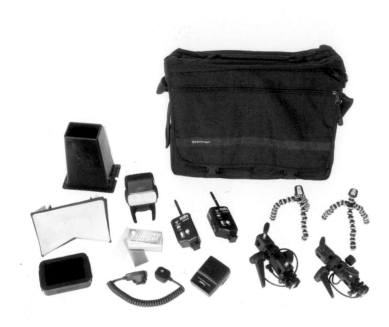

Reflectors: Anything that reflects light can be used to add light to your composition. Portable reflectors are small, light, and easy to use in the field. You can also aim your accessory flash at the reflector to create a more diffused light. Some reflectors can also double as shades, which is helpful at high noon when the sun creates high contrasts and harsh shadows.

Diffusers: If you don't want to completely shade your subject, then a diffuser is an excellent light modification tool. Diffusers spread and soften the light to create more even looking lighting and subtle, pleasing shadows. A diffuser can be made out of any white translucent material, and there are many kinds of diffusers available on the market for photographic work.

ACCESSORIES

LIGHT MODIFIERS

Accessory Flash: Although the nature photography almost always takes place outside where there is ambient light, an accessory flash can be a handy tool for bringing your own light into the field. Fill flash is one way to modify the ambient light. In landscape photography, it's an effective way of filling in shadow areas or highlighting foreground elements. In wildlife photography, fill flash can be used as a tool to add catchlights to the animal's eye (see page 87). In macro photography, fill flash can minimize subject movement by freezing the subject in the frame. For more control over your flash as an alternative light source, include an off-camera flash cord in your lighting kit.

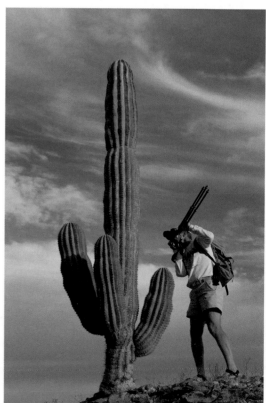

Cardon Cactus, Baja California, Mexico

(Canon EOS 5D, Canon EF 16-35mm f/2.8L II USM, 1/125 second @ f/11, ISO 200, no filter)

CAMERA SUPPORT

Tripods: There are a number of other reasons for carrying and using your tripod—sharp images being the main reason. You can shoot with slower shutter speeds and smaller apertures on a tripod, and, most importantly, a tripod slows you down and makes you more selective with your compositions. It takes extra work and time to set up a shot. This measured approach will improve your images because you'll be looking at the world in a new way. A tripod comes in handy for almost every subset of nature photography, and it is essential for landscape and macro work.

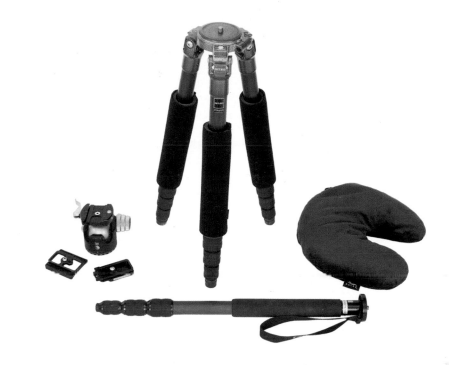

Choosing a Tripod

Tripods are a serious investment. To help ensure that you'll love your tripod (and therefore use it), here are a few features to consider:

- Carbon Fiber: much lighter than metal to ensure you carry the darn thing

- Size: large enough to hold your heaviest lens, tall enough for eye-level shooting

- Four-segmented leg sections, instead of three: shorter and more compact for packing

- Removable center post, or none at all: enables ground level shots

- Ball head: fluid motion for panning, easy to switch from horizontal to vertical; can also be used on a monopod

- Quick-release plates: have one for every camera and lens collar

- Gimbal-style head: for wildlife with long lenses

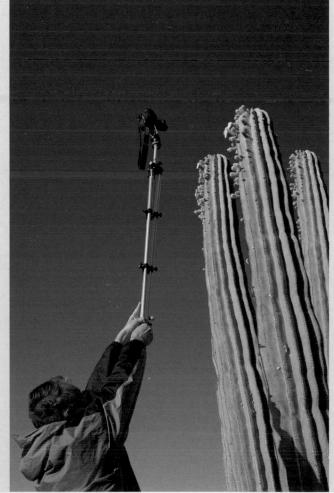

Baja California, Mexico

(Canon EOS 5D, Canon EF 24-70mm f/2.8L USM, 1/640 second @ f/5.6, ISO 100, -0.33 EV, polarizing filter)

Can't reach the flower? Pre-focus, set the self-timer, and use the tripod to get the shot.

If you don't love your tripod, you won't use it. You want a lightweight, sturdy model with a good ball-head that uses quick release plates. Be sure that each of your cameras and longer lenses have their own quick release plates. Trust me, and make it easy for yourself. The last thing you want to be doing when the light is good is screwing around switching lens plates.

It's funny the lengths people will go to not set up their tripod, even though they've carried it around all day long. There's also those special, creative uses of your tripod that make lugging it around worthwhile. From narrow slot canyons, to flowers at the top of a cactus out-of-reach, always use your tripod.

Monopods: Monopods are a good alternative to lugging around a tripod, and in certain situations, are preferable. Shooting with long lenses from the deck of a ship is a good example of when a monopod works best. A monopod is also helpful when shooting from open safari vehicles and a beanbag is not an option. It's also best for overhead "Hail Mary" shots, like reaching for a tall cactus flower. I carry a lightweight, 4-segmented monopod on most trips.

Beanbags: Beanbags are extremely portable and are a great camera support option, especially if you have limited space. You can stabilize your camera on the railing of a ship's deck, on a boulder, or right on the ground using a beanbag. And it doubles as a neck pillow on those long flights!

SHUTTER RELEASE

Remote Cable: To minimize or eliminate camera shake that results in a soft or fuzzy images, nature photographers routinely us a remote shutter release cable to click the shutter. A remote shutter release cable attaches to a port on the side of your camera, enabling you to activate the shutter without physically touching the camera. More sophisticated D-SLRs have wireless capabilities, making clicking the shutter possible without the cable.

Intervalometer: Another type of auto remote can be programmed to click the shutter at different times or intervals of time, and is called an intervalometer. Say you wanted to do a time-lapse sequence: you can program the remote shutter release so that it takes a picture every 3 seconds for as long as you want (or until your is memory card full or the battery goes dead). You can set the remote to keep the shutter open at 5-minute intervals—or however long you want over an extended time period—for photographing the night sky, a meteor shower, or the northern lights.

FILTERS

It's no secret that digital nature photographers still use filters. Although it's tempting to do everything on the computer in Lightroom and Photoshop, filters still have a secure place in my photo bag. My top three favorite filters are: (1) the polarizer, (2) the graduated ND, and (3) the Singh-Ray variable ND.

Polarizers: Polarizers darken blue and bright skies, emphasize clouds, control reflections, and bring too-bright highlights into a better exposure range. Polarizers work by rotating the front element of the filter to selectively block scatter light. This results in up to a 2-stop difference. With through-the-lens (TTL) metering, the camera

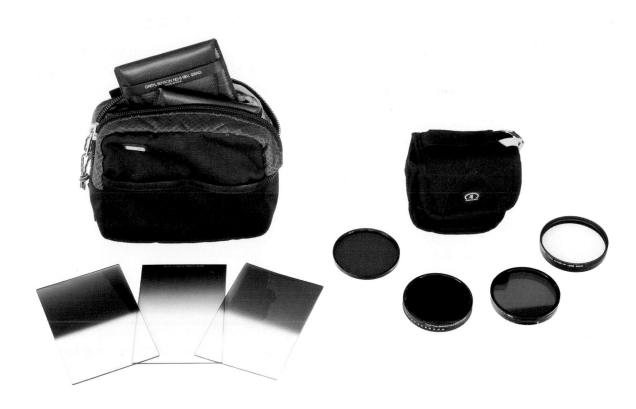

automatically compensates for the effect of the filter. The polarized effect is most pronounced when the camera is at a right angle to the sun, which is perpendicular to the axis of the filter.

Don't keep a polarizer on your lens all the time, rather keep it handy and use it when you need the effect of darkening skies or cutting surface reflections on water. It also cuts the reflections on wet leaves and is particularly effective boosting saturation in forest scenes.

Graduated Neutral Density:

Lightroom's graduated filter does a great job at balancing out bright skies and dark foregrounds when processing RAW images, but I still get the best results using a graduated ND (grad-ND) filter in the field. A graduated neutral density filter is a half clear, half gray filter and works effectively to balance the extreme contrast situations; place the gray side of the filter over bright areas of an image to bring down the high key tones

and capture a better exposure. My favorite is the 2-stop, hard-step ND filter. The hard-step refers to a sharp transition from gray to clear. The soft-step grad-ND is where the gray to clear transition is more gradual.

Variable Neutral Density: The

other favorite filter in my camera bag is Singh-Ray's variable ND (vari-ND) filter. You can determine how much light you hold back—from 2 – 5 stops—by rotating the front element the filter, enabling you to shoot at slow shutter speeds, even in bright conditions. Pushing it any farther will sometimes results in vignetting. Although I carry both, I find the vari-ND more user-friendly than the grad-ND for controlling the shutter speed.

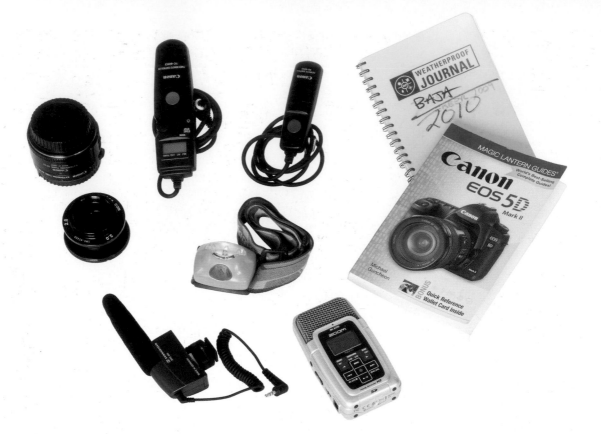

EXTRAS

Camera Manual: If you have an advanced camera with a lot of available features, it's a good idea to pack a camera manual. I find the manufacturer's manuals to be somewhat insufficient; I suggest a more comprehensive manual—such as the books in the Magic Lantern Guide series— for D-SLRs.

Journal or Notebook: It always helps to make notes in the field when you are shooting. Digital technology allows us to see what settings we used when making a shot by including the shooting data with the image file (called EXIF data), so frame-by-frame notes are no longer necessary, but you never know what you might want to record in words.

Headlamp: A headlamp is a great light source, especially for nature photographers. It allows you to light your way hands-free, and you can even use it for special techniques, such as light painting (see page 97).

Digital Audio Recorder: An audio recording device is great for recording ambient sounds and giving your viewers (and listeners!) a more complete experience of your images.

Digital Storage Device: A digital storage device is important for storing and backing up your images in the field. Don't count on your memory cards alone to keep your important images; back them up!

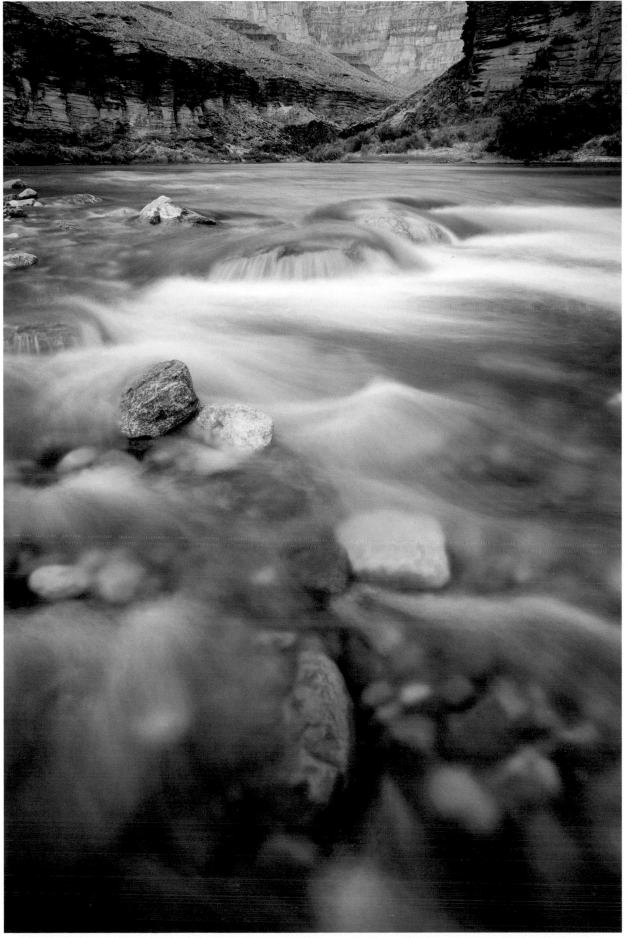

Colorado River Rocks at Blacktail Canyon, Grand Canyon, Arizona

(Canon EOS 5D Mark II, Canon EF 16-35mm f/2.8L II USM, 2 seconds @ f/11, ISO 100, +0.33 EV, grad-ND filter)

TRAVELING WITH GEAR

What to pack? This is an age-old dilemma for the photographer. I try my hardest to keep things simple, be organized, and be adequately prepared for the trip ahead. What I pack and how I pack it depends on my mode of travel, as well as what I'm doing.

FLYING

If I'm flying to a location, I fit as much camera gear as possible into my carry-on, which is usually a rolling camera bag that fits into the overhead-luggage bins. For navigating airports, my laptop and external hard drives go in a carry-on shoulder bag that slips over the handle of the rolling bag. Extra equipment, like battery chargers and spare lenses, are packed in a hard-sided Pelican case that fits inside a medium-sized duffel for checked luggage. My tripod, monopod, and camera backpack or beltpack are packed in a large duffel bag, padded with clothes, foulweather gear, and other essentials. If packed carefully, my two checked bags weight just under 50 lbs each. When I get to the location (usually a National Geographic ship), I reconfigure my gear from the rolling camera bag to the backpack and Pelican box.

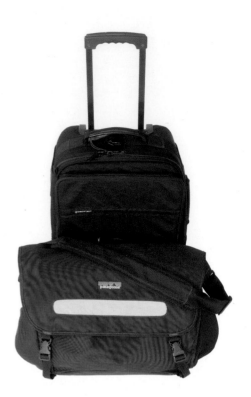

Carry-on bags: rolling camera case and computer bag

SHIP

The beauty of traveling on a ship is that once you embark, the ship sails from location to location, so there's no constant packing and re-packing. For most ship-based expeditions, you fly to the port of embarkation, so you can re-configure your gear once on board. To protect your gear while out on the water, it's critical to have a good camera beltpack or backpack, complete with a rain hood for both the pack and your camera.

Checked bag: Pelican case, tripod, and monopod

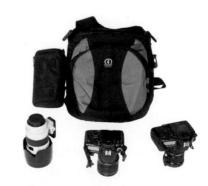

Single bag for on-location

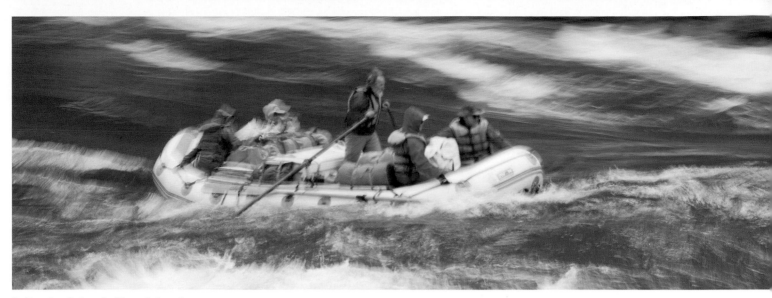

Rafting the Colorado River, Colorado

(Canon EOS 5D, Canon EF 70-200mm f/22.8L IS USM, 1/15 second @ f/22, ISO 100, +1.0 EV, no filter)

Rivers present challenges for keeping gear dry.

RAFT

The best way to protect your gear on the river while keeping it easily accessible is with a Pelican case. On shore, I transfer my camera gear to a backpack or beltpack, which has been stored in a dry bag while on the water. Tripods can handle getting wet, but be sure to clean off as much sand as possible before retracting the legs. I leave the laptop at home when I'm on the river, relying on compact flash cards for the entire expedition. Sometimes I bring a portable digital storage device—like an EPSON P-7000—and save the downloading and backing up until I get home.

Pelican case for easy access to gear and protection in wet environments

Luck favors the prepared. When out on my own, I often find myself walking back in the dark or hiking to a scouted location before dawn. So be sure to always carry emergency supplies, raingear, and headlamp, and know where you are at all times with maps and a GPS, if going off trail.

CAMPING

You have the best of all worlds when hitting the road with your camera gear. You can bring the arsenal, reconfigure your gear to fit the situation, download and backup as needed, and edit on your laptop when the sun is down. Dust is the enemy when traveling overland with you gear, so be sure to keep all camera bags zipped between locations, and store spare gear in airtight containers or storage bins. I re-configure my gear into a camera backpack for extended hikes.

SAFARI

Traveling over land on safari presents many unique challenges. For starters, there's getting there; depending on the destination, smaller planes are involved which means weight restrictions. Then there's the limited room in the safari vehicles, and the dust factor. When booking a safari, choose an outfitter and itinerary designed for photographers, which usually have a higher weight allowance and less people per vehicle. As for the dust, protect your gear with stuff sacks or plastic bags. And keep that camera bag zipped up!

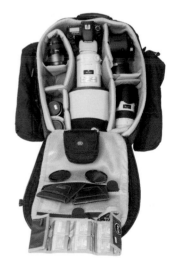

Backpack for hiking and road trips

King Penguins, South Georgia

(Canon EOS ID Mark II, Canon EF 70-200mm f/2.8L IS USM
w/1.4x, 1/500 second @ f/5.6, ISO 200, +1.0 EV, no filter)

Chapter 3: Digital Workflow

"There are no rules for good photographs, there are only good photographs." – Ansel Adams

Digital cameras are making all of us better photographers, but the quantum leap into the digital world requires that we understand the basics first. Mastering a few of the key technical aspects of photography will help you understand your digital camera better, and as a result, your work will become that much more creative and artistic. It's a significant time investment to work an image completely through the digital process from capture to output, but there are no shortcuts or magic bullets. The name of the game is workflow efficiency, and that starts with a good image. But before you start shooting, pay attention to the basic camera settings and the creative controls that affect the look and feel of a photo.

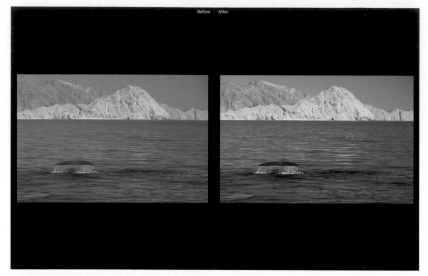

Blue Whale Lifting its Fluke, Gulf of California, Mexico

(Canon EOS 1D Mark II, Canon EF 70-200mm f/2.8L IS USM w/1.4x, 1/250 second @ f/5.6, ISO 200, no filter)

RAW images require post-processing in the digital darkroom. Note the difference between the unprocessed (left) and processed file (right).

Three reasons to shoot JPEG:

• Smaller files take up less space on a memory card

• Camera operates at faster frames per second (fps) with longer continuous bursts

• Does not require post-processing, therefore less computer time

Three reasons to shoot RAW:

• Highest image quality possible, broader tonal range, and better shadow detail

• Color balance not set at the time of capture

• Post-processing in Camera RAW for total control of final image

BASIC CAMERA SETTINGS

Developing a good workflow begins with the camera. The game is to shoot, download, and keep track of your images while on the go. The very first step is learning to shoot the best images from the start.

CAPTURE FORMAT

Capture format refers to the type of image file your camera records. To make things simple, you only have two choices: RAW or JPEG.

RAW: The RAW format retains all information from the time of capture, creating a file that is unprocessed and uncompressed. RAW files must be processed in a RAW converter in Photoshop or other image-editing programs like Lightroom or Aperture. It's during this RAW conversion process that information for exposure, color balance, saturation, brightness, and contrast is fixed into the pixel information and output as a new file (usually as an uncompressed TIFF or PSD file). Even after outputting these changes, the master RAW file remains untouched, allowing you to return again and again to the original settings. Thus, just like printing from a film negative, you can generate an unlimited number of conversions from a single RAW file without degrading the original image.

The fundamental advantage of RAW capture is that you control all aspects of post-processing of the image. The downside is the time factor—it takes time to make the RAW conversion then further optimize the image in Photoshop.

Mobula Ray, Gulf of California, Mexico

(Canon EOS 1D, Canon EF 70-200mm f/2.8L IS USM, 1/2000 second @ f/8, ISO 320, -1.0 EV, no filter)

This is a comparison of a high-resolution, uncompressed image file (left) and an overly compressed, low-resolution JPEG file (below).

JPEG: JPEGs are compressed image files that are processed according to the parameters set by the camera manufacturer and agreed upon by the "Joint Photographic Expert Group"—thus, JPEG. The camera processes the picture by applying some level of compression, color correction, saturation, and sharpening to enhance the image straight out of the camera. This information is fixed into the pixels of the image file. Many D-SLRs now have custom parameters, so that you can control the levels of in-camera processing.

JPEGs are created at different resolution and compression levels, controlled by settings in the camera. The highest resolution settings (the lowest compression settings) capture image information from the maximum number of pixels possible, retain more image information, and create a larger file. Higher compression results in smaller files, lower resolution, and a loss of image quality. For the best JPEG image, shoot the highest JPEG resolution at the lowest compression.

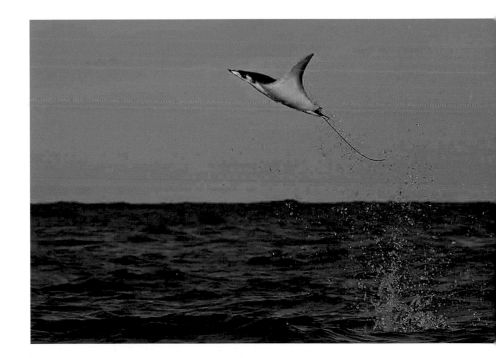

IMAGE COLOR

Color Space: A camera's color space setting determines the range of colors—or gamut—available in the image file. The color space sets the color profile for your camera in terms of red, green, and blue channels (RGB) of information recorded by the sensor. The chosen color space is like a painter's palette: the more colors captured, the greater the range of possibilities.

The decision here is simple because there are only two color space choices for digital capture: sRGB or Adobe RGB (1998). Adobe RGB (1998) records an exponentially wider range of colors than sRGB, and it ideally suited for nature photographers intending to publish and make prints. In fact, it's designed to closely match the color profiles of most inkjet printers. The sRGB color space, with its narrower color gamut, is designed to match the color range of computer monitors. It is the best option for viewing images in emails, on the web, and for digital projection. For most digital cameras, sRGB is the default color space, so you must go into the menu in order to switch to Adobe RGB (1998).

White Balance: Digital cameras see the world differently than our eyes. Our eyes automatically adjust to a wide range of colors and intensities of light. Through our eyes, a scene never appears too blue or too green. Digital cameras, however, are not as advanced as our eyes, and therefore "see" the color of light as it is. To adjust for different kinds of light, digital cameras use white balance (WB), a control that can enhance or minimize colors of light so that the whites appear white. If you shoot RAW files, you make WB decisions with RAW processing software; if you shoot JPEG files, you make WB choices with your camera. Most digital cameras have a number of choices for setting the WB: Auto mode, Preset modes, and custom settings. Preset WB modes are most useful for nature photographers because the settings are designed for the kinds of light we most frequently encounter.

Light wavelengths are expressed as color temperatures on the Kelvin scale; higher temperatures (10,000K) are closer to the blue end of the spectrum (cool), and lower temperatures (1000K) are toward the red end of the spectrum (warm). Sunlight is white light, and falls in the middle of the spectrum—approximately 5500K. On a cloudy day, the clouds filter the warmer wavelengths, so the light has a slightly blue color cast (approximately 6500K). Open shade on a cloudless, blue-sky day has an even stronger blue color cast (7500K).

Sun Rays and the Sierra de la Giganta, Baja California, Mexico

(Canon EOS 1D, Canon EF 70-200mm f/2.8L IS USM w/1.4x, 1/2500 second @ f/8, ISO 400, -0.33 EV, no filter; left image 3500K; right image 9500K)

The typical presets used in nature photography are Daylight, Cloudy, and Shade. Daylight WB is the most neutral, intended for daylight conditions on a sunny day at high noon. Cloudy WB warms overcast days like a warming filter intended to remove the blue color cast on a cloudy day, while Shade WB acts as an even stronger warming filter to correct the deep blues of open shade.

Think twice before setting your camera to Auto White Balance (AWB) for making outdoor nature photos. When set to AWB, the camera constantly tries to keep a scene neutral, making the whites white, without any color cast. If there's too much blue in a scene, like in deep shadows, then the camera compensates with a higher color temperature, making the image appear warmer. Conversely, if a scene is too warm, then the camera adjusts to make it look cooler, or more neutral, with a lower color temperature. This can result in washed-out colors, especially at sunrise and sunset, because your camera is trying to make the scene look neutral. AWB works well in situations with mixed light sources like street scenes.

EXPOSURE SETTINGS

When it comes to exposure, the camera sees the world in black and white. The light meter reads the "correct" exposure to be middle gray—like the 18% gray card in the film days. The camera sees the world as one big midtone, halfway between black and white. It doesn't matter what the subject is, the meter always suggests a setting for middle gray. To expose correctly, the photographer must understand how the camera sees the world and compensate. For instance, a white object in a bright setting will "fool" the camera's light meter and the image will be underexposed; the photographer must compensate for this by overexposing the white object. (The reverse holds true for a black object in a darker setting; the photographer must underexpose the image in this instance.) It's our job to interpret how the camera will expose the scene and compensate for our light meter so that lava stays black and the polar bear is creamy white, not gray.

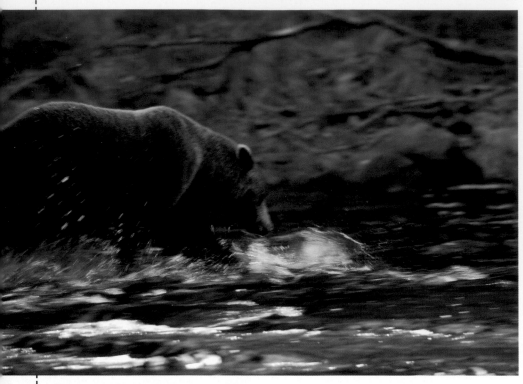

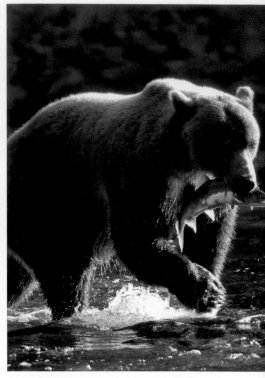

(Canon EOS 1D Mark II, Canon EF 300mm
f/2.8L IS USM w/1.4x, 1/80 second @ f/5.6,
ISO 400, -1.0 EV, no filter)

(Canon EOS 1D Mark II, Canon EF 300mm
f/2.8L IS USM w/1.4x, 1/250 second @ f/5.6,
ISO 400, -1.0 EV, no filter)

Aperture and Shutter Speed:

Aperture controls the depth of field (DOF) in an image. DOF refers to how much of the photo will appear acceptably sharp from foreground to background, with larger apertures (lower f/stop numbers) resulting in a shallow DOF and smaller apertures (larger f/stop number) showing a deeper DOF.

The f/stop of a lens refers to the size of the opening—or aperture—through which light travels. Opening or closing down the aperture controls the amount of light reaching the image sensor. Larger apertures correspond to the lower f/stop numbers, such as f/4. Conversely, a smaller aperture means a larger f/stop number, such as f/22. The aperture you choose depends on the intended look of the image you are trying to make. In a landscape situation, you want a deep DOF where everything from the rocks in the foreground to the mountains on the skyline is acceptably sharp. In this case, stop down to the smallest aperture and let optics do the work for sharpness from near to far.

Shutter speed is also known as exposure time because it is the length of time the shutter is open and exposing the image sensor to light passing through the lens. Together, shutter speed and aperture control the exposure. Faster shutter speeds freeze the action depending on how fast the subject is moving, and usually require larger apertures. With a slower shutter speed, there is more time for movement to be recorded by the camera; capturing motion blur requires a slower shutter speed, so limiting the amount of light coming through the lens by setting a smaller aperture is necessary.

ISO:

ISO refers to the light sensitivity of a recording medium; in digital photography, the recording medium is the camera's sensor. Just as with film speed, higher ISO numbers represent greater sensitivity to the light, and allow for faster shutter speeds at a given f/stop. Lower ISOs mean the sensor is less sensitive to the light coming through the lens, and require a slower shutter speed for a given f/stop.

 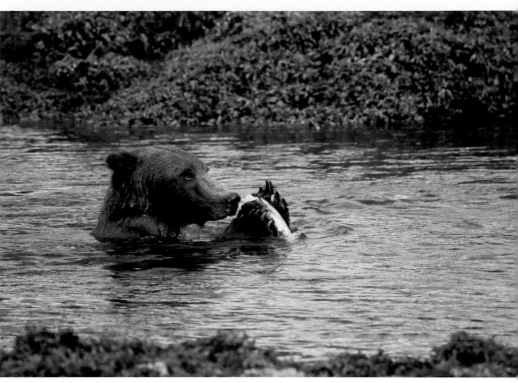

Brown Bear Fishing for Salmon, Chichagof Island, Tongass National Forest, Alaska

(Canon EOS 1D Mark II, Canon EF 300mm f/2.8L IS USM w/1.4x, 1/100 second @ f/5.6, ISO 400, -0.67 EV, no filter)

Higher ISOs result in an increase in digital grain—called noise—so it's important to shoot with the lowest ISO setting possible for the conditions. But unlike film, where you had to commit to a specific ISO setting for an entire roll of film, digital allows you to adjust the ISO for each image. This is a huge advantage over film; shoot a few frames in full sun at ISO 100, then bump it up to 400 to work in the shade. This flexibility makes ISO an important exposure control in digital photography.

Exposure Compensation: The natural world is not middle gray, but our camera's light meter wants to make it that way. Therefore, we are constantly battling to compensate for the way the camera sees light. In manual mode, we do this naturally by metering on a middle tone and then setting the f/stop and shutter speed accordingly. In semi-automatic modes, like aperture and shutter priority, we use our camera's exposure compensation setting instead.

Working in difficult light conditions often requires adjusting the ISO. In the case of this brown bear fishing for salmon, I bumped the ISO up to 400. In the first image, I panned with the bear fishing in the shadows, resulting in motion blur at 1/80 second shutter speed. When the bear caught the salmon and came out into the sun, the shutter speed of 1/250 second was fast enough to stop the action. Back in the shadows eating the salmon, the higher ISO helped capture a sharp image at 1/100 second (shooting on a tripod).

Polar Bear Leaps between Ice Flow, Arctic Ocean, Svalbard Archipelago, Norway

(Canon EOS 1D Mark II, Canon EF 300mm f/2.8L IS USM w/1.4x, 1/500 second @ f/8, ISO 400, no filter)

Because of the white ice dominating this scene, your camera will always tend to underexpose this scene. Intentionally overexposing by 2 stops will keep the ice white.

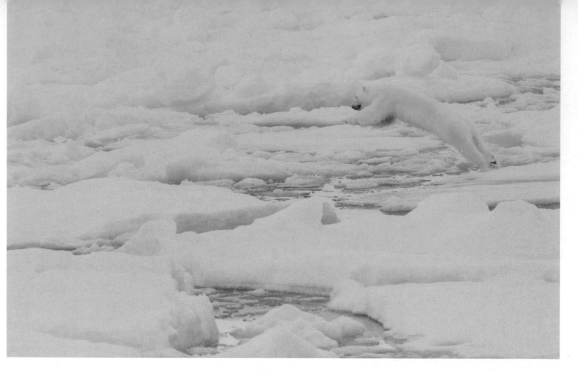

(Canon EOS 1D Mark II, Canon EF 300mm f/2.8L IS USM w/1.4x, 1/500 second @ f/8, ISO 400, -2.0 EV, no filter)

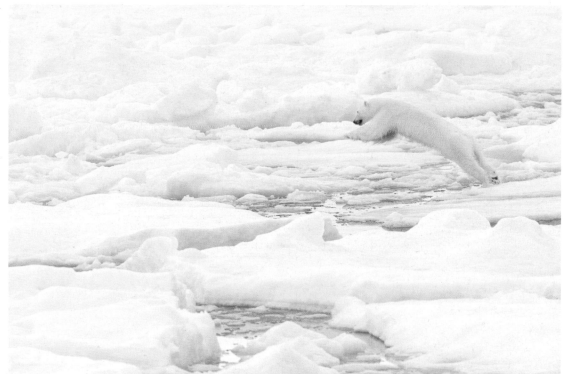

Depending on your brand of D-SLR, the exposure compensation setting (+/- EV) is either a button or a dial. It is calibrated in units of exposure value (EV), or stops; a -1 EV value intentionally underexposes the scene by one stop, while a +1 EV value purposely overexposes the image by one stop.

The advantage of using exposure compensation with aperture or shutter priority is that once it's set, it stays there. So if you are shooting a polar bear out on the pack ice at +1 EV, you can shoot with confidence until there's a change in the light conditions. The camera will continue to shoot +1 EV until you tell it not to, so you have to be vigilant and remember to adjust it as the lighting changes.

Chinstrap Penguins, Antarctica

(Canon EOS 1D Mark II, Canon EF 70-200mm f/2.8L IS USM, 1/2000 second @ f/5.6, ISO 200, +1.0 EV, no filter)

This histogram screenshot from Lightroom shows a low peak to the left that represents the dark penguin feathers and sharp peak to the right that represents the white snow.

Judging Exposure: Histograms

One of the great advantages of digital photography is the histogram, a graph that represents the light levels and tonal range of all the pixels recorded in an image. The histogram is like a "digital light meter" that measures exactly how the image sensor is catching the light. The graph represents 256 tonal values from pure black to pure white, with black to the left (shadows), gray in the center (midtones), and white on the right (highlights).

Image sensors record light differently than film. In the film days, we routinely underexposed images to get rich, saturated colors with strong contrast. With digital, you want to do the opposite, and avoid underexposing the scene. Digital sensors record the majority of color information toward the white side of the scale (to the right). This means that underexposed images have less color information.

The histogram can help you determine an exposure with confidence. I often shoot a test image first and review the histogram on the LCD. (Note that the "brightness" histogram is most helpful for determining exposure, not the RGB histogram.) If the graph indicates that the highlights are blown out (peaks too far right and goes off the scale), then adjust the exposure compensation (+/- EV) to purposely underexpose (-EV) and bring the highlights back in range. In the other direction, if the highlights are too dark, then purposely overexpose (+ EV) to shift the highlights as far right a possible without clipping.

There is no such thing as a "good" histogram. Shoot a white object, and the peak is to the right. Shoot a dark object, and it shifts to the left. Shoot a grassy meadow, and you'll get a bell curve representing the midtone qualities of the scene. Start shooting combinations of these light values out in nature, and you may get a complex graph with peaks and valleys. The shape of the histogram does not matter—it's the position of the highlight peak that is most critical. Most D-SLRs have a highlight warning setting that will flash where blown-out pixels occur; fine tune the shot with exposure compensation until the "blinkies" disappear.

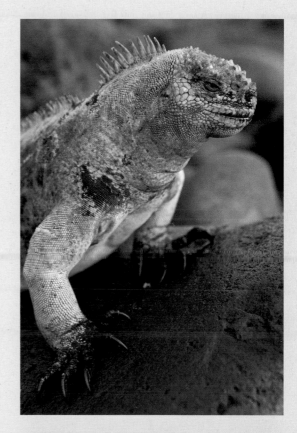

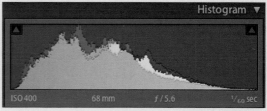

Marine Iguana, Galapagos Archipelago, Ecuador

(Canon EOS 1D Mark II, Canon EF 24-105mm f/4L IS USM, 1/60 second @ f/5.6, ISO 400, -0.33 EV, no filter)

This histogram shows a broad curve that represents the midtones of the iguana and dark gray rocks dominating the scene.

SHOOTING MODES

Today's digital cameras have many different shooting modes for making images. If you are pleased with your photos shot in fully automatic modes, then there may be no need to change your ways. Pay attention to those programmed modes for specific situations—the flower icon is for macro, the mountain for landscapes, the fast runner for action—and you are in the game. However, if you've always wondered how the pros handle difficult lighting situations or fast moving action, then maybe it's time to push some buttons and turn some dials. The shooting modes that I commonly use in nature photography are manual (M), aperture priority (A or Av), and shutter priority (S or Tv). I almost never use the auto (A) or program (P) modes because it gives the camera too much control.

Manual: Beginning photographers usually avoid manual mode because you are in complete control, not the camera. In manual, you choose both the f/stop and the shutter speed to determine the exposure. This means you have to know what you are doing.

Manual mode allows you to keep exposures consistent. I use manual mode in difficult lighting situations, when shooting multiple frames that will be stitched together later as a panoramic, or when I use fill flash to open up deep shadows or create a special effect.

Aperture Priority: Aperture priority frees you to think in terms of DOF. Once you choose an aperture, the camera will choose a shutter speed to match that aperture according to the camera's internal light meter. If you find yourself in a situation where a fast shutter speed is more important than DOF, then set the f/stop to the widest aperture (lowest f/stop number), and the camera will shoot with the fastest shutter speed possible, even if the light changes. Not fast enough, then bump up the ISO.

For me, aperture priority is the most efficient way to work in nature when DOF is the most important consideration. But remember, since the camera is adjusting the shutter speed for a given f/stop, the exposure always stays the same. To change the exposure, you must use the exposure compensation setting (see page 59).

Cardon Cactus, Baja California, Mexico

(Canon EOS 5D Mark II, Canon EF 16-35mm f/2.8L II USM, 1/125 second @ f/11, ISO 200, no filter)

One situation where I use manual mode is when using fill flash. Here, I meter on the sky and dial down the strength of the flash burst to -1 stop. The two images have a completely different look, but because the camera is on manual, the background exposure is the same.

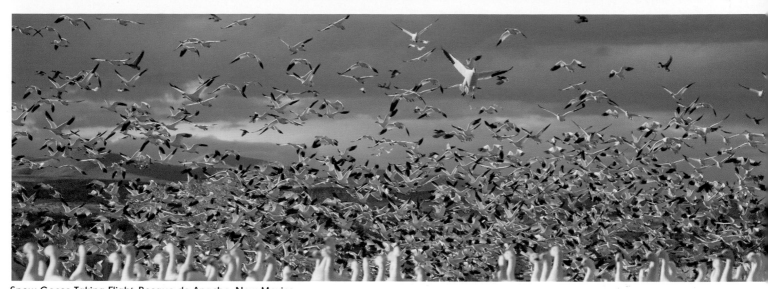

Snow Geese Taking Flight, Bosque de Apache, New Mexico

(Canon EOS 1D Mark II, Canon EF 70-200mm f/2.8L IS USM w/1.4x, 1/640 second @ f/5.6, ISO 400, -0.33 EV, no filter)

Sometimes you want to stop the action with a faster shutter speed. Here, bumping up to ISO 400 and opening the lens up to f/5.6 achieved a shutter speed fast enough to render every bird sharply.

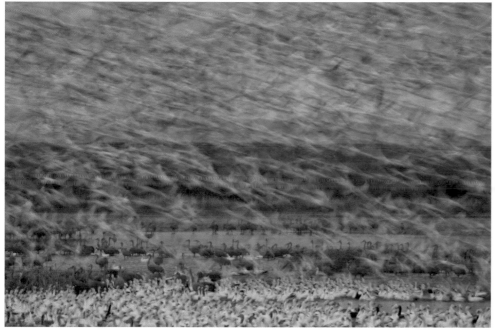

Snow Geese Blasting off at Dawn, Bosque de Apache, New Mexico

(Canon EOS 1D, Canon EF 70-200mm f/2.8L IS USM w/1.4x, 1/5 second @ f/5.6, ISO 800, -0.67 EV, no filter)

Even though I cranked up the ISO to 800 for this image, there's not enough light for a fast shutter speed, so I went for motion blur at 1/5 second.

Shutter Priority: Shutter priority is the shooting mode of choice when shutter speed, not DOF, is the primary concern. You set the shutter speed and the camera picks the correct f/stop for the given lighting conditions. Setting an adequate shutter speed is important when image sharpness is critical, like when handholding the camera in low light or working with a long lens on a tripod. Shutter speed also controls the freezing or blurring of moving subjects. I know from experience that photos of running animals look best somewhere between 1/15 and 1/30 second, and flowing water looks silky smooth at 1 second or more.

With shutter priority, you must always be aware of what the light is doing. Say you want to freeze the action of leaping dolphins by shooting at 1/2000 second. If it's late in the day, there may not be enough light, even at the widest aperture, to attain this shutter speed, so the photo will be underexposed unless you bump up the ISO to meet the conditions. Conversely, when trying to shoot a waterfall in full sun at 1 second, there's too much light for this shutter speed, so the photo will be overexposed.

Galapagos Penguin, Galapagos Archipelago, Ecuador

(Canon EOS 1D Mark II, Canon EF 300mm f/2.8L IS USM w/1.4x, 1/320 second @ f/5.6, ISO 400, -0.67 EV, no filter)

These are two situations where I might use the spot meter instead of matrix metering. The camera would tend to underexpose the bright background in this sea lion image, whereas it would overexpose the dark background behind the penguin's white feathers.

Galapagos Sea Lion Pup, Galapagos Archipelago, Ecuador

(Canon EOS 1D Mark II, Canon EF 70-200mm f/2.8L IS USM, 1/200 second @ f/4, ISO 200, +0.67 EV, no filter)

METERING MODES

Today's digital cameras have a number of metering modes to choose from, the basic ones being evaluative (Canon) or Matrix (Nikon), center-weighted, and spot metering.

Evaluative or Matrix Metering:
When set to evaluative metering, the camera takes the light reading from across the entire frame and averages it to create a "middle" meter reading. I generally rely on evaluative metering to get me in the ballpark. Then, I review the histogram and compensate with the exposure compensation setting, if necessary. Evaluative metering relies on computer algorithms to determine exposure and can perform miracles in complex light situations.

But cameras can't handle the extremes like our eyes can, so we are sometimes fooled in high contrast scenes where the light meter makes the wrong assumptions. Check the histogram often, and always keep exposure compensation in mind to avoid over or underexposing the highlights.

Center-Weighted Metering:
Shooting portraits and backlit subjects are appropriate times to use center-weighted metering. As the name implies, the meter is weighted in the center of the frame, so the camera takes a meter reading from the center of the frame and the background takes on less importance.

Spot Metering: The spot metering selection takes light information from a very small area of the image frame. Only in certain difficult lighting situations will I use spot meter in manual mode with digital. One situation is photographing an animal moving along different background brightness levels. Without compensation, matrix metering in aperture priority would underexpose the animal against a bright background, and overexpose the animal against a dark background. In this case, I spot meter off a middle tone on the animal, then shoot with consistent results as the background changes.

WORKFLOW: ON THE ROAD

BACKING UP

The most important rule in the digital world is to back up your work at all times. We all have our own horror story, and if you're reading this and can't recall the last time you backed up, put this book down and go back up now. The question is not if your computer or hard drive will fail, it's when.

Downloading images to your laptop is not backing up. A "backup" copy is a second copy of your images stored on a separate device, usually an external hard drive or digital wallet. While on the road, I back up to any number of external hard drives. Depending on the length of the shoot, I may have as many as four drives with me, but I can usually get by with two.

Reformat the Memory Card

Once you have downloaded and backed up your images, it's time to clean the memory cards. The best way to clean your cards is to reformat the card in-camera rather than deleting the images on the computer or in-camera. The reason is that the format function resets the correct file directory structure that is specific to the camera model.

Simply deleting the pictures from the card, on the computer, or in-camera does not completely erase the images or reformat your card. Card failure or corrupt files can result from previously deleted images lingering around on the memory card. The same goes for deleting images one by one during a shoot. It's best to shoot, download all the images, and then reformat the memory card. Resist the temptation to delete as you go.

ORGANIZING AND CATALOGING

Once my images are downloaded and backed up, I begin the task of organizing my files. I use a browser to navigate images in the digital world; the browser is an application that serves as a digital light-box. Photo Mechanic is my preferred browser at the beginning of my workflow for downloading, backing-up, and making a quick first sort and edit.

I rename images while downloading with Photo Mechanic. Some photographers prefer to renumber later in their workflow, like after editing, so that the images are always numbered sequentially; for me, I only care that each image has a unique number. For simplicity, I use a naming nomenclature that helps me immediately recognize the location and year it was shot. On an African safari, for example, the prefix would be "TZ"

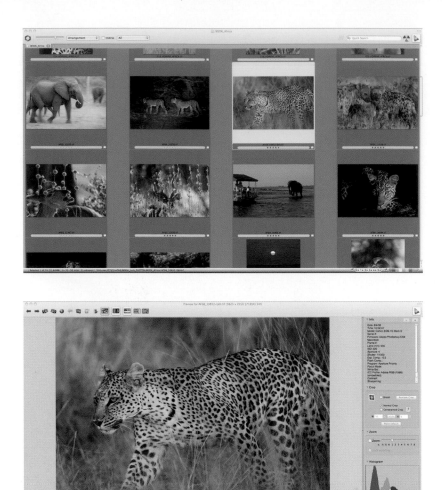

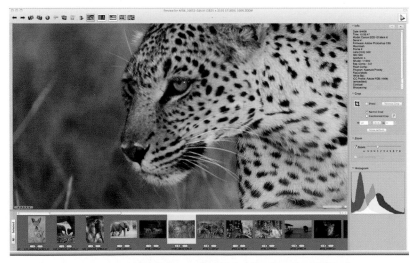

for Tanzania, followed by the year "09," then an underscore, and finally a sequence number (TZ09_001, TZ09_002, TZ09_003, etc.). Use an underscore instead of just a space; it's easy to accidentally add an extra space, which confuses search results.

I begin by organizing my images into folders within a master folder while in Photo Mechanic. For example, I would have a master folder "Tanzania_2009" and inside have folders either by location, like Ngorongoro Crater, Serengeti, Lake Ndutu, etc. Adopt a filing system that works for you and stick with it. It's important to be consistent so that you can locate images efficiently.

Once all the images are downloaded, renumbered, and organized, I do a quick first edit in Photo Mechanic, deleting the obvious mistakes. I'm very liberal with the number of images I keep and save the tough decisions for back home on the digital darkroom's larger monitor. I also enter some basic caption information in the metadata, especially species names and locations that might be easily forgotten.

Next, I import the images into Lightroom, creating a "catalog." How much work I do on the road from here on out depends on the nature of the project, deadlines, and the pace of the travel schedule. I do enjoy making selections in Lightroom and doing basic adjustments on images for sharing in slideshows. Sharing fresh results from the day's shoot is a powerful teaching tool on photo expeditions and field workshops.

Photo Mechanic is a very slick browser developed by photojournalists for speed and efficiency. I use the grid view (top) for making a quick first edit. To evaluate image quality, I view images in full screen mode (center). and zoom to 100% to check sharpness (bottom). When I download images using Photo Mechanic, I renumber, add basic captions and keywords, and back up to an external hard drive.

WORKFLOW: AT HOME

Chores in the digital darkroom begin the moment you return home. In the old days, you at least had a little time to rest while your film was processed. Today, the burden is all on you to transfer images from your laptop or travel hard drives to your desktop computer (a.k.a., the digital darkroom) and begin the workflow of making final selections, and then processing and optimizing your images.

PROCESSING

All digital images, even JPEGs, need a little processing—or "optimizing" as it's known in the business—to be the best they can be. For efficiency, I use Adobe's Lightroom, Photoshop, and Bridge to process and manage my image files. Each has its strengths and a place within my workflow. I use Lightroom as my RAW converter, Photoshop for fine-tuning image adjustments and removing sensor dust, and Bridge for organizing output. Lightroom is an integrated application that is a browser, RAW converter, image processor, and database manager all in one. The power of Lightroom is the way it handles image files. Importing images into Lightroom creates a "catalog" of high-resolution thumbnails, but does not duplicate the original RAW image files, saving tons of hard disk space.

Lightroom Library Module: I begin by working in the "Library Module," sorting images using the grid view, which is like a virtual light box. To sort images, it's simply a matter of selecting and dragging groups of images from one file to another. If an image doesn't make the cut, hit "x" to tag the images as "rejected." Periodically sort for all rejected photos, review them one more time, then hit delete to send to the trash.

Digital Darkroom Workflow

Developing a consistent workflow in the digital darkroom is critical to working efficiently and keeping track of your images. I use Lightroom as my do-it-all application, but still use Photoshop and Bridge for specific tasks.

- Transfer images to the digital darkroom
- Import travel catalogs into Lightroom
- Edit to Lightroom collections in Library Module
- Optimize selects using Lightroom's Develop Module
- Use Photoshop for further adjustments and spotting
- Export selects to project or portfolio folders as TIFFs or another output file type
- Manage exported images with Bridge for renaming, contact sheets, etc.
- Back up working files to digital archive

As I sort images, I create "collections" for various projects and portfolios. A collection is a folder of "virtual" images, similar to a playlist in iPod language. Each collection represents my selections for that project. Within collections, I rank individual images to further tighten my edit. Just like in iTunes, where the same song can appear in multiple playlists, the same image can be in more than one collection. Any adjustments or metadata changes made to an image in one collection translates to all copies in other collections and back to the original RAW file. This makes it easy to tweak and add metadata at any step along the way.

Lightroom Develop Module: One of the beauties of Lightroom is the "Develop Module"; adjustment sliders are easily accessible along the right hand side of the window, just like in Camera RAW, and make it easy to apply basic adjustments like exposure, contrast, color balance, and saturation. You can also apply curves, noise reduction, and vignette corrections. And if a series of images are similar—for instance, they were shot in the same lighting scenario—you can sync any or all adjustments from one image to another.

Lightroom further simplifies cropping and straightening horizons, a tool that I rely on constantly. I often have different cropped versions as virtual copies, side by side. I also like to play around with color balance and with black-and-white conversions. (Virtual copies are not the same duplicate copies, which take up space on your hard drive.)

Once I've made basic adjustments in Lightroom, I open the top selects in Photoshop. I use layer masks to make local area adjustments and the healing brush for sensor spots. (I find the healing brush in Lightroom to be very clumsy and difficult to use effectively.)

Together, Lightroom and Photoshop give the photographer the complete freedom and control in processing the image. This workflow offers a non-destructive path for optimizing your images. Adjustments in Lightroom are recorded as metadata tags, which are applied only when the image is exported. Thus, you can process and output original RAW files and make changes an infinite number of times without degrading the pixels.

EXPORTING

After optimizing my selects with the Lightroom sliders and adjustment panels in the Develop Module, I output the images using Lightroom's export function. At this point in the workflow Lightroom applies the changes made with the RAW converter to the actual image files. The export window allows a number of options to control destination, format, and size of the final images. You can also choose to apply sharpening or add a copyright watermark.

Once the image exists as a JPEG or TIFF file, I use Adobe Bridge to further organize, batch rename, and make contact sheets. Unlike Lightroom, you do not have import images into Bridge—it will read any image in any folder connected to the digital darkroom so it's an efficient way to manage outputted files.

ARCHIVING

Digital images are stored on electronic media as bits of information, and you need a computer to look at them. It's a funny concept, but, in a sense, digital images become real only if you make prints or publish them.

Do what it takes to protect your images. Every step along my workflow, there is a working copy of my files and a secure backup. Connected to the digital darkroom is an array of multiple hard drives configured to share information in a way that can be restored if one drive fails. I back up using ChronoSync data management software (econtechnologies.com) that synchronizes the changes between the working copy and the archived files. In addition, to protect images from a fire or natural disaster, I also keep a set of hard drives offsite in a safety deposit box at the local bank.

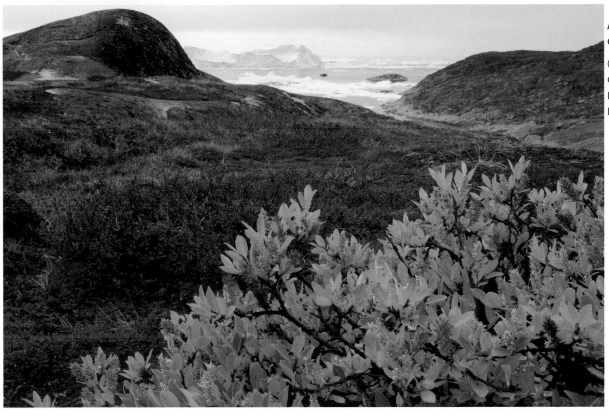

Arctic Tundra, Ilulissat Fjord, Greenland

(Canon EOS 5D Mark II, Canon EF 16-35mm f/2.8L II USM, 1/50 second @ f/22, ISO 400, -1 EV, no filter)

Strange things can happen in the digital world. Images get misfiled, disappear, or unexplainably get corrupted. You can't be too careful managing your image files. If you haven't already, create your own digital archive and do it right. You'll rest easier knowing your files are safe.

SHARING

Want to be a better photographer? Then learn to recognize your best work and, most importantly, show only your best work. The truth is that most photographers are not good editors, present company included. During photo workshops, I ask students to share just five images each day for the critique sessions. At first, this is a difficult assignment with so many choices, but with experience, it gets easier. The important thing is to always put your best work out there.

Do your best to keep emotion out of making your selections. It doesn't matter how long it took you to make that image, or how difficult it was. Find the ones that work, and let go of the rest. If it doesn't work, learn from it and move on. Be brutal in your editing, while celebrating every success.

As you progress as a photographer, it's natural to want to share, print, and exhibit your work. There are countless online venues for posting web galleries, making prints and cards, or even self-publishing online books. I use the Lightroom modules for making slideshows, printing, and web galleries, although I use Apple's iPhoto and Quicktime for adding music, and Keynote for making professional presentations. And iWeb is an easy way to create your own website.

Many of us find real joy in making our own prints. Today's ink jet printers meet archival standards and yield amazingly consistent results. As with the other technical aspects of the craft, it's important to understand the necessary steps for making a good print. Work with a calibrated monitor, choose the correct color profiles, and make sure to print small proofs before going for the home run and burning lots of ink. The printers are affordable; it's the ink that gets you.

Natural Arch at Sunset, Elephant Rock, Santa Catalina Island, Loreto Bay National Park, Sea of Cortez, Mexico

(Canon EOS 5D, Canon EF 24-105mm f/4L IS USM, 1/30 second @ f/5.6, ISO 400, -0.33 EV, no filter)

When the light is happening, it's important to be in the right spot. The pelican adds a sense of moment to an already magical sunset.

Chapter 4: Light

"The camera captures light, our minds capture images." – Anonymous

Light and composition—the creative journey into digital photography starts here, and I consider the quality of light first. Is it the right time of day or should I come back at sunset or sunrise? Will advancing clouds soften the light? Can I control the angle of light by changing my position?

I work the scene as the light changes, all the time searching for compositions that have potential. I'm always asking, "Is it worthy?" "Should I stay and work it more, or move on?" It's better to stake out one spot and wait for the light than to be undecided and dashing all over the place when the light gets good. Once I settle on a strong composition, I wait for the light and the moment. If synchronicity happens and the light and moment merge, or the light becomes the moment, then you've hit the jackpot.

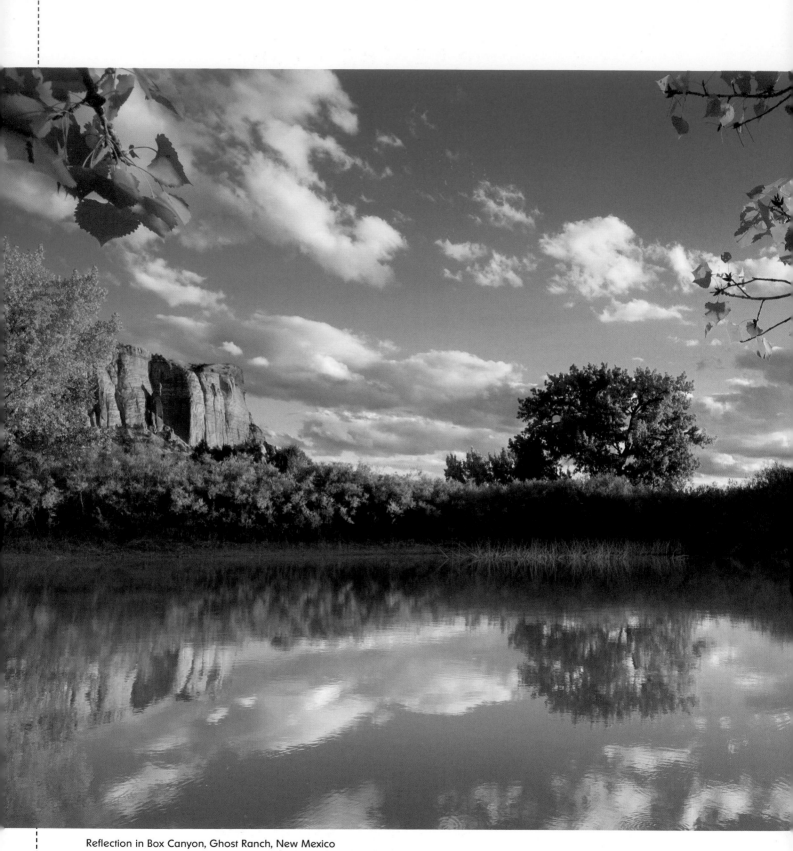

Reflection in Box Canyon, Ghost Ranch, New Mexico

(Canon EOS 5D, Canon EF 16-35mm f/2.8L II USM, 1/60 second @ f/11, ISO 200, -0.67 EV, 2-stop grad-ND)

Learn how your camera's eye sees the light. Here, a 2-stop hard-step grad-ND filter balances the contrast of the bright sky and brings out the reflection in the pond.

SEE THE LIGHT

In digital photography, we compensate for how our camera sees light by making adjustments to exposure, saturation, and color balance. Tweaking images in Lightroom and Photoshop are necessary steps in the digital workflow from capture to output, but it all starts with making the best image possible at the moment of capture.

Yogi Berra is credited with saying, "You can see a lot just by looking." How true. We can rephrase this for photographers by saying it's a matter of learning how to see like a photographer, rather than just looking. It takes time to recognize the subtle qualities of light and how the camera records it. It also takes experience and extra effort to make good photos in any kind of light.

THE CAMERA'S EYE

We all understand that our camera sees the world differently than our eyes. Our eyes can handle extreme contrasts, from bright sun to shade, but our cameras can't; this makes attention to exposure critical. Digital offers more latitude than film in this regard, but still needs attention to ensure you create the best quality image possible at the moment of capture. Paying attention to these two aspects of light can take your images beyond the ordinary.

Contrast: The camera's sensor is sensitive to extreme light contrasts and this can affect the exposure reading from the camera's internal light meter. Remember that your camera sees the world in black and white and wants to make the world middle gray. Thus, you must fool your camera to keep highlights bright (to the right on the histogram), but not pushed so far that you get the "blinkies"—a highlight warning

indicating that parts of the image are blown out or overexposed. The same concept applies to dark scenes with low light; the sensor tends to overexpose these situations.

In practice, I shoot in aperture priority and control exposure using positive exposure compensation (EV) to avoid underexposing images dominated with white or bright highlights, like clouds, snow, and ice. And I keep the EV on the minus side to avoid overexposing darker scenes, being that the camera wants to render black medium-gray. For certain situations when the light is constant, I often switch to manual and meter off a middle tone (green grass, blue sky), shooting with confidence, knowing the light meter isn't being fooled if the background brightness changes.

Look for scenes in nature where the light is balanced and try to avoid the extreme contrast of midday. Work on the edges of the day when the light is warm and dramatic, typically starting before dawn and through the moments after sunrise, and from just before sunset through twilight.

Color: Color balance is important. The camera records the color of light accurately—if you don't compensate with a white balance (WB) setting, then shady light will render with a blue tone, sunset light will render orange, and daylight will record as pure white. On the flip side, when WB is set to "Auto", the camera will look for a neutral tone and adjust the color temperature around 5500K, often dulling the color and saturation of your images.

A simple way to warm the colors in your images is by switching from Daylight WB to Cloudy WB if you like warmer and saturated colors. Going a step further, switching to Shady WB (7500K) will add more punch to your images. On the cool side of the spectrum, you can try processing images using Tungsten WB (2800K), resulting in blue renditions of daylight-balanced scenes. If you do experiment, be sure to remember to reset the WB.

My personal preference is to almost always keep my camera on Cloudy WB. (One exception is when I'm shooting scenes dominated by white and blue, like in polar regions when I don't want the camera correcting for natural blue in the landscape.) Even though I can change the color balance during processing because I shoot RAW, I still like to see a warm rendition of the scene in the moment. But remember, in the field, you can't judge color or exposure accurately on your camera's LCD screen. Strive to shoot a scene in a variety of ways to give yourself lots of choices once you are back in the digital darkroom.

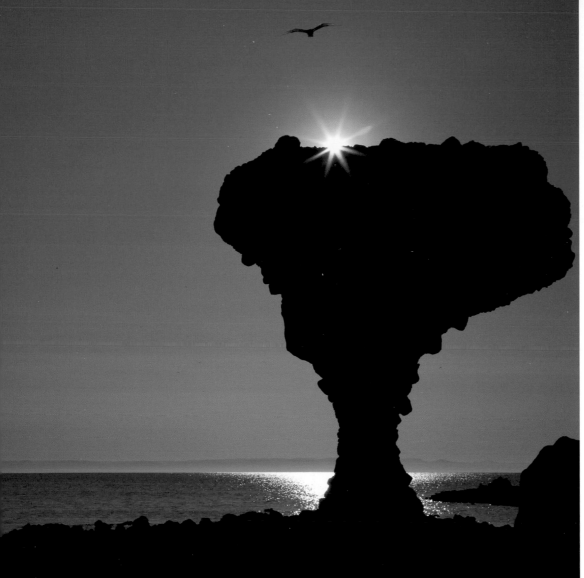

Mushroom Rock, Bahia Balandra, Baja California, Mexico

(Canon EOS 5D, Canon EF 24-105mm f/4L IS USM, 1/320 second @ f/22, ISO 200, -1.0 EV, no filter)

You have to get creative when shooting against clear blue sky. The sunburst effect is created using a small aperture (f/22) and pinching the sun against the rock formation. Slight underexposure emphasizes the blue.

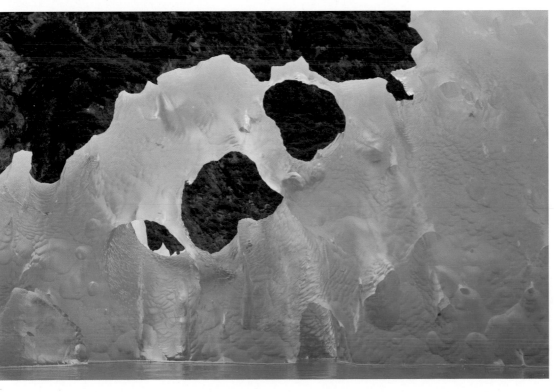

Cloudy Light on Blue Iceberg, Tracy Arm Fjord, Tongass National Forest, Southeast Alaska

(Canon EOS 10D, Canon EF 70-200mm f/2.8L IS USM, 1/1000 second @ f/5.6, ISO 200, -0.33 EV, no filter)

Understanding white balance is key to capturing dramatic colors. Here, Daylight WB keeps the camera from correcting for the ice's extreme blue hue.

Equipment Checklist: Lighting for Nature

- Filters: polarizers, grad-ND, vari-ND
- Reflector
- Diffuser
- Lens hoods
- Tripod for low-light shooting
- Accessory flash
- Spotlight, flashlight, or headlamp
- Shutter release cable

Bottlenose Dolphins, Sea of Cortez, Baja California, Mexico

(Canon EOS 1D Mark II, Canon EF 24-105mm f/4L IS USM, 1/500 second @ f/5.6, ISO 200, -0.67 EV, polarizer)

Polarizing filters minimize reflections, such as those from the surface of the water, to help create a good exposure so you can better see below the water's surface.

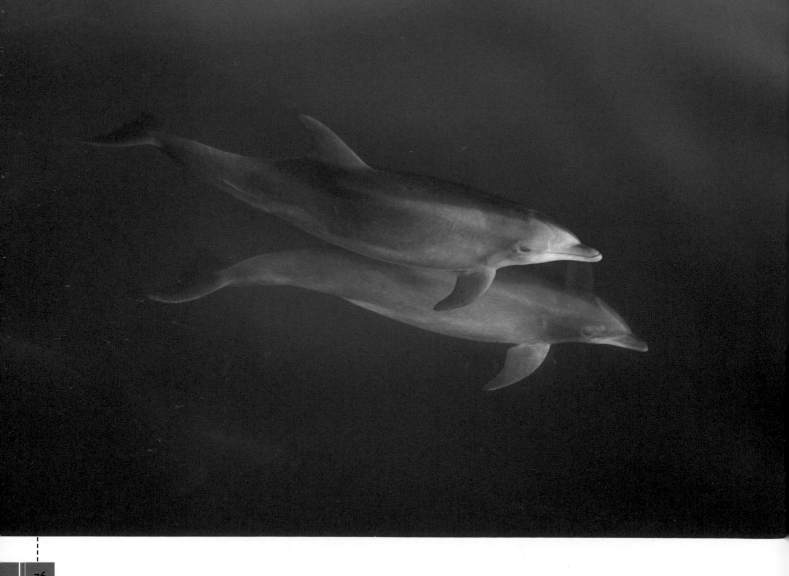

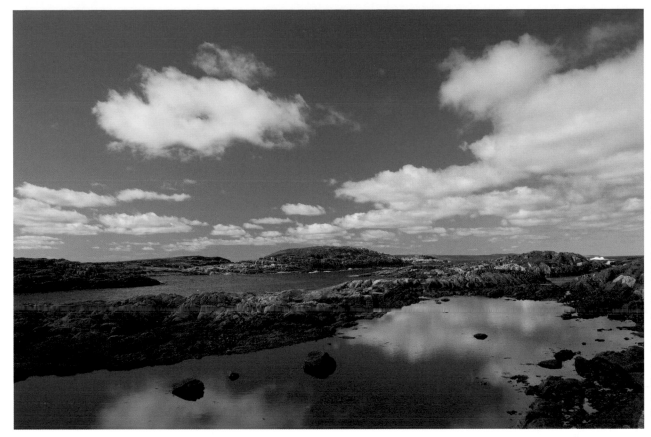

Reflection in Tidal Pool, Battle Harbor, Labrador, Arctic Canada

(Canon EOS 5D Mark II, Canon EF 24-105mm f/4L IS USM, 1/250 second @ f/8, ISO 200, 0.00 EV, polarizer)

Polarizing filters darken the sky, effectively bringing the scene's contrast into a range that is easier for the sensor to render.

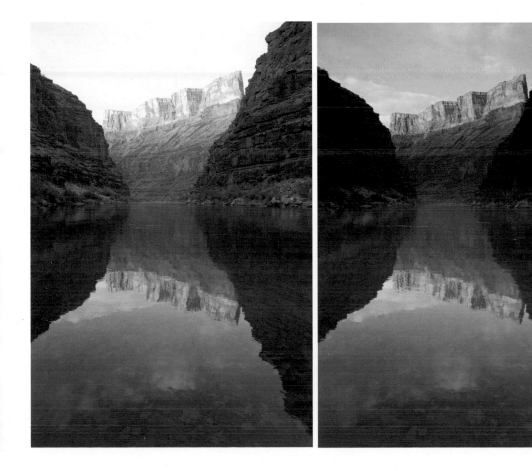

Reflection Along the Colorado River, Marble Canyon, Arizona

(Canon EOS 5D Mark II, Canon EF 24-105mm f/4L IS USM, 1/20 second @ f/8, ISO 100, -0.67 EV, with and without grad-ND)

To balance the exposure between sky and reflection, a 2-stop, hard-edged graduated neutral density (grad-ND) filter was used to hold back the exposure value of the sky.

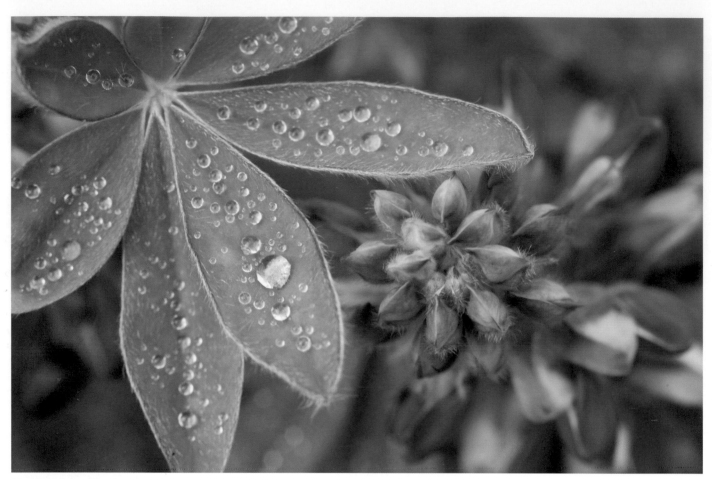

Cloudy Light on Nootka
Lupine, Tracy Baranof
Island, Tongass National
Forest, Southeast Alaska

(Canon EOS 5D, Canon EF
100mm f/2.8 Macro USM,
1/30 second @ f/11, ISO
200, 0.0 EV, no filter)

QUALITY OF LIGHT

It's been said by many before me, "Find the light and shoot what's in it." The first step is to recognize what type of light you are dealing with and explore the photographic possibilities within that light. It's amazing how the different qualities of light affect the feeling, tone, and mood of the final image.

SOFT OR DIFFUSED LIGHT

I love overcast skies for nature photography. Clouds, those giant diffusion filters in the sky, create soft light with far lower contrast than full sun. This diffused light helps move highlights and shadows into a range that digital cameras can handle.

It may surprise you that for many situations, diffused light is the best light of all. It imparts a warm, saturated look, bringing out subtle colors and details. This is ideal light for shooting animal portraits, waterfalls, deep forests, close-ups, and for landscapes where sky is not included.

As clouds get thicker, they filter out more of the sun's warmer wavelengths, causing a blue colorcast. While this is good for emphasizing the blue in icebergs (the ice looks bluer on cloudy days), most situations require correcting for the blue, either at the moment of capture by changing WB to Cloudy or Shady, or during processing in Lightroom.

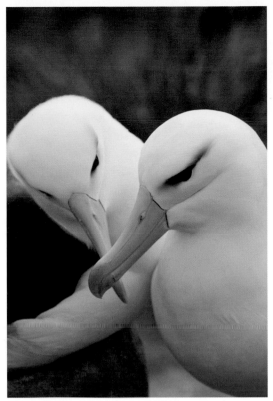

Cloudy Light on Black-Browed Albatross,
Falkland Islands

(Canon EOS 1D Mark II, Canon EF
70-200mm f/2.8L IS USM w/1.4x, 1/500
second @ f/8, ISO 100, +1.0 EV, no filter)

Shoot It: Under cloudy conditions, I begin shooting in evaluative or matrix metering mode. Diffused light is even with little contrast, so you generally can believe the camera's light meter. One exception is shooting a bright subject under cloudy conditions. In this case, push the exposure compensation to + EV until the "blinkies" appear, then dial the EV down -0.33. To avoid underexposed image the mantra is "add light to white." I often find that I add +1.66 EV when shooting white flowers, birds, or polar bears under cloudy conditions.

If the light is not changing, I switch to manual and meter off a middle tone—like green grass or a gray rock—then recompose the frame and shoot. And I always check the histogram to be sure that I'm not overexposing the white feathers or flower petals.

When the light is soft, I get in close to a subject, either making tight compositions with wide-angle lenses or intimate portraits of animals with longer zoom lenses, because the soft light creates natural-looking shadows and enhances color tones. For landscapes, I look for compositions that avoid the sky. Working below the horizon I fill the foreground with color and form. Even though the sun isn't shining directly in diffused light, I still use a polarizing filter to cut reflections and saturate color, especially after a fresh rain when everything is shiny and wet.

Cloudy Light on
Moose in Fog, Denali
National Park and
Preserve, Alaska

(Canon EOS 1D Mark
II, Canon EF 300mm
f/2.8L IS USM w/1.4x,
1/400 second @ f/4,
ISO 800, +0.67 EV,
no filter)

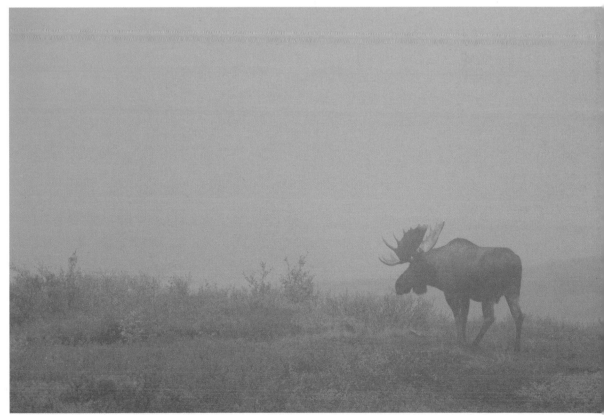

REFLECTED LIGHT

Another "quality" of light is reflected light, which can range from warm to cool, depending on the color of the object it is reflected off of. I put this under light quality, and not direction, because reflected light takes on the color tone of what it is being reflected from. Light reflected off of sandstone canyon walls can be very warm, while reflected light from clear blue skies result in a blue color cast that can either be pleasing or require correction. Reflected light scenarios can be a combination of soft light (the actual reflected light) and direct light (right from the light source).

Shoot It: When working with reflected light, give your eyes time to adjust to the conditions. Sometimes you may even be standing in the sun while aiming your camera in the shade, making it difficult to see the true color. Find a composition and make a few test shots. You'll discover that the camera sees much differently than your eyes, picking up hues that are not obvious at first.

The camera's sensor tends to underexpose reflected light situations, especially if the light source appears in your frame. If possible, avoid hot spots where there is direct sunlight, as the camera can't handle extremes. It is difficult to balance bright sun on the canyon wall with deep shade, and although grad-ND filters can help, you'll find the most rewards simply working with the reflected light in the shadows.

Cool Reflected Light on Flowing Water, Colorado River, Grand Canyon

(Canon EOS 5D Mark II, Canon EF 24-105mm f/4L IS USM, 2 seconds @ f/22, ISO 100, +1.0 EV, no filter)

Because shadows were creeping across the canyon, I used a long exposure to enhance the reflected light from the blue sky.

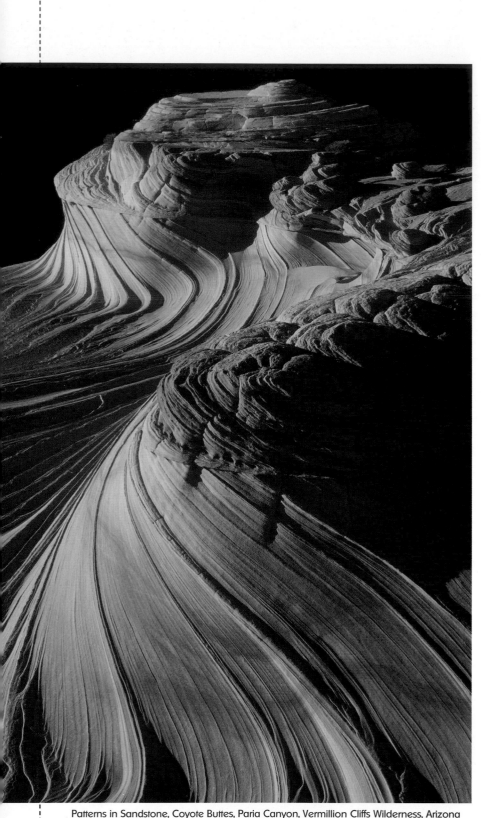

HARD OR DIRECT LIGHT

Direct light is a necessary evil in nature photography. It is at its harshest on a sunny day without clouds. In general, it is best to avoid direct, midday light because it creates the most contrast, but you can also use its characteristics to your advantage. Direct light makes very distinct shadows, and thus can create interesting graphic elements in landscapes as well as for macro photography.

Shoot It: Direct or hard light usually has a more extreme contrast and dynamic range. You will usually have to choose whether you want to expose for the highlights or for the lowlights. Remember to adjust your EV value to compensate for the sensor's tendency to underexpose highlights in bright scenarios and to overexpose lowlights in darker scenarios.

You can create some interesting images by utilizing the hard-edged shadows that direct light creates. Look for those shadows and expose for the light source to make them black.

Patterns in Sandstone, Coyote Buttes, Paria Canyon, Vermillion Cliffs Wilderness, Arizona

(Canon EOS 10D, Canon EF 16-35mm f/2.8L II USM, 1/250 second @ f/22, ISO 100, +0.33 EV, no filter)

Direct light of later afternoon creates shadows that emphasize patterns.

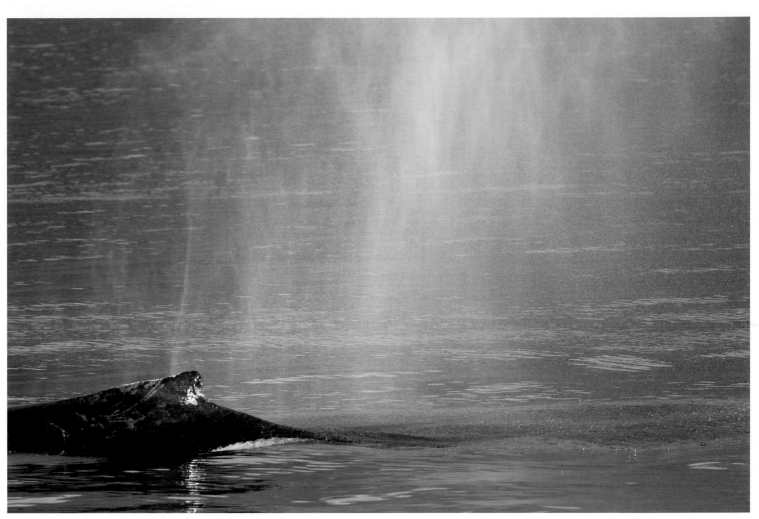

Rainbow Blow, or "Rainblow", Humpback Whale, Chatham Strait, Southeast Alaska

(Canon EOS 1D Mark II, Canon EF 300mm f/2.8L IS USM w/1.4x, 1/1000 second @ f/5.6, ISO 200, -0.67 EV, polarizer)

A polarizing filter helps enhance the effect of the rainbow. Adjusting the black point and boosting saturation in post-processing further enhances that effect.

DIRECTION OF LIGHT

When approaching a photographic opportunity, think about the angle of the light. The angle of the sun is extremely important in nature photography. When the sun is out, nature photographers seek sidelight or backlight situations, avoiding like the plague the harsh light of high noon, or the flat light of front lit subjects (when the sun is behind you).

When photographing whales, for example, sidelight is best for breaching activity and backlight is best for the blow, and also for when the whale lifts its fluke as it makes its dive.

I knew I had the dream job as an Expedition Leader when the Captain of the Lindblad ship called me on the radio and asked, "There's a whale ahead. What side do you want the sun on?"

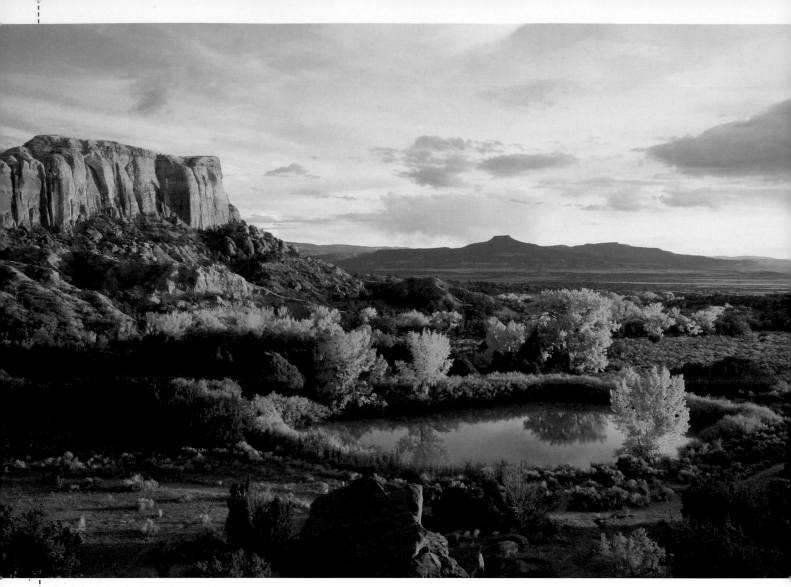

Sidelight in Box
Canyon, Ghost
Ranch, New Mexico

(Canon EOS 1D
Mark II, Canon EF
24-70mm f/2.8L
USM, 1/60 second @
f/8, ISO 100, -0.33
EV, no filter)

When shooting
landscapes, choose
a composition that
takes advantage of
the direction of light.

SIDELIGHT

Sidelight occurs when the sun strikes a scene from either side, creating interplay between highlights and shadows. The lower the angle of the sun, the longer the shadows will be and the warmer the light.

Visualize yourself standing on the rim of the Grand Canyon. At mid-day, the light is flat, with no separation of the ridges or canyon walls. Later in the day, sidelight defines every ridge and baths the canyon walls with a warm glow. The Grand Canyon is particularly photogenic because of its east-west orientation, creating sidelight conditions both early and late in the day.

Sometimes you can "control" the position of the sun relative to the subject by moving your position. In this way, wildlife photographers look for sidelight to add "catchlight" or sparkle to the animal's eye, and for casting interesting shadows.

Landscape photographers love sidelight for the way shadows add a sense of depth and dimension. Shadows help subjects separate from the background, highlighting shape and form to impart a 3D effect. Sidelight also emphasizes texture and detail in close-ups, so it's important to recognize and work with sidelight in macro photography as well.

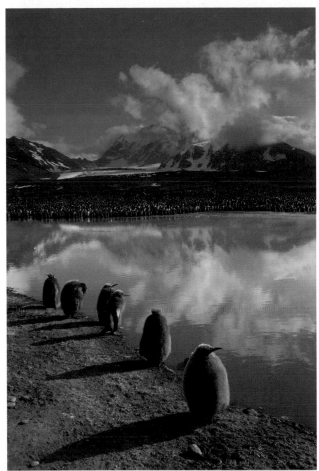

Sidelight on KIng Penguins, St. Andrews Bay, South Georgia

(Canon EOS 5D, Canon EF 24-70mm f/2.8L USM, 1/125 second @ f/11, ISO 100, -0.33 EV, no filter)

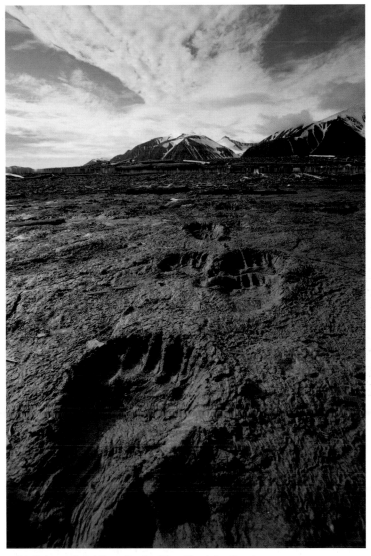

Sidelight on Polar Bear Tracks, Woodfjord, Svalbard Archipelago, Norway

(Canon EOS 5D Mark II, Canon EF 16-35mm f/2.8L II USM, 1/320 second @ f/11, ISO 200, -0.67 EV, no filter)

Shoot It: To photograph texture, look for interesting light striking interesting things. As light hits a textured surface, it accentuates the look and feel of that surface. But you have to find the right angle. If it's not working through the viewfinder, shift your position relative to the sun. Texture is often most dramatic when there's an interplay between light and shadow. It also helps to shoot sidelight at an oblique angle, so get down low; sometimes my wide-angle lens is almost on the ground.

To emphasize texture, try slightly underexposing the scene, especially where there's sunlight and shadow. For high contrast scenes, processing the image in black and white can also have interesting results.

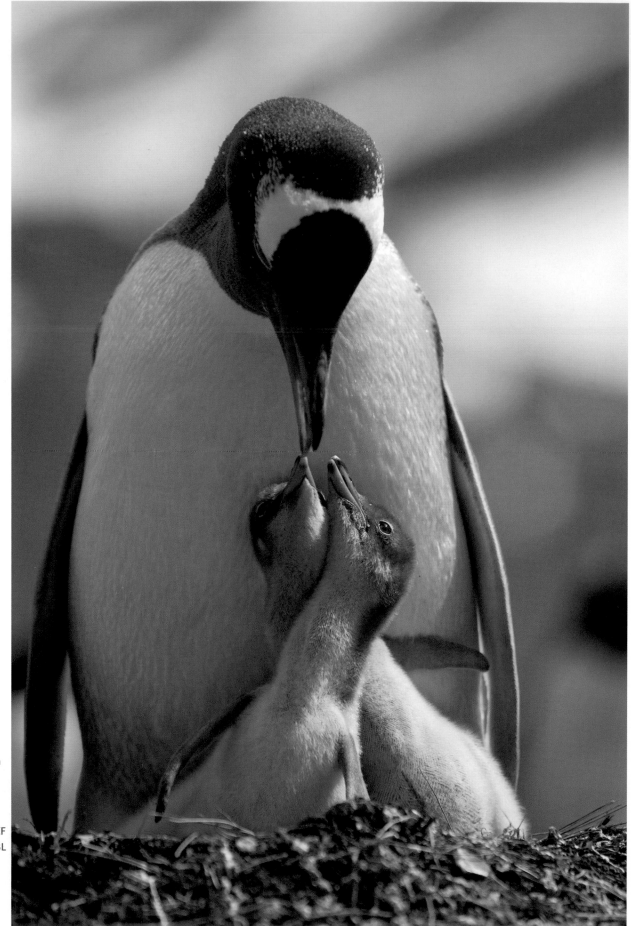

Sidelight on Gentoo Penguin with Chicks, South Georgia

(Canon EOS 1D Mark II, Canon EF 70-200mm f/2.8L IS USM, 1/500 second @ f/5.6, ISO 200, -0.33 EV, no filter)

Catchlight

A catchlight in an animal's eye makes it come to life. Without it, eyes appear flat, dark, or even sinister.

To photograph the all-important catchlight, wait for the animal to turn its head so that the sun or bright sky is reflected in the animal's eye, click the shutter, and bang—you nailed it. Easier said than done. For one, animals don't always remain still long enough to catch the reflection, or they don't look in the right direction.

There are several things you can do to make this easier. Often a slight shift in your position will give you a better angle. Or, you can add the catchlight with fill flash. Many wildlife photographers use a little pop of flash, dialing the flash compensation down to -2 stops, so that the effect is subtle. This adds a catchlight to the eye, without altering the ambient light and overall look of the scene.

It's a little thing, but thinking about the catchlight will add a professional touch to your animal portraits.

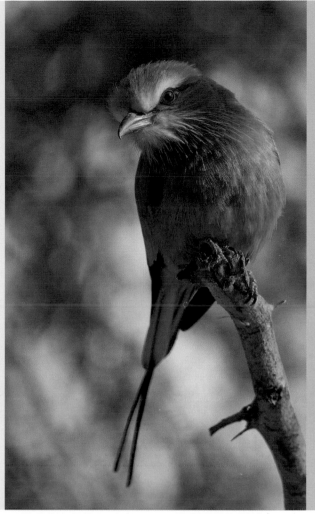

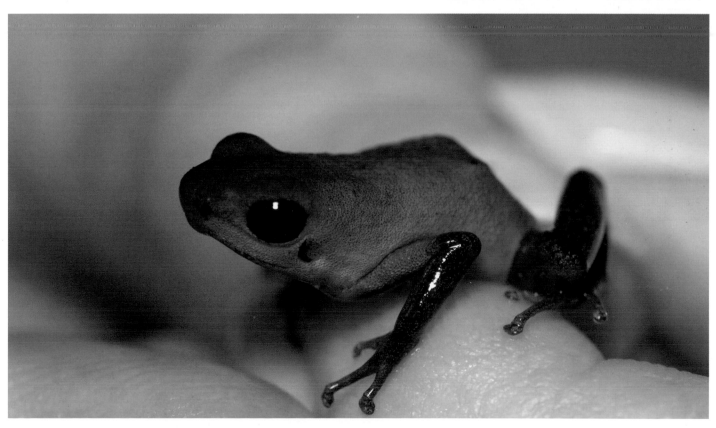

BACKLIGHT

Backlight is one of the more difficult light directions to effectively photograph, but if you can get the hang of it, you'll soon discover that backlight is perhaps the most dramatic light of all. Backlight can make colors glow, water sparkle, and create beautiful silhouettes. It also emphasizes mist, clouds, smoke, and steam to bring the air to life.

Many photographers tend to avoid backlight situations because it is a much more difficult exposure situation. The camera is often fooled into being underexposed, and sometimes you need a third arm to shield the front lens element. Lens flare is also a problem.

Backlight on Galapagos Sea Lion at Sunset, Santiago Island, Galapagos Archipelago, Ecuador

(Canon EOS 1D Mark III, Canon EF 70-200mm f/2.8L IS USM w/1.4x, 1/8000 second @ f/4, ISO 200, -1.0 EV, no filter)

Silhouettes are dramatic when shot with the setting sun.

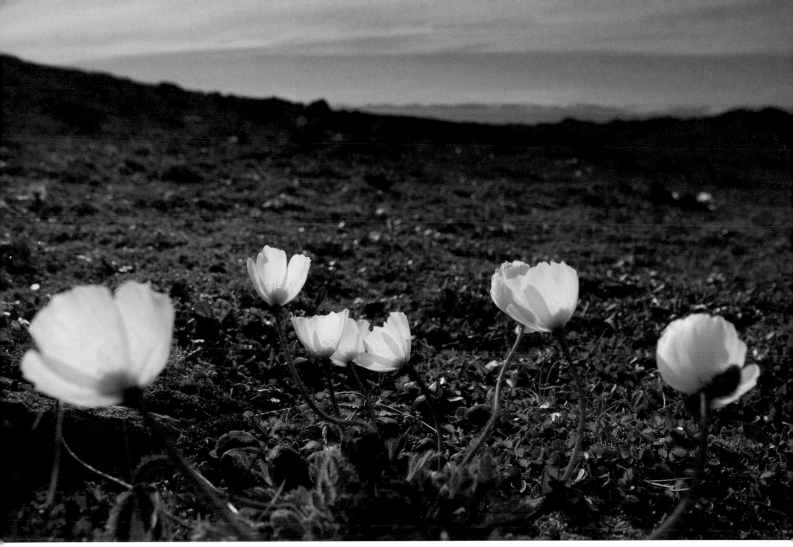

Backlit Svalbard Poppies, Woodfjord, Svalbard Archipelago, Norway

(Canon EOS 5D, Canon EF 100-400mm f/4.5-5.6L IS USM, 1/500 second @ f/8, ISO 200, -0.33 EV, no filter)

Shoot It: Start by framing compositions that don't include the sun in the viewfinder. It is easiest to work on a tripod so that your hands are free. To avoid lens flare, shield the lens from the sun with your hand, or use a lens hood.

When approaching a backlight situation, underexpose the overall scene. For example, underexposing by -1 stop creates lovely silhouettes. Be sure to guard against blowing out the sky. On the water, backlighting makes whale blows light up like a light bulb, and in the ice can reveal the steamy breath of a polar bear in the midnight sun. Again, avoid lens flare by blocking the sun with your hand, or finding a position where your camera is shielded from the sun. Also, underexpose the scene slightly to emphasize the mist.

If the orb of the sun is in included in the image frame, try stopping down to f/11 or smaller to create a starburst effect around the sun and off highlights on the water. With the bright sun included in the frame, the camera will naturally compensate for the brightness, resulting in an underexposed image. If this is not the look you want, then push the exposure compensation to a + EV value—say +1—to see if you like the results.

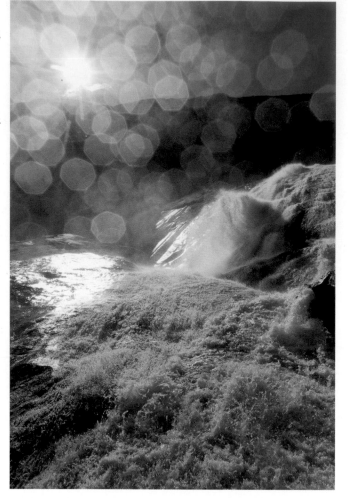

Backlit Waterfall, Nordjord, Norway

(Canon EOS 5D, Canon EF 16-35mm f/2.8L II USM, 1/1600 second @ f/8, ISO 200, +0.33 EV, no filter)

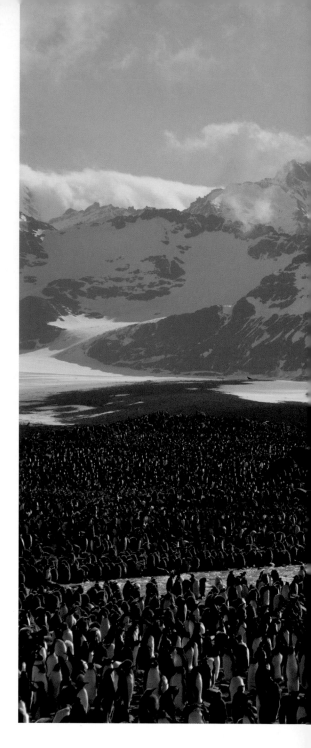

One pleasing and sometimes unexpected result when shooting into the sun is the polygonal look of water droplets on the front of the lens. Sometimes I purposely let mist from a waterfall build up on my lens, or I sprinkle a few splashes off water on my lens when shooting from water level. It's fun to experiment, but be sure to wipe off your lens before too long to avoid water drops seeping inside your lens.

RIM LIGHT

Backlight also creates the sought after rim lighting, or halo effect, particularly with the backlit fur of polar bears, when the pack ice acts like a fill card on the shadow side. Another more subtle effect, is the luminescent glow in leaves and flowers when backlit, and I love the polygonal look of water droplets on my lens when photographing waterfalls into the sun.

Shoot It: To capture rim light effectively, it's critical to fool the camera's light meter and purposefully underexpose the scene. One way to do this is by shooting with aperture priority mode and dialing down the exposure compensation. As a starting point, bracket exposures between -1 and -2 EV.

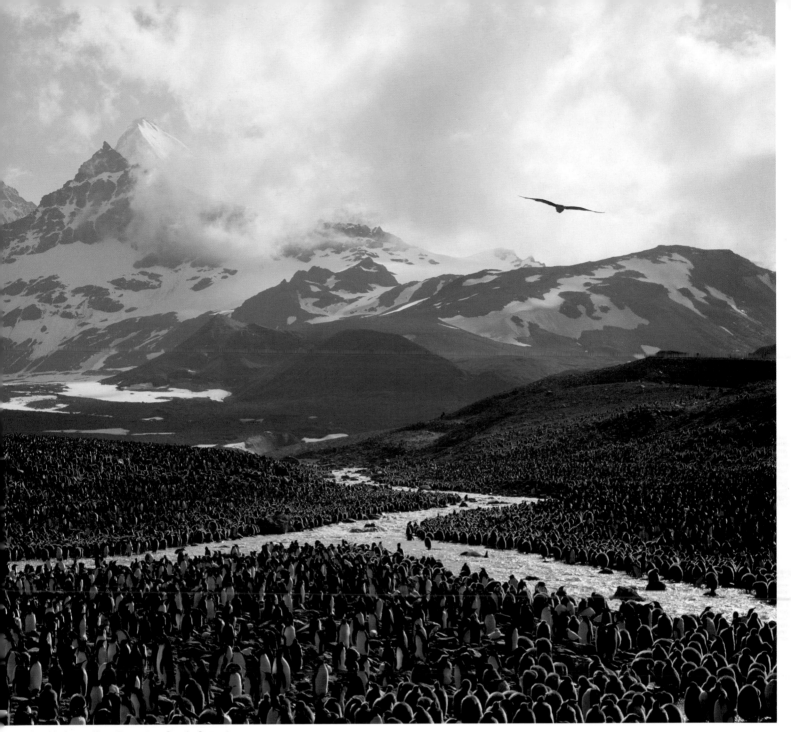

Backlight on King Penguins, South Georgia

(Canon EOS 5D, Canon EF 24-70mm f/2.8L USM, 1/500 second @ f/8, ISO 100, -0.67 EV, no filter)

Backlighting adds a touch of rim light to each penguin.

Under these difficult or extreme lighting conditions, the camera's histogram is often difficult to interpret. In this situation, it's sometimes best to switch to manual shooting mode and use the spot metering mode (instead of evaluative or matrix metering). Spot meter on the highlights or rim light itself and make a test shot; then increase the exposure by one stop and shoot the scene again. Make sure you spot meter on the highlights instead of the overall scene; this will get you in the ballpark, where the rim light glows but is not blown out, and the rest of the scene isn't too underexposed.

Magic Light

The "magic hour"—the time a half hour before and after sunset or sunrise—is absolutely the best time for nature photography. Early and late in the day is when the light is soft, warm, and balanced. It's the light that photographers dream of; when the magenta hues in the pre-dawn sky and the golden light at sundown, colors the landscape and everything that's in it. Then there's twilight, often the most interesting light of all.

Scout It: Capturing the magic light requires being in the right place at the right time. This means you must be set up and ready to go as the magic hour approaches. Scouting is essential. I often use the flat light of midday to scout sunset locations. For sunrise locations, scout the day before, so that you know exactly where you want to be. This will save fumbling around the dark before the sun is up. A GPS and headlamp will help you find your location.

Tripod: It's essential to work on a tripod for shooting magic light. Amazing things happen at a low ISO and when the shutter is left open for several seconds. Longer exposures seem to capture the subtleties of light, the purple and magenta hues at dawn or dusk.

Blowing Sand at Sunrise, Magdalena Island, Baja California, Mexico

(Canon EOS 5D, Canon EF 16-35mm f/2.8L II USM, 2 seconds @ f/5.6, ISO 100, +0.67 EV, grad-ND)

A slow shutter speed shows the motion of the blowing sand.

Mirror Lock-Up: Even when you camera is firmly mounted on a trip, camera shake when the mirror flips up can become an issue, especially with longer lenses. It's good practice to employ the mirror lock-up function in situations where slow shutter speeds and long exposures are involved. This is especially important when shooting at twilight, when shutter speeds are between 2 – 5 seconds, depending on the ISO and f/stop settings. The mirror lock-up function is typically found in your camera's custom menu.

Magic Light on Tabular Iceberg, Gerlache Strait, Antarctica

(Canon EOS 5D, Canon EF 70-200mm f/2.8L IS USM, 1/125 second @ f/2.8, ISO 200, -1.0 EV, no filter)

Out on the deck of the National Geographic Endeavour at 4:00 A.M., a golden shaft of light illuminates an iceberg.

Shutter Release Cable: Use a remote shutter release (or cable release) to trip the shutter. If you don't have a cable, put your camera on the timer function, and let the camera click the shutter automatically after two seconds. Either way, you avoid camera movement that can be caused by pushing the shutter.

Filters: Another thing to think about when chasing the magic light is balancing the light between darker landscapes and the brighter sky. Again, this is where grad-ND filters come into play, to hold back the sky and bring out detail in the foreground. I use a 2-stop hard-edged grad-ND for scenes with distinct horizons, like when shooting across water. Alternatively, I'll use a 2- or 3-stop soft-edge grad-ND when the horizon is indistinct or varied, like in the case of a mountain scene.

Wandering Albatross and Rainbow, Prion Island, South Georgia

(Canon EOS 1D, Canon EF 300mm f/2.8L IS USM w/1.4x, 1/1000 second @ f/5.6, ISO 200, -0.67 EV, polarizer)

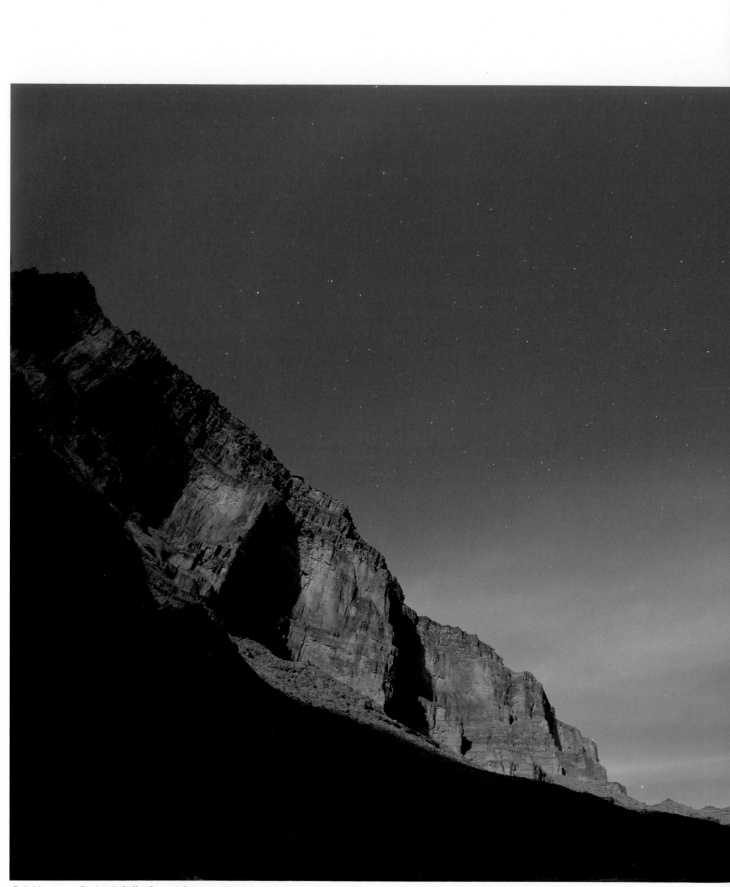

Full Moon on Redwall Cliffs, Grand Canyon, Arizona

(Canon EOS 5D, Canon EF 14mm f/2.8L II USM, 30 seconds @ f/2.8, ISO 200, 0.00 EV, no filter)

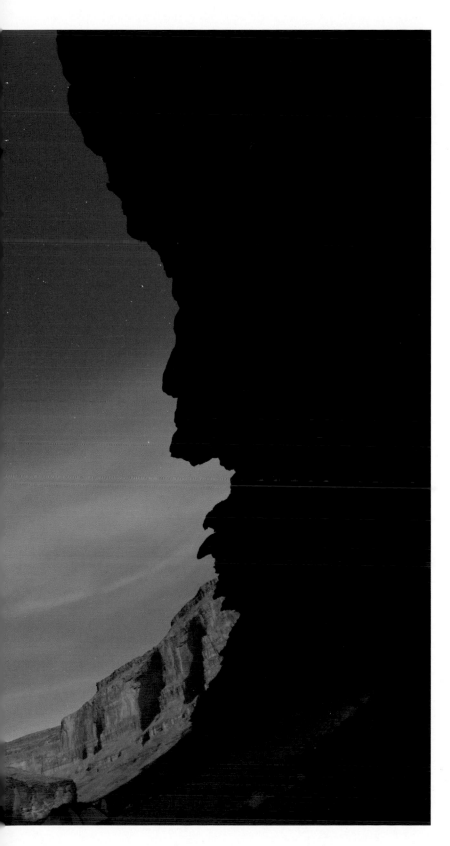

NIGHT LIGHT

It seems counterintuitive to talk about night light, but there opportunities to make some amazing images by utilizing the nighttime lights. Start by shooting twilight scenes on aperture priority at f/8 for 20 seconds, and push the ISO as necessary to bring up the sky. As the light fades, open up to f/2.8 or what ever your widest aperture is.

To capture the night sky with stars as pin-points of light, try a 30 second exposure and bump up the ISO as needed (and be sure to have your long exposure noise reduction switched "on"). I find that exposures any longer than 30 seconds make the stars start to streak, but I've had good results with exposures up to 90 seconds. For star trails, keep your shutter open for several minutes up to hours. Be sure to have your long exposure and high ISO noise reduction turned on.

It's also fun to photograph landscapes under the full moon. I always try to plan Grand Canyon river trips around the full moon. It's amazing how the canyon walls light up like daylight with long exposures, but with stars in the sky.

ARTIFICAL LIGHT

"There's no substitute for great light," as one of my younger workshop students used to say, and by light, we're talking any available light. Any light is great light if you understand the different qualities of light and can find interesting subjects. But sometimes you will be in situations where you need to augment the light—or even produce the light yourself—in order to create an image.

Although I primarily work with natural light, I find that certain situations call for adding light, either with fill flash or painting in the light with a flashlight. I work with the natural light of the particular situation, modifying it only when I see a creative opportunity or necessity.

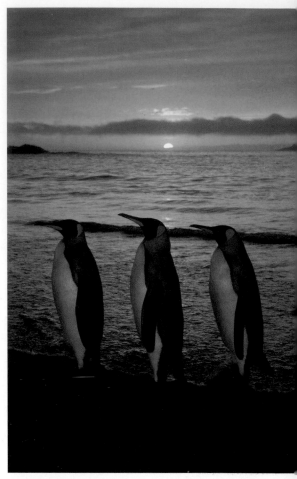

King Penguins Coming Ashore at Sunrise, St. Andrews Bay, South Georgia

(Canon EOS 1D Mark III, Canon EF 24-70mm f/2.8L USM, 1/250 second @ f/8, ISO 320, -1.33 EV, grad-ND)

Fill flash transforms this image from a sunrise silhouette into a colorful portrait of three king penguins.

FILL FLASH

As I've mentioned prior, fill flash is an easy way to add light to a scene. You can highlight foreground areas in landscapes, freeze motion in a macro shot, and add catchlights to an animal's eyes.

Fill flash looks the most natural when the effects are subtle; for the best results with fill flash, try setting the flash compensation at -2 EV. At two stops underexposed, this throws just enough light to the catchlight to the animal's eye, and will also help separate the animal from the background. If you need to add more light, try -1 EV.

SPOTLIGHTS, FLASH-LIGHTS, AND TORCHES

Another artificial light situation is on night safaris in Africa, where animals are viewed with a powerful spotlight. Common sense needs to be the guide, so limit the time spotlighting any one animal, pay attention to the animal's behavior, and listen to your guide. Spot lighting animals at night is exhilarating but also challenging for photographers. With digital cameras, you can increase the ISO and keep shooting, panning with the animal's movement.

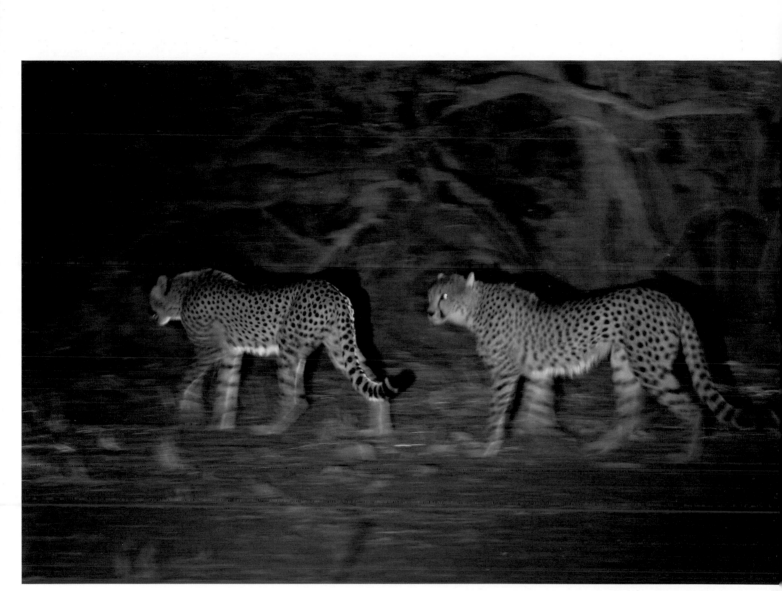

Spotlight on Cheetah, Mashatu
Game Reserve, Botswana

(Canon EOS 1D Mark III, Canon
EF 70-200mm f/2.8L IS USM, 1/13
second @ f/2.8, ISO 1600, -1.0 EV,
no filter)

It's also fun to use a flashlight or torch to paint foreground elements with light during timed exposures, especially crisp desert scenes with moving clouds. The high ISO and low noise capabilities of modern digital cameras have made night photography possible. It's possible to shoot in the dark, literally, and the instant feedback on the camera's LCD encourages experimentation.

Shooting time exposures at twilight can yield interesting results. Here, I lit the boulders, boojum tree, and cactus with a flashlight. I was working fast before the light faded, so it was a stroke of serendipity—or the perfect "moment"—when the satellite to moves across the sky in the frame.

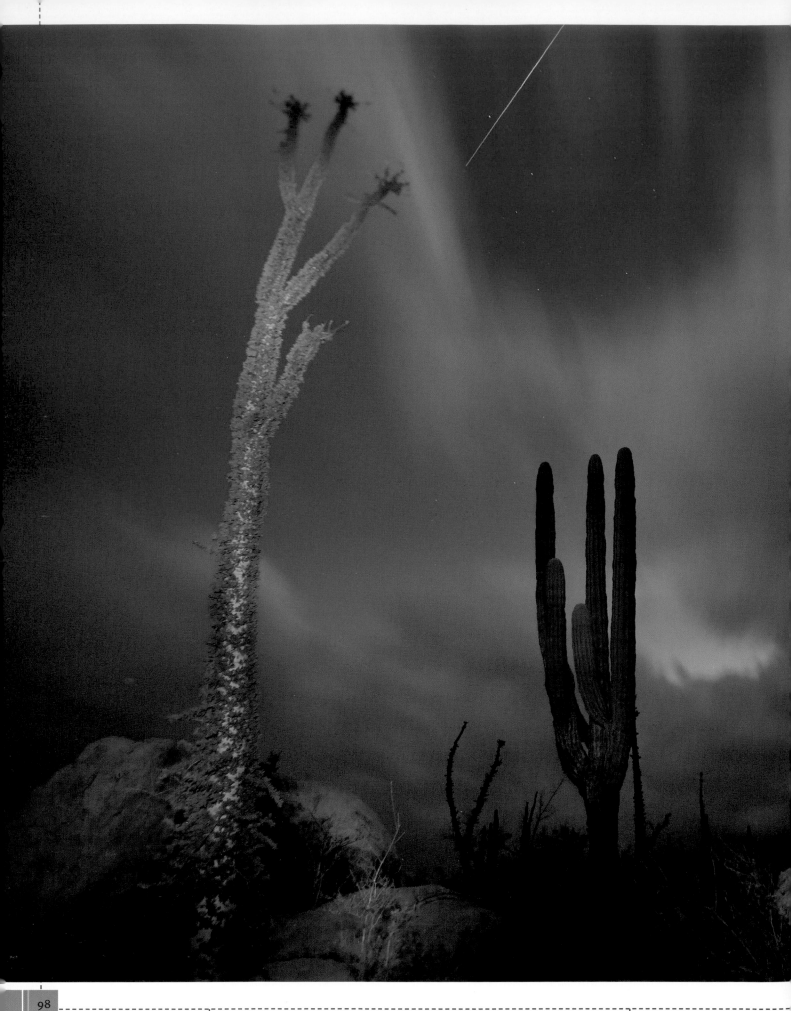

Painted Landscape,
Boojum Tree and Cardon
Cactus, Catavina Boulder
Field, Valle de los Cirios,
Baja California, Mexico

(Canon EOS 5D, Canon EF
16-35mm f/2.8L II USM, 20
seconds @ f/2.8, ISO 100,
+1.0 EV, no filter)

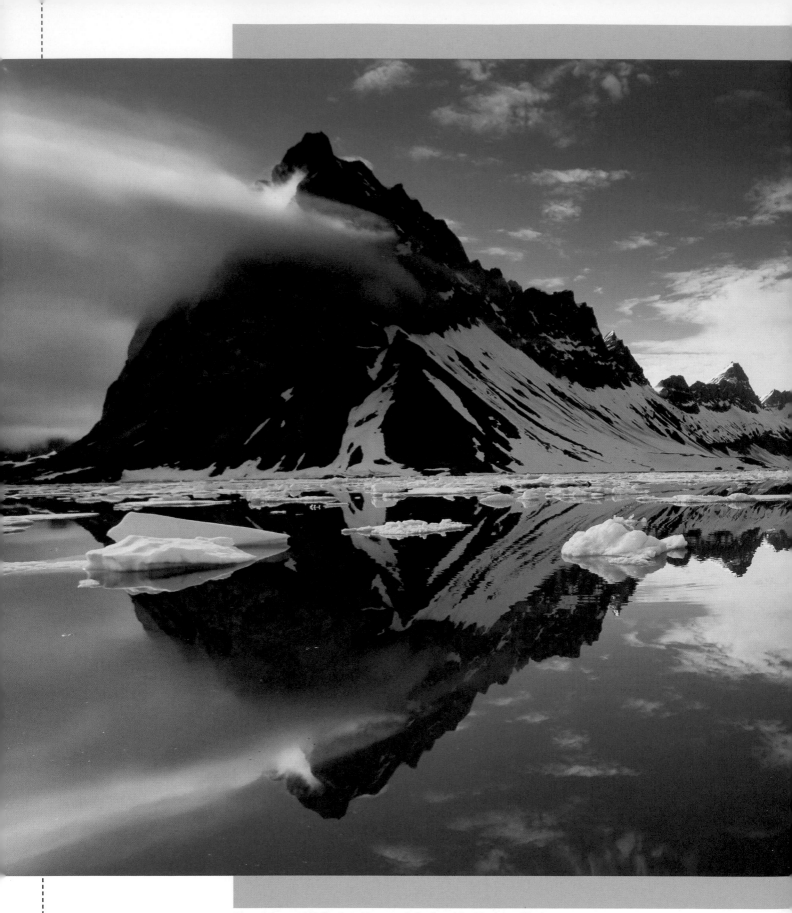

Mountains and Reflection, Hornsund, Svalbard Archipelago, Norway

(Canon EOS 5D, Canon EF 16-35mm f/2.8L II USM, 1/250 second @ f/8, ISO 200, -0.33 EV, grad-ND)

The mountain peaks and reflection create diagonals that give the viewer's eye something to follow into the frame.

Chapter 5: Elements of Composition

"What the human eye observes causally and incuriously, the eye of the camera notes with relentless fidelity." Berenice Abbott

When it comes to the essence of creativity and the art of photography, all rules are out the window. There are many different elements of composition and an infinite number of ways they can be arranged in nature. Unfortunately, there are no shortcuts for making interesting and dynamic images that portray nature in all its beauty.

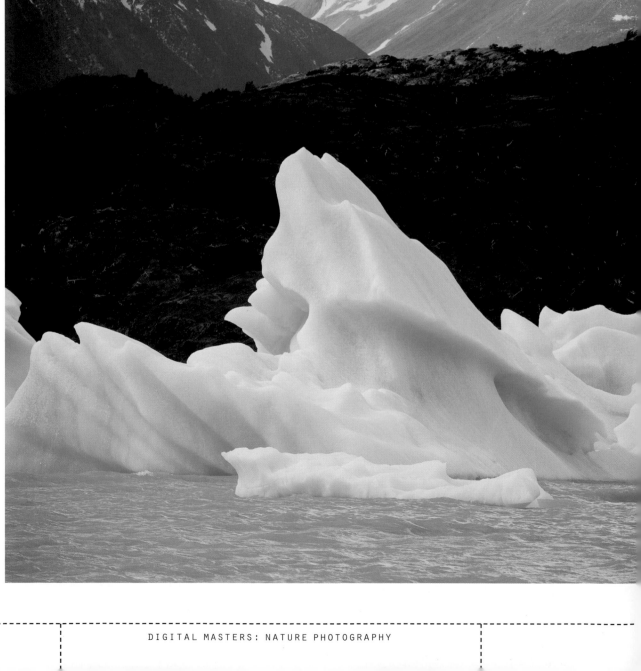

Icebergs at Gray Lake, Torres del Paine National Park, Chile

(Canon EOS 5D, Canon EF 70-200mm f/2.8L IS USM, 1/400 second @ f/8, ISO 100, -0.67 EV, grad-ND)

Icebergs provide a strong foreground in this medium tele-photo composition.

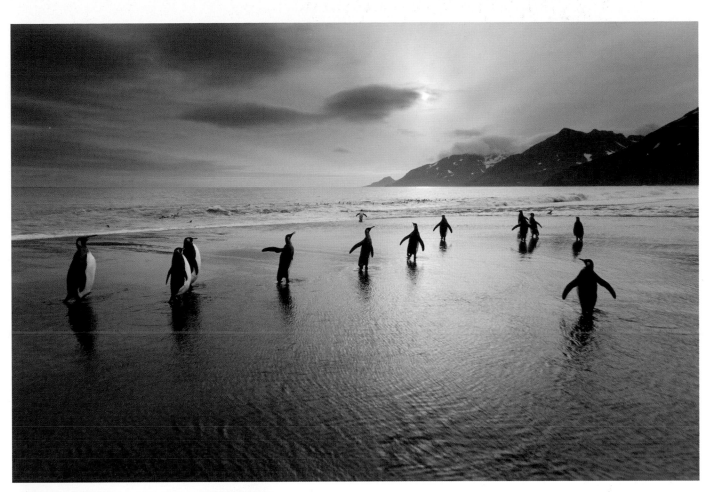

THE BASICS

Composition is the arrangement of visual elements in a work of art; in our case, the photographic image. In art terms, you can think of composition as the visual order—or design—of the image.

Artists talk about visual elements in terms of "elements of design," which can be easily translated into "elements of composition" employed by photographers. Although there is no formula in art or photography, there are certain fundamentals that provide guidelines for how the elements of composition are arranged. This is critical when thinking about an image; how you arrange the visual elements helps determine the impact of the image on the viewer.

Beginning nature photographers often try to include too much in a single photo. Three of the common pitfalls I see in student's photos are having too many compositional elements with no clear subject or emphasis, distracting foregrounds or backgrounds that confuse the eye, and the primary subject being too small or centered in the frame.

Learn the rules so you can learn how to break them.

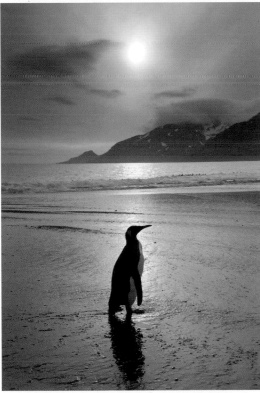

King Penguins, St. Andrews Bay, South Georgia

(Canon EOS 5D, Canon EF 24-70mm f/2.8L USM, 1/1250 second @ f/2.8, ISO 100, -0.33 EV, grad-ND)

Basic Elements of Composition

Lines: Lines are important because they give the eye a visual path to follow through the frame. The sinuous crest of a sand dune is a perfect example.

Shapes: Shapes are defined by edges providing form and symmetry within an image. Different shapes can apply different feeling tones to an image. Sharp angles appear agitated and uneasy, whereas smooth and rounded forms feel more calm and peaceful, like rounded boulders or meandering streams.

Color: The characteristics of color—hue, intensity (or saturation), and color temperature—work together to create different moods, adding an emotional content to an image. Warm, saturated colors are invigorating and exciting, while blues are cool and refreshing. Vibrant color combinations, especially among primary colors (reds, yellows, and blues) demand attention and add impact, making the eye jump between bright colors. Gentler more pastel combinations are more soothing and somewhat romantic.

Texture: Think of texture as the surface qualities that give an image a visual feel or tactile dimension. Surfaces can be smooth, or rough and gritty. Sidelight can emphasize uneven and gritty textures, as angled light catches shapes and shows imperfections in surfaces. In contrast, diffused light can help smooth out the textural feel of an image.

Size: Size is the proportion and dimension of shapes and objects relative to one another. Object size can vary in photography, and the true size of something can be manipulated. We can make objects appear larger than life depending on what lens we use and how we frame them. Abstract photos often work best without any hint of real scale.

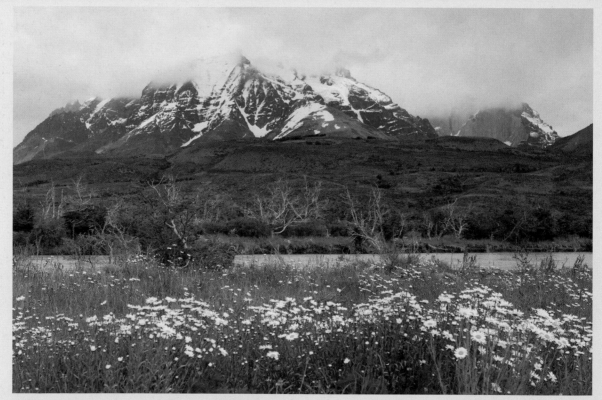

Field of Daisies, Torres del Paine National Park, Chile

(Canon EOS 10D, Canon EF 24-70mm f/2.8L USM, 1/320 second @ f/8, ISO 100, -0.67 EV, grad-ND)

This image is a first attempt and shows little effort in composing an interesting photo.

Field of Daisies, Torres del Paine National Park, Chile

(Canon EOS 10D, Canon EF 24-70mm f/2.8L USM, 1/1250 second @ f/5.6, ISO 100, -0.67 EV, grad-ND)

Coming in close on the flowers with a shallow DOF throws the background out of focus to give more importance to the subject.

Perspective: Simply stated, perspective is the arrangement of objects as they appear to our eye based on their spatial relationships and relative size. Perspective is a key compositional element because it can add depth and the appearance of a third dimension to an otherwise two-dimensional image.

Space: How much you choose to include, or not include, in your compositions impart a feeling of openness or closeness. Negative space—or the space between objects—is as important as the objects themselves.

Field of Daisies and Rainbow, Torres del Paine National Park, Chile

(Canon EOS 10D, Canon EF 24-70mm f/2.8L USM, 1/320 second @ f/8, ISO 100, -0.67 EV, grad-ND)

This image is the big payoff. Magic happens as a passing rainshower adds a rainbow to the scene.

SIMPLIFY THE FRAME

Sometimes when critiquing photos in a workshop I'm speechless, not because the student's image is horrible, but because there's too much going on in the frame. When I'm stuck, I'll say, "Nice use of the horizontal frame." That usually means there's a picture in there somewhere, but I can't find it.

If there are too many things going on in an image, the eye doesn't know where to look. If there is no emphasis or focal point to guide the viewer's eye to the important parts of the photo, then the image will lose its impact. Here are some ways to simplify the frame and thus create a more striking composition.

Direct the Eye: Directing the eye establishes movement and makes the photo more dynamic. Selective focus with a shallow depth-of-field is one way to direct the viewer's eye, since the eyes are attracted first to what appears sharp in the frame. Another way is to place the main subject in a bright spot, as the eyes are naturally attracted to the brightest object in the frame. Leading lines, such as diagonals, direct the viewer's eye through the frame, usually from near to far. In contrast, crossing lines direct the eye to specific points of interest.

Narrow the Angle of View: It's just as important to learn what not to include, as it is what to include. Change your view by getting closer, changing lenses, or zooming in or out. Look for details hidden

Kayak and Iceberg, Svalbard
Archipelago, Norway

(Canon EOS 5D Mark II,
Canon EF 70-200mm f/2.8L
IS USM, 1/1000 second @ f/8,
ISO 200, -0.33 EV, no filter)

This composition is simpli-
fied by cropping into a
panoramic, excluding the
horizon.

within the overall landscape, and look for elements that you can eliminate. By zooming in or changing to a longer lens, you are narrowing the angle of view, choosing to focus on only on a limited area within an overall grand scene. This helps to simplify the image by eliminating distracting elements.

Use Negative Space: Photographers like to talk about the use of "negative space," or the open or empty space between objects in the frame. Less is more when it comes to composing images. Simplify the frame by leaving lots of room provides room for the eye to wander through the frame.

Negative space can be created in a number of ways, such as placing an animal against a dark background or a single flower against the sky. Negative space is also created by using a shallow depth of field (DOF).

Red-Footed Booby, Isla Genovesa, Galapagos Archipelago, Ecuador

(Canon EOS 1D Mark II, Canon EF 24-70mm f/2.8L USM, 1/40 second @ f/5.6, ISO 200, -0.33 EV, no filter)

Watch the Background: Distracting elements can kill a frame—in particular, backgrounds. Whether shooting flower close-ups or animal portraits, a distracting background with random blades of grass or branches is confusing to the eye.

In a field of flowers, I start out by taking a few shots at a comfortable distance, exploring as I move closer. I look for ways of simplifying the background, and usually I end up on my knees, up close and personal.

Another way to simplify the background is to shoot with a shallow DOF. Even when you can get close to a subject, it's often better to back off and use a longer lens to simplify the image by blurring the background.

Getting low and shooting animals against a clean sky is a good way to simplify the background.

Watch the Edges: Watch the edges of the frame. Many camera viewfinders, especially compact and advanced compact digital cameras, do not include 100% of what you see as you're looking through the camera. This is why it's so easy to have unwanted tree branches or other distractions along the edge of the frame. Sure, you can crop or otherwise clone it out later in Photoshop, but it is better to shoot it correctly the first time.

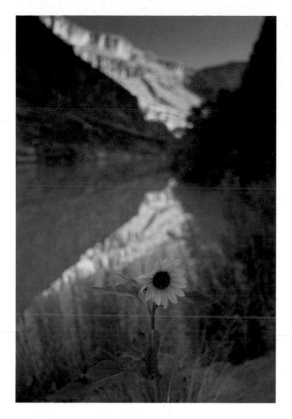

Single Sunflower along the Colorado River, Marble Canyon, Grand Canyon National Park, Arizona

(Canon EOS 5D Mark II, Canon EF 16-35mm f/2.8L II USM, 1/125 second @ f/2.8, ISO 200, -0.33 EV, grad-ND)

This single flower is pleasingly simple; if there were other flowers peaking into the frame at the edges, they would lessen the image's impact.

CREATE A STRONG FOREGROUND

Strong foregrounds create a sense of balance in a photograph and can be an effective compositional tool in nature photography. A confusing or complex foreground can be distracting. Be selective in what you choose to include in the frame, and pre-visualize the DOF and how much of the frame you want in focus. As with the background, varying DOF is a good way of simplifying the frame. Our eye tends to go with what is sharp, so choose your plane of focus carefully.

Blue-Crowned Motmot, Monteverde Cloud Forest Reserve, Costa Rica

(Canon EOS 1D Mark II, Canon EF 300mm f/2.8L IS USM, 1/40 second @ f/2.8, ISO 400, -1.0 EV, no filter)

At first, I was happy with this close shot of a Motmot. Then it landed on a different branch and I made a better composition with a soft, out of focus background and a less distracting foreground.

Giant Barrel Cactus Flowers, Isla Santa Catalina, Sea of Cortez, Baja California, Mexico

(Canon EOS 5D Mark II, Canon EF 16-35mm f/2.8L II USM, 1/1250 second @ f/2.8, ISO 200, +0.00 EV, no filter)

The cactus in the foreground helps to create a sense of depth in the image.

Move in Close: When exploring a subject, move in close. Look for an interesting foreground element, like a rock or tree truck, and get closer. Fill the frame from edge to edge until it feels crowded and uncomfortable, then back off until it feels right. Shoot the scene in different ways, varying the DOF and focus point.

Create Depth: I'm always searching for strong foreground elements in my compositions. In the Grand Canyon, I look for interesting rocks or patterns in a cliff. In Galapagos, I use the animals themselves because they are so approachable, and in the high arctic, I lay on my belly for the wildflowers.

Use Leading Lines: Any kind of leading line that directs the eye into the frame are especially effective, such as diagonal lines. The classic "S" curve is the strongest of them all because it leads the eye through the picture, usually starting from the bottom of the frame. The curve of a winding trail naturally leads your eye from near to far. Straight or flat lines appear static and can actually divide the image. If parallel lines appear to converge they create a vanishing point, resulting in the appearance of depth and distance in the image.

Find Natural Frames: Foreground frames help focus the composition and immediately tell the viewer where their eye should look. Natural arches or tree branches can effectively frame a portion of the image, as well as add a feeling of depth and dimension.

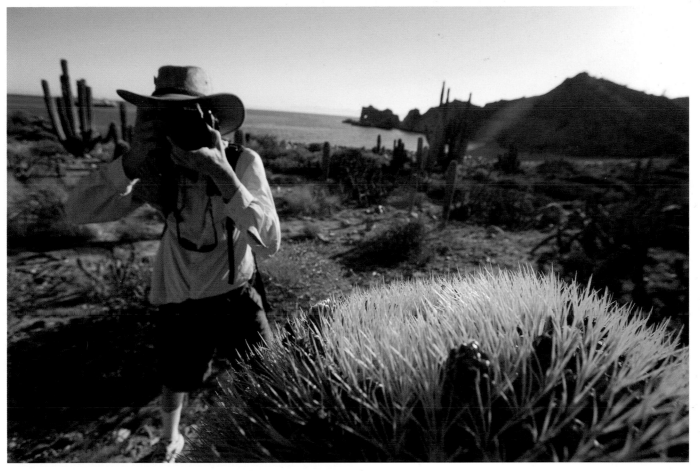

Photographer and Giant Barrel
Cactus, Isla Santa Catalina, Sea of
Cortez, Baja California, Mexico

(Canon EOS 5D Mark II, Canon EF
16-35mm f/2.8L II USM, 1/250 second
@ f/5.6, ISO 200, +0.00 EV, no filter)

Golden Cottonwoods
Frame Sandstone Cliffs,
Ghost Ranch, New Mexico

(Canon EOS 5D Mark II,
Canon EF 70-200mm f/2.8L
IS USM, 1/500 second @ f/22,
ISO 200, +0.33 EV, no filter)

Window through Blue
Iceberg, Paulet Island,
Antarctica

(Canon EOS 5D Mark II,
Canon EF 16-35mm f/2.8L
II USM, 1/30 second @ f/22,
ISO 200, -0.33 EV, no filter)

Shoot with Wide-Angles: Wide-angle lenses are most effective for emphasizing the visual impact of foreground elements because the field of view is wider that our eyes, forcing us to use our peripheral vision to create an almost 3D effect. Wide-angle lenses create the most dramatic compositions because of the layering of foreground, middle ground, and background elements in the frame. Get close, vary the DOF, and change the location of the focal plane.

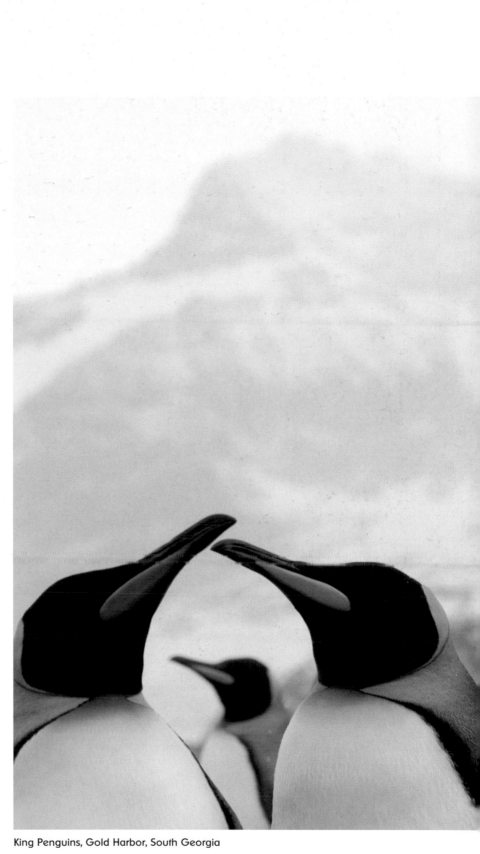

Sometimes the foreground looks best
sharp with a deep DOF (f/22); other times
it works better to blur the foreground with
a shallow DOF. Shoot it a variety of ways
to provide choices for editing later.

King Penguins, Gold Harbor, South Georgia

(Canon EOS 1D Mark II, Canon EF 24-70mm f/2.8L USM, 1/1250 sec-
ond @ f/5.6, ISO 100, +0.33 EV, no filter)

POINT OF VIEW

Another important aspect to composition is the point of view of the image. The camera location, the angle of view, and the lens choice all control how elements appear in an image.

Avoid Eye Level: Most photographers tend to shoot from comfortable positions. On the trail in Galapagos, I see photographers all the time standing up straight, pointing their camera at a bird or lizard on the ground. While it may be the best shot they've ever taken, the image could be improved by shooting from a lower angle. It's common to set up our tripods at eye level, so that we don't have to work hunched over. (This works in some situations, like when using long lenses and shooting distant subjects.)

To really work the subject, change your angle to the subject—as well as the distance from the subject—in order vary the point of view of the image. Animals appear larger and look more powerful when shot at a slight angle from below, and shooting landscapes from the ground emphasizes a dramatic foreground.

Get Low: Tripod legs are adjustable for a reason. Ideally, use a tripod that can lay flat on the ground, or a beanbag support that can stabilize your camera on the ground. (While getting down into position is easy, as years pass, it gets harder and harder to get up.) Choose your locations carefully. It's also a good idea to use kneepads when working low angles, especially in rocky or thorny places.

If it doesn't work to physically lie on the ground and look through your camera (rock, cactus spines, and guano all come into play), simply kneel and position the camera without looking through the viewfinder. This is the "no look" shot, often called a "Hail Mary" in the industry. Fire off a couple of test shots to refine the composition, then work the situation by varying DOF, plane of focus, and camera angle.

Reindeer Antlers,
Barentsoya, Svalbard
Archipelago, Norway

(Canon EOS 5D Mark II,
Canon EF 16-35mm f/2.8L
II USM, 1/800 second @ f/8,
ISO 200, -0.67 EV, no filter)

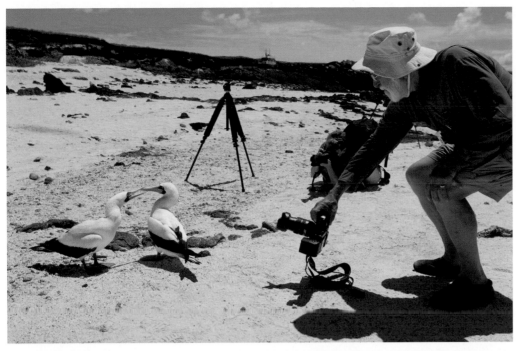

Photographer and Nazca Boobies, Isla Genovesa, Galapagos Archipelago. Ecuador

(Canon EOS 1D Mark II, Canon EF 16-35mm f/2.8L II USM, 1/1250 second @ f/5.6, ISO 100, 0.00 EV, no filter)

Shooting from a comfortable position, standing, often results in boring pictures.

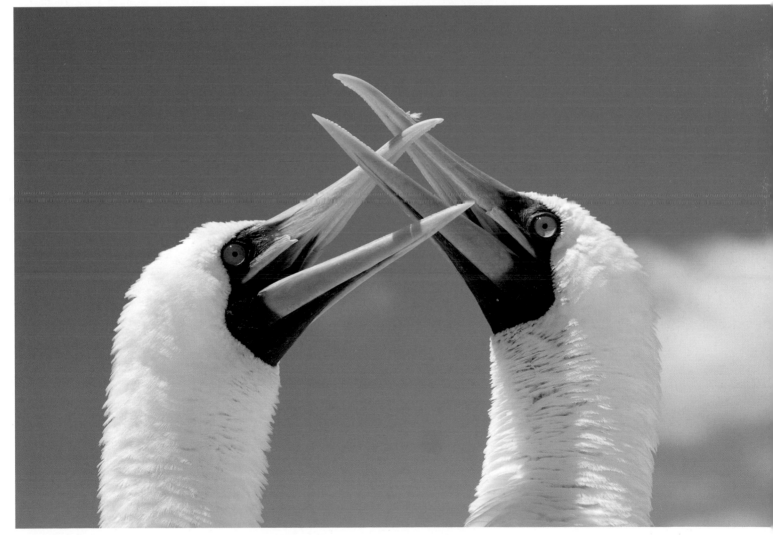

Nazca Boobies, Isla Genovesa, Galapagos Archipelago, Ecuador

(Canon EOS 1D Mark II, Canon EF 16-35mm f/2.8L II USM, 1/1250 second @ f/5.6, ISO 100, 0.00 EV, no filter)

A successful "no look" shot.

Gentoo Penguin, Anvers Island, Port Lockroy, Antarctica

(Canon EOS 5D Mark II, Canon EF 16-35mm f/2.8L II USM, 1/500 second @ f/8, ISO 100, -1.0 EV, no filter)

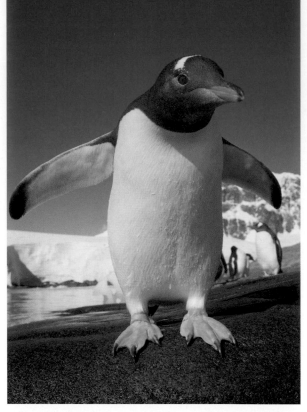

California Sea Lions, Los Islotes, Gulf of California. Baja California, Mexico

(Canon EOS 5D, Canon EF 16-35mm f/2.8L II USM, 1/1600 second @ f/8, ISO 400, -0.67 EV, no filter, Ikilite underwater housing with dome port)

This image was shot at water level while snorkeling with sea lions.

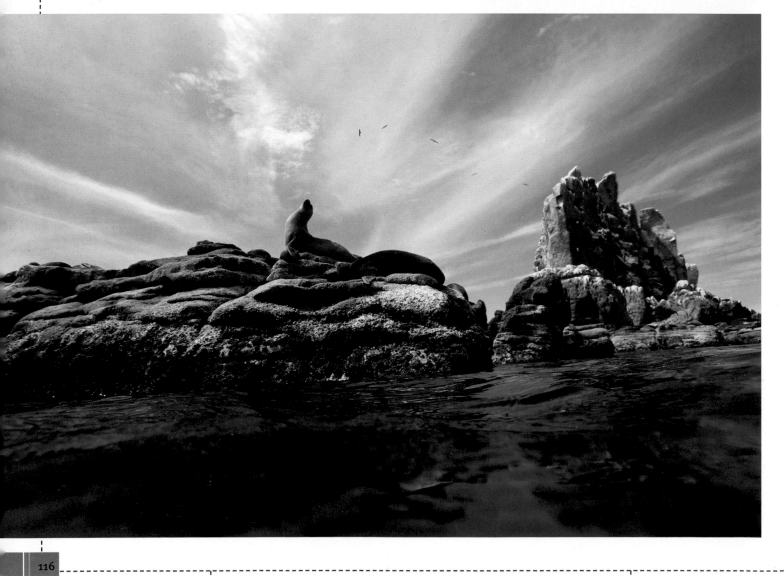

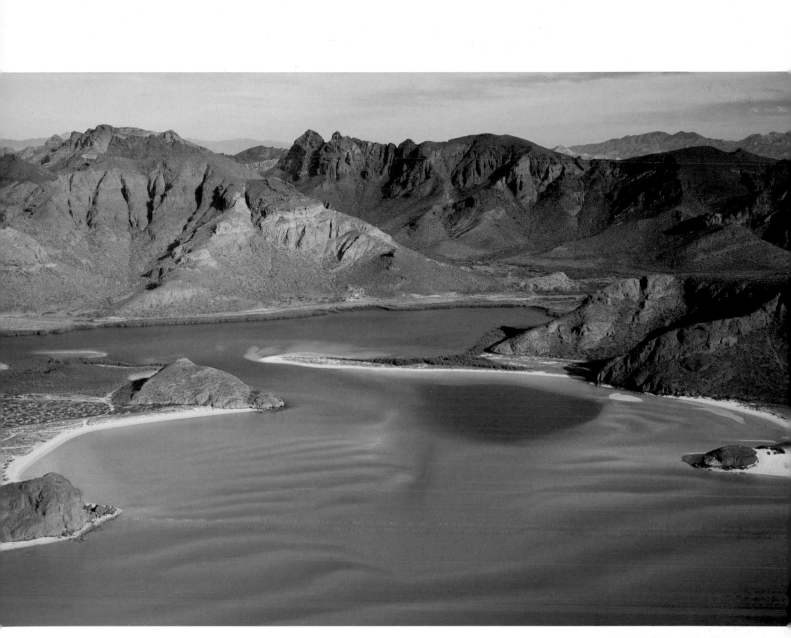

Bahia Balandra, Gulf of California. Baja California, Mexico

(Canon EOS 5D Mark II, Canon EF 16-35mm f/2.8L II USM, 1/1600 second @ f/8, ISO 400, -0.67 EV, polarizing filter)

This aerial view was shot from an ultra light plane.

Get High: Another way to vary your point of view is to find an elevated perch for an overhead perspective. Climbing a hill or a nearby mountain offers viewpoints not possible otherwise. This works well for landscape images of coastlines, rivers, and canyons, and also for groups of animals.

Taking this a step further, getting up in the air offers an even better overall perspective. Small planes equipped with a window that can open for a clean view are ideal, and high-wing planes are preferable for better visibility looking down. Depending on your sense of adventure, there are a number of other alternatives for gaining an aerial perspective like ultralights, parasails, and remote cameras on balloons or kite systems.

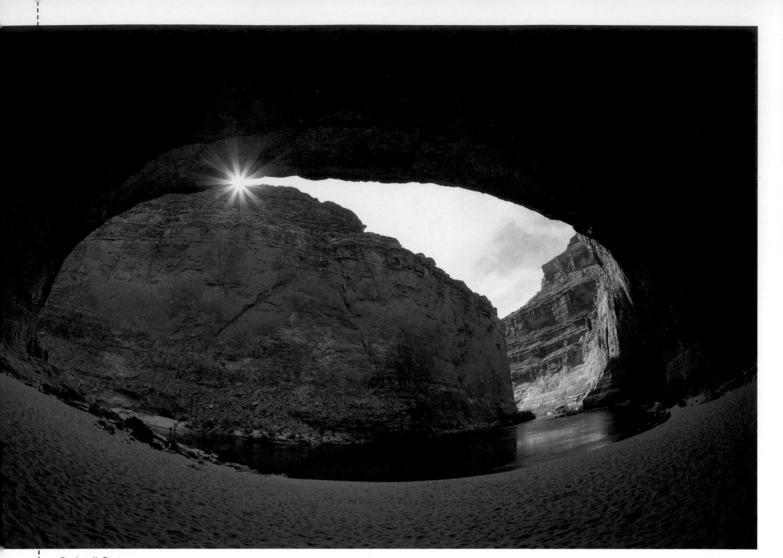

Redwall Cavern,
Colorado River, Marble
Canyon, Grand Canyon
National Park, Arizona

(Canon EOS 5D Mark II,
Canon EF 14mm f/2.8L
II USM, 1/250 second
@ f/8, ISO 100, 0.00 EV,
no filter)

Is this creative distortion
with a fisheye lens or
just a bad picture?

Use Different Lenses: You can
heighten the effect of an uncommon angle
of view by choosing a complementary lens.
When using wide-angle lenses, the optics will
cause the convergence of vertical lines when
the camera is tilted upwards. Converging ver-
tical lines create a feeling of height and can
be used creatively when photographing tall
subjects like trees and cacti.

Telephoto lenses narrow our field of
view, which focuses the attention of the
viewer only on a limited part of the scene.
Telephoto and longer zooms are perfect for
isolating patterns, and can also be used to
great affect to create drama, juxtaposing ani-
mals against a distant horizon, or stacking
mountains together along a distant skyline.

Medium telephoto lenses see the world
more like our eyes. Since images made with
a medium telephoto appear so familiar, you
have to work harder to create a dramatic
image. Framing and use of foreground
is key. Frame the mountain through tree
branches, or get close to a foreground ele-
ment and throw it out of focus.

An interesting point of view is the extreme
perspective of the fisheye lens. While it's
possible to hold the fisheye level to limit
the distortion, play a little. Tilting the cam-
era will curve the horizon, which can have
interesting effects when used creatively.

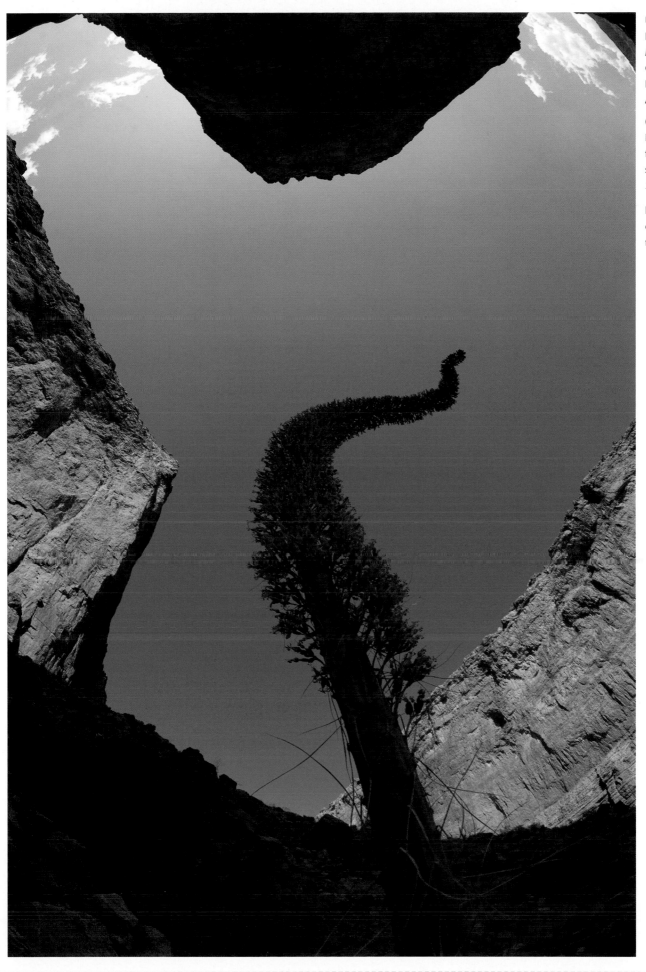

Utah Agave in Bloom, Buck Farm Canyon, Marble Canyon, Grand Canyon National Park, Arizona

(Canon EOS 5D Mark II, Canon EF 14mm f/2.8L II USM, 1/250 second @ f/22, ISO 200, -0.67 EV, no filter)

Here a fisheye lens does fun things with the towering canyon walls.

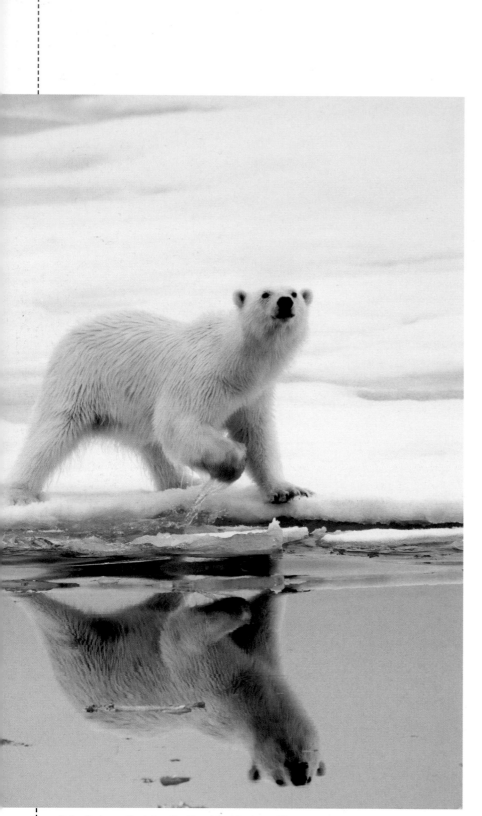

Polar Bear on Pack Ice, Svalbard Archipelago, Norway

(Canon EOS 5D, Canon EF 16-35mm f/2.8L II USM, 1/800 second @ f/8, ISO 200, -0.67 EV, no filter)

It takes optimal conditions to get a perfect mirror reflection of a polar bear.

BALANCED FRAMES

Our eyes are naturally attracted to patterns and elements in nature that appear balanced. This sense of balance is described in the art world as symmetry. Often, the most pleasing nature photographs have symmetry working in one form or another, giving the image a feeling of peace and harmony.

Symmetry: Symmetry in nature is all around us. Look no farther than plants and animals to see symmetrical body shapes, patterns, and colorations. Most animals, when viewed head-on, are bilaterally symmetrical, where one half is the mirror of the other half. A butterfly and a maple leaf are also perfect examples of bilateral symmetry. Some flowers are also bilaterally symmetrical, while others have a radial symmetry around a central axis. Many marine organisms also have radial symmetry, such as sea stars and jellyfish.

The most obvious form of symmetry in a landscape is a reflection. It takes a calm day with perfect conditions to create an image with mirror symmetry. There's also the geometrical symmetry of a triangle. Working in groups of threes allows for triangular symmetry to happen.

There's also broken symmetry, where something is out of line. This is sometimes referred to as the "odd man out," like when one penguin walks the wrong way, or one bird is looking the other way.

Broken symmetry makes a photo feel out of balance, which can be a good thing if it adds a sense of tension. Robert Bateman said he would paint blades of grass or branches across an animals face just to create tension. As photographers, we are always looking for that clean view, without distracting lines, so adding a sense of tension in our images is a good thing.

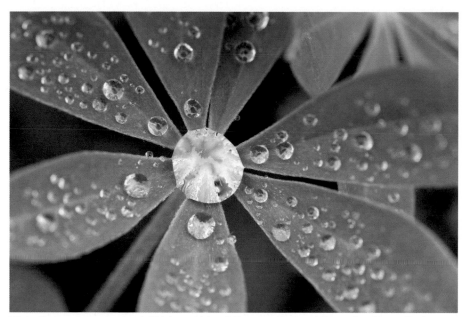

Water Drops on Lupine Leaf, Chichagof Island, Tongass National Forest, Southeast Alaska

(Canon EOS 5D, Canon EF 100mm f/2.8 Macro USM, 1/40 second @ f/8, ISO 200, 0.00 EV, no filter)

A lupine leaf is an excellent example of radial symmetry.

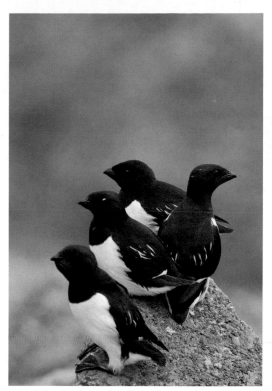

Little Auks, Hornsund, Svalbard Archipelago, Norway

(Canon EOS 1D Mark II, Canon EF 300mm f/2.8L IS USM w/1.4x, 1/500 second @ f/8, ISO 200, 0.00 EV, no filter)

Although an even number is not as dynamic, the one Little Auk looking the other way breaks the symmetry.

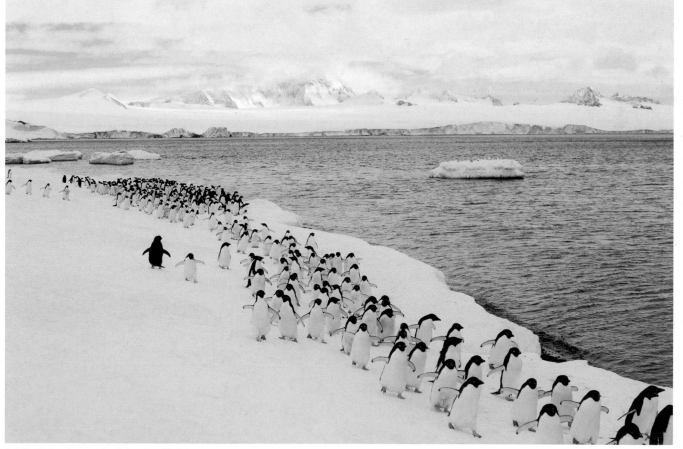

Adelie Penguins on Pack Ice, Paulet Island, Antarctica

(Canon EOS 1D Mark II, Canon EF 300mm f/2.8L IS USM, 1/500 second @ f/8, ISO 200, +1.0 EV, no filter)

The one penguin walking the other way is a break in the pattern, or "odd man out."

Ripples on Water, Gulf of California. Baja California, Mexico

(Canon EOS 5D, Canon 70-200mm f/2.8L IS USM, 1/1250 second @ f/5.6, ISO 200, -0.33 EV, no filter)

Ripples and reflections form repeating patterns on water.

Patterns: Patterns in nature can have repetitive arrangements of form or color that lead the eye. Repeating patterns occur among clouds and melting icebergs, or as ripples on water and sand. Groups of animals, flowers, or leaves can also exhibit repeating patterns. Once you start noticing patterns, you'll see them everywhere. Including them in your compositions will make your images seem more active and alive.

King Penguins, St. Andrews Bay, South Georgia

(Canon EOS 1D Mark II, Canon EF 70-200mm f/2.8L IS USM, 1/500 second @ f/5.6, ISO 100, -0.67 EV, no filter)

Repeating patterns in nesting king penguins.

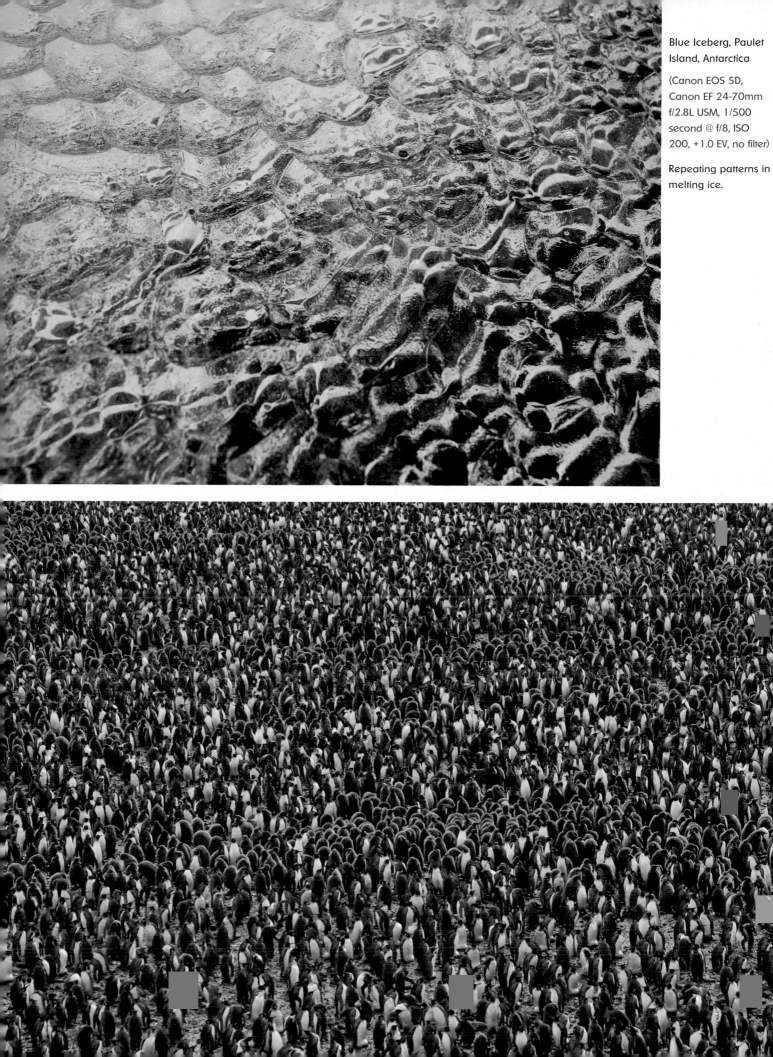

Blue Iceberg, Paulet Island, Antarctica

(Canon EOS 5D, Canon EF 24-70mm f/2.8L USM, 1/500 second @ f/8, ISO 200, +1.0 EV, no filter)

Repeating patterns in melting ice.

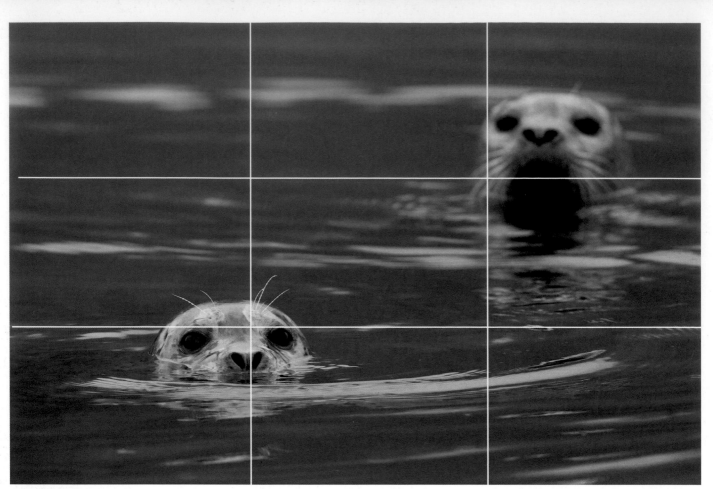

Harbor Seals, Basket
Bay, Tongass National
Forest, Alaska

(Canon EOS 1D
Mark II, Canon EF
70-200mm f/2.8L IS
USM, 1/250 second
@ f/2.8, ISO 400, 0.00
EV, no filter)

Rule of Thirds: You can't talk about composition without mentioning the "rule of thirds," which has been referred to by visual artists for centuries. Imagine your image area with a grid of two equally spaced vertical lines and two equally spaced horizontal lines. The four points where the grid lines intersect are described as power spots in the visual arts, and are thought to create the best balance within a frame, as well as be the most pleasing subject placement. For a more dynamic photo, place compositional elements along these lines or at intersections. Some cameras even have grids built into their focusing screens to help you visualize the rule of thirds.

Too often photographer's naturally shoot bull's eyes without thinking, simply because their focus point is located in the center. Get in the habit of locking focus and recomposing to put the subject or horizon off center. For example, for flying birds, choose a focus spot in the upper left or right of the frame. For jumping dolphins, I might choose focus points in the lower part of the frame.

When shooting landscapes, if I have an interesting foreground I'll place the horizon in the upper third of the frame so that the foreground has more presence in the image. If the sky is more interesting, I'll minimize the foreground and place the horizon in the lower third of the frame. Of course, place the setting sun or full moon at the points of intersection.

In your own work, remembering this rule is a way of training yourself not to always place the subject or the horizon directly in the center of your composition. This helps to create a more balanced image, keeping horizons out of the center and also away for the edges of the frame. Sure, there are times when it works to break the rules and center the subject, like a close-up of an animal's eye, or a perfect Christmas tree in a snowy meadow. But in the never-ending quest for making powerful images, master this rule before you choose to break it.

Sense of Scale

A sense scale adds perspective, dimension, and depth to photographs. In nature photography, scale is achieved by including objects of known size, like people, boats, trees, and animals. The impact of scale depends on a number of factors, including lens choice and the distance from the subject.

Long lenses compress the scene, exaggerating the scale of the background; this is an effective technique for making mountains look taller and animals look bigger than they really are. Conversely, wide-angle lenses emphasize foreground elements, making objects close to the camera look bigger than they really are.

In this way, you can use scale elements to your advantage to create feelings of awe and grandeur. Instead of always shooting wildlife with a long lens for tight compositions, for example, shoot with a wide-angle lens and include the animal in the overall landscape. The animal will appear smaller in the frame, but the landscape will be huge.

Another way to use scale to affect the viewer's perception is to eliminate all clues about the size of the subject. Removing any sense of scale from your composition creates intrigue. This technique is common in fine art photography. Photographs without scale challenge the viewer by creating an abstract image from everyday objects.

Editors love scale elements because they make good establishing shots or opening spreads for stories and portfolios. As one editor told me, "It's okay to submit cliché, as long as it's the best I've ever seen."

Patterns in Sand, Floreana Island, Galapagos Archipelago, Ecuador

(Canon EOS 5D, Canon EF 16-35mm f/2.8L II USM, 1/320 second @ f/8, ISO 200, +0.33 EV, no filter)

This image has no sense of scale, making the viewer look twice. Is it an aerial? Are the dark rocks boulders, or are they small pebbles?

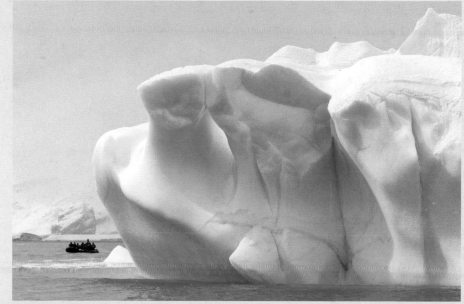

Zodiac and Iceberg, Elephant Island, Antarctica

(Canon EOS 10D, Canon EF 24-70mm f/2.8L USM, 1/800 second @ f/8, ISO 100, -0.33 EV, no filter)

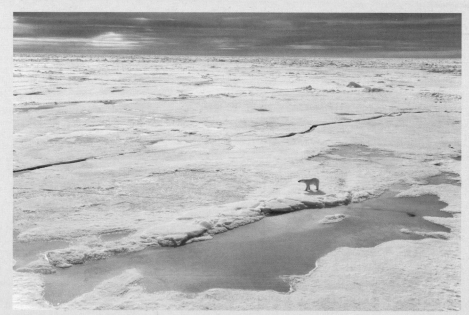

Polar Bear crossing Pack Ice, Hinlopen Strait, Svalbard Archipelago, Norway

(Canon EOS 5D, Canon EF 24-105mm f/4L IS USM, 1/1600 second @ f/8, ISO 200, +0.33 EV, no filter)

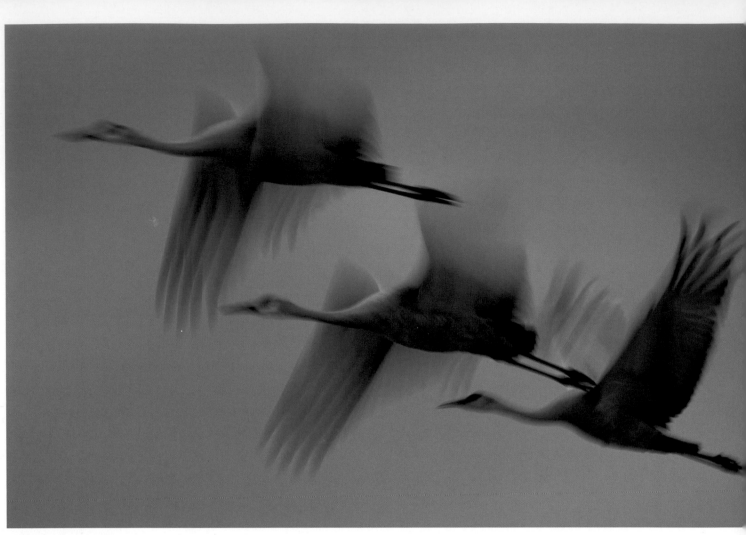

Sandhill Cranes in Flight, Rio Grand, Bosque del Apache National Wildlife Refuge, New Mexico

(Canon EOS 1D Mark III, Canon EF 100-400mm f/4.5-5.6L IS USM, 1/20 second @ f/8, ISO 100, -0.67 EV, no filter)

MOTION BLUR

Motion blur is an effective way to convey a quiet mood, in the case of flowing water, or a sense of speed and action, think of running animals. I like to call it "creative or artistic blur." But why shoot blurry pictures on purpose?

Too often we are stuck in our ways and fixated on making sharp images. After all, we have this expensive glass, so we're always thinking sharpness first. Landscape photographers strive for acceptable sharpness from foreground to background, stopping down for a deep DOF, and wildlife photographers tend to shoot with fast shutter speeds to freeze the action.

Once you've nailed the sharp pictures in any given situation, switch modes and think about other possible compositions. Let artistic motion blur come to mind.

Slow Shutter Speed: The most common technique for creating motion blur is to set a slow shutter speed. Lower the ISO to 100, set the shooting mode to Shutter Priority, and select a speed that will appropriately blur the moving subject. If there is too much light in the scene, use a neutral density filter or a polarizing filter to cut the light coming through the lens. When working on a tripod, experiment with shutter speeds of 1/8 second or less; a landscape with flowing water is an ideal example—you can capture sharpness in the landscape and movement in the water.

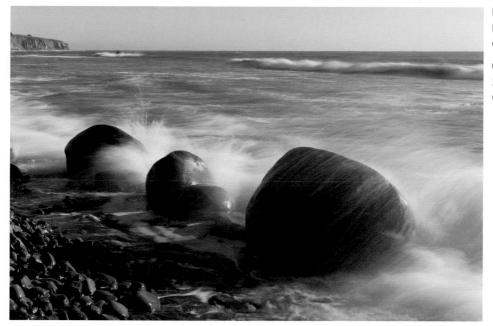

Boulders in the Surf, Bowling Ball
Beach State Park, Mendocino
Coast, California

(Canon EOS 5D, Canon EF
24-70mm f/2.8L USM, 1/2 second
@ f/11, ISO 100, +1.0 EV, vari-ND)

Guanacos on the Run, Torres del Paine
National Park, Chile

(Canon EOS 10D, Canon EF 70-200mm
f/2.8L IS USM w/1.4x, 1/8 second @
f/5.6, ISO 100, -1.0 EV, no filter)

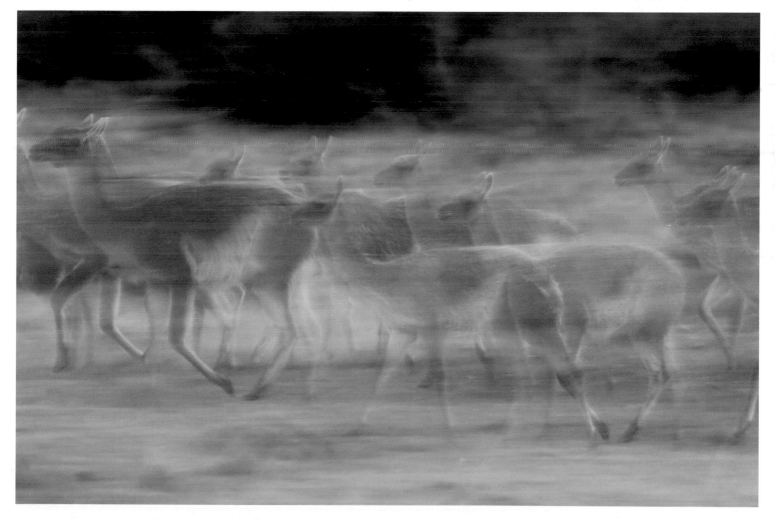

Move the Camera: Another way to capture motion is to actually "paint" with the camera by moving it while the shutter is open. This can create some interesting impressionistic effects, but you have to shoot lots of frames to zero in a motion effect that is most pleasing to the eye.

Pan with the Subject: Panning with a moving subject creates a real sense of motion; a blurred background makes the sharp parts of the subject pop. With practice, it's possible to handhold the camera while panning with moving animals, shooting at speeds of 1/15 or 1/30 seconds. The idea with animals is to capture one part of the animal in reasonable focus, preferably the head or the eye. Flying birds look best between 1/60 and 1/100 second.

Aspen Forest, Sange de Cristo Mountains, Santa Fe National Forest, New Mexico

(Canon EOS 1D Mark III, Canon EF 70-200mm f/2.8L IS USM, 1/8 second @ f/11, ISO 200, -0.33 EV, no filter)

I moved the camera up and down, essentially painting with the camera, to create this impressionistic look.

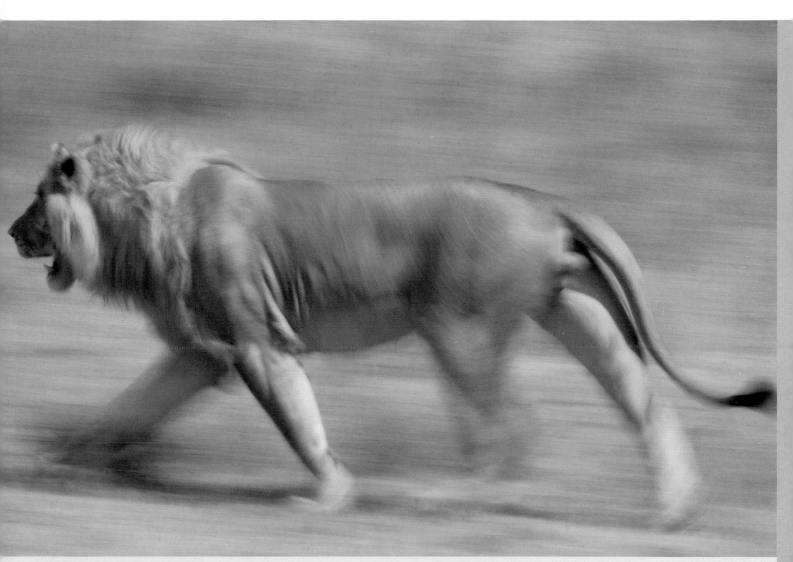

African Lion on the Move, Tanzania

(Canon EOS 1D Mark III, Canon EF 70-200mm f/2.8L IS USM, 1/15 second @ f/16, ISO 100, vari-ND)

Panning with Confidence

The best situation for mastering the art of panning with moving subjects is when animals are doing repetitive behaviors, like birds taking off in sequence or dolphins following along with the ship. If you can predict the path of the animal you have a much greater chance at nailing the shot.

It's also important to choose the right animal to pan with. Animals that are moving parallel to you are easiest to work with, since they are staying about the same distance away, and are therefore in the same focal plane. Animals coming toward you or moving away are not good subjects for this kind of motion blur, since the plane of focus is constantly changing (in this instance, I will turn my autofocus off and use manual focus instead). Switch your lens image stabilization to the setting that allows for lateral movement. In its normal setting, your lens will fight against you, trying to stabilize against the panning movement.

Once you've locked in on an animal or group of animals, squeeze off a rapid burst of shots, while attempting to move the camera at the same speed as the animals. Using continuous shutter release or burst mode is a must. Shooting frames in sequence will give you a better chance of getting good results, since it may be only one frame where the camera is moving at the same speed as the animal.

Proper technique can help, so follow through with your camera like it's locked on with a laser. Purposely exaggerate the motion, like swinging a baseball bat in slow motion. As the animals speed by, repeat the bursts over and over until you think you might have a good frame. Don't look at your image sequence while the birds are still flying by and the dolphins still jumping; keep shooting until the action is over.

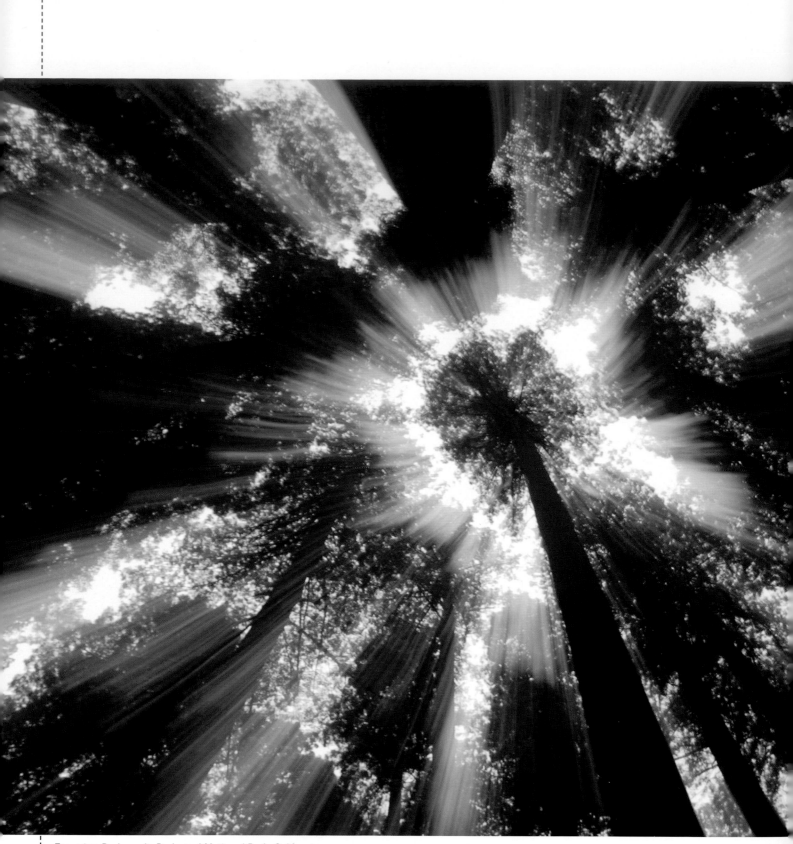

Towering Redwoods, Redwood National Park, California

(Canon EOS 30D, Canon EF 16-35mm f/2.8L II USM, 1/2 second @ f/8, ISO 100, +1.0 EV, no filter)

Zooming the lens out while the shutter is open creates the streaking effect in this image.

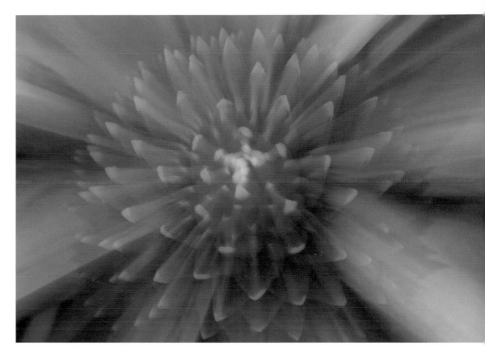

Wild Ginger, Monteverde Cloud Forest Preserve, Costa Rica

(Canon EOS 1D, Canon EF 24-70mm f/2.8L USM, 1/3 second @ f/22, ISO 100, -0.67 EV, no filter)

Zoom blur works well for objects with radial symmetry.

Zoom the Lens: The "zoom effect" is where you zoom the lens out (or in) while the shutter is open. This works well with radial objects like flowers and palm trees, and with converging lines, like looking up in the forest with a wide angle.

I find it works best to zoom in first, lock focus, and then zoom out quickly while the shutter is open. Experiment with shutter speeds between 1/4 and 1/15 second. It takes practice to hold the camera steady while zooming out; for best results, use a tripod.

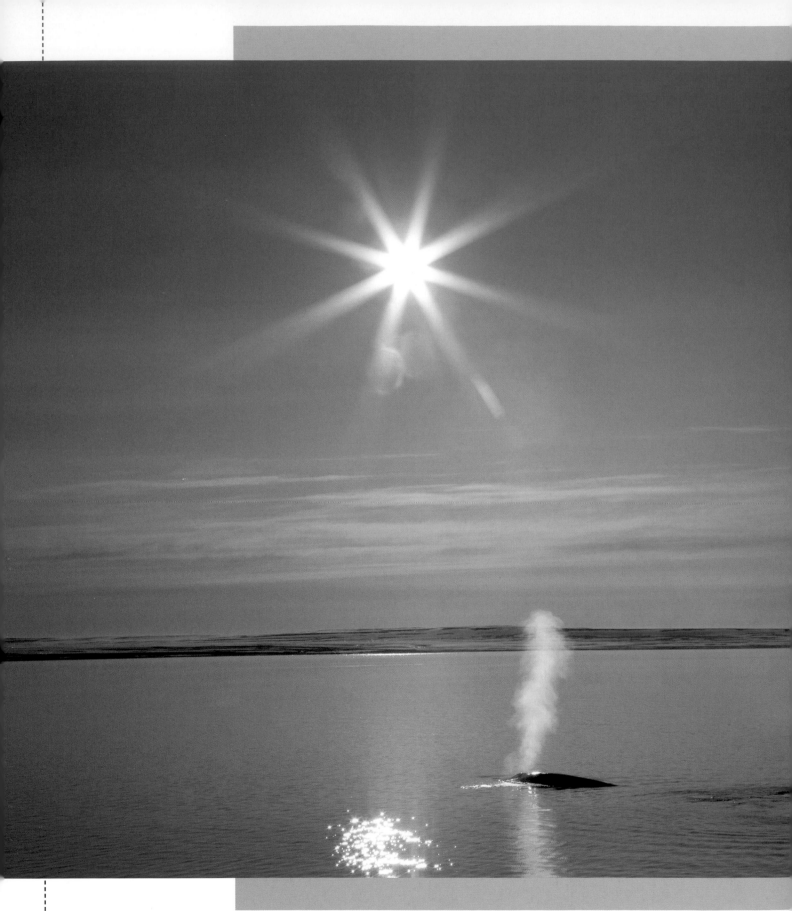

Blow of the Blue Whale, Woodfjord, Northwest Spitsbergen National Park, Norway

(Canon EOS 5D Mark II, Canon EF 24-105mm f/4L IS USM, 1/800 second @ f/22, ISO 200, +0.67 EV, no filter)

Backlighting emphasizes the moment of a whale blow, and a small aperture (f/22) creates the sunburst effect. Envision the image you want to create, and then wait for all the elements to come together.

Chapter 6: Power of the Moment

"You can catch the moment, and once it's caught, you can see it forever." — Life Magazine photographer, John Loengard

A blend of nice light and a strong composition are keys to creating good nature images with impact and meaning. But great images are born from the photographer's vision, when layered with a natural moment.

Like all photographers, nature photographers strive to capture the essence of the moment. The importance of the "wild moment"—as opposed to set-up shots in captive animal situations—challenges us to use precious time in the best way possible, thinking creatively with every step. The power of a moment communicates the essence of the experience, and can transport your viewer to a sense of "being there."

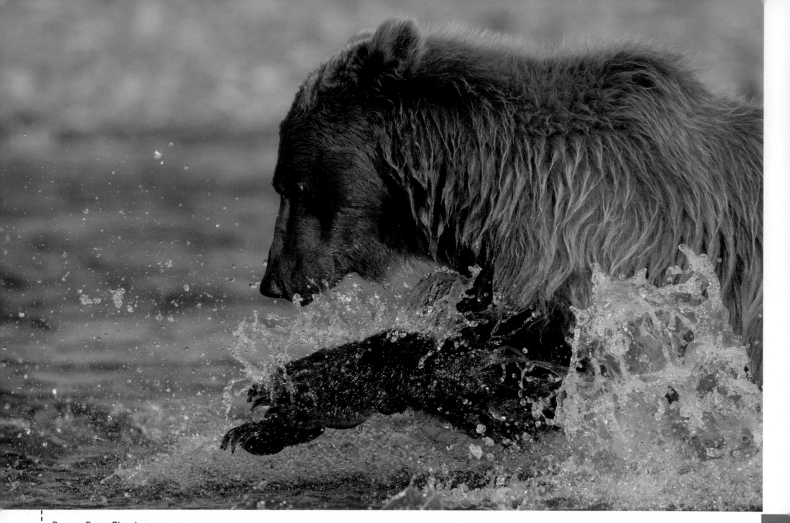

Brown Bear Chasing
Salmon, Katmai National
Park and Preserve, Alaska

(Canon EOS 1D Mark III,
Canon EF 500mm f/4L
IS USM w/1.4x, 1/2500
second @ f/5.6, ISO 400,
-0.33 EV, no filter)

LIGHT,
COMPOSITION,
AND MOMENT

Light, composition, and moment—this is the mantra photographers live by. Anticipate the light, create a strong composition, and then wait for the moment.

What makes a good photo? Why do certain pictures warrant attention, while others do not? It's hard to discuss photography without injecting a great deal of subjectivity and emotion into the discussion. For some, a good photo has to be tack sharp from corner to corner. Others look for layers of interest, from foreground to background. Still others like the artistic look of selective focus with a shallow depth of field (DOF).

In our National Geographic Traveler seminars, my partner Bob Krist distills what makes a good photograph into the three basic elements: light, composition, and moment. Bob is a wise man, so I've repeated his mantra to my workshop students over and over through the years. I can still hear their whispers, "Look at the light, find a composition, and wait for the moment!"

Thinking in terms of these three universal elements, consider an image with only one out of three of the basic elements. Typically, such an image is a flat, uninteresting picture not worthy of a second look. A strong composition in poor light cries out that you

might not understand how your camera sees light. A distracting foreground kills even the most magical sunset, so recompose and find a stronger foreground element. The only exception to having only one of the three elements is capturing an amazing moment never to be repeated again. If a UFO is landing at the bottom of the Grand Canyon, shoot it no matter what the light is doing!

Once you learn to recognize the three basic elements in isolation, the next step is to blend two out of three into a single image. Strive to be in the moment and learn to recognize the potential in any scene or situation. Finding a strong composition in unusual or dramatic light is every nature photographer's dream.

Finally, learn to combine all three—(1) great light with (2) a killer composition taken at the exact (3) natural moment—and you may have a masterpiece. Although it sounds like a simple formula, the all-important "decisive" or natural moment in photography is as difficult to capture as it is to define. The quest for capturing the moment is a search to impart a feeling, quality, or mood to your images. Sometimes it's a matter of waiting for the bird to fly, the polar bear to jump, or the whale to breach. Other times, the natural moment is not an event or behavior, but rather a fleeting shaft of light sticking to a canyon wall for only a minute, or an unexpected storm breaking the natural calm of a landscape.

Brown Bear Catching a Salmon, Katmai National Park and Preserve, Alaska

(Canon EOS 1D Mark II, Canon EF 500mm f/4L IS USM w/1.4x, 1/1600 second @ f/5.6, ISO 400, -0.33 EV, no filter)

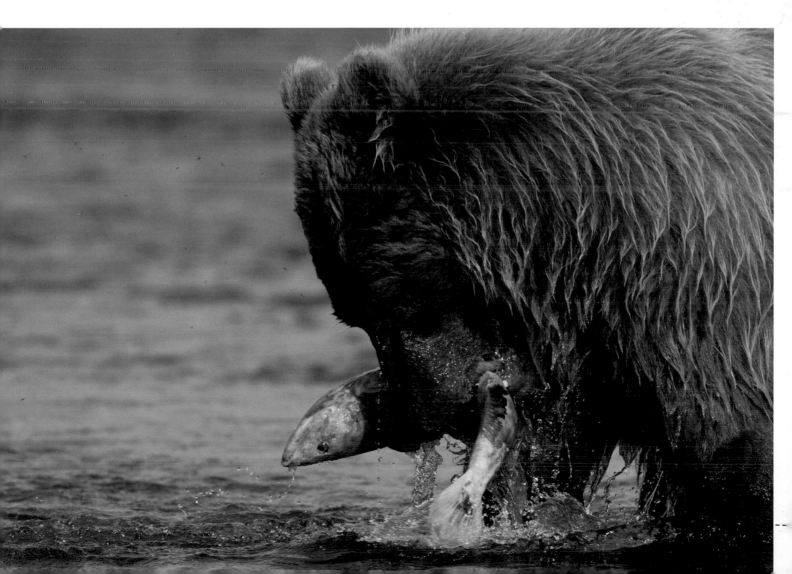

PREP IS IMPERATIVE

Documentary photographer Sebastiao Salgado emphasized the importance of moment during a presentation about his work on refugees saying that, "if these 100 images were each shot at 1/100 second, then they represent only 1 second of human suffering." In the blink of an eye, he documented the horrific story of the refugees' plight. Salgado's photographs illustrated just how important moment really is.

To be successful in your search for meaningful images, it's not as much about technique as it is about being there. "f/8 and be there," as the old newspaper photographers used to say. Bob Krist points out that beginning photographers are too hung up on the "f/8" part, rather than the "being there" side of the equation. Push yourself to get beyond the technical crossing over into a creative approach to making images.

KNOW YOUR GEAR

When I'm working with my camera, I get into a zone where all other thoughts drop away. Once in the zone it's not longer about the camera, it's about being there. To truly be in the moment requires you to be thoroughly familiar with your equipment—so familiar that making a good exposure is second nature. Don't miss the shot because you're fumbling with your camera!

First, prepare your equipment. Use a tripod if you are shooting slow shutter speeds or using long lenses. Charge your batteries and have plenty of backup batteries ready. Clean and check all of your gear so you aren't surprised in the field. Format and clear your memory cards. Being prepared is vital; you don't want to miss a tropical bird displaying for a mate because your battery is dead.

Next, double-check all the camera settings before the action starts. Determine your shooting mode. If you are concerned about low light, set the camera to Aperture Priority and put it on the largest aperture. If you have plenty of light and want to freeze the action of a fast-moving subject, set the shooting mode to Shutter Priority and decide on a shutter speed. Shooting JPEG files means you must set the appropriate controls on your camera, such as white balance. If the light is changing frequently—such as rolling clouds on a sunny day—considering setting the white balance to automatic.

Capturing moments with your camera requires different strategies depending on what you are shooting. Sometimes it's better to work hand-held so you can move more freely and react more quickly. Don't depend too much on your zoom, and keep moving as the light or situation dictates. When you find the key spot, slow down, be patient, and work the situation.

Pre-visualize the images you want to create. Experienced photographers are often accused of being "lucky," or that the reason they get the shots is because they have a good camera. Following that logic, good painters must have really good paintbrushes. We all know the truth: you make your own luck by being in the right place at the right time. To do that you have pre-visualize a moment or a situation you seek to photograph, execute the logistics to get there at the right time, then seize the moment by being patient and making the best image possible.

KNOW THE SUBJECT

Whether it's observing animals in the wild, anticipating the blooming cycles of springtime flowers, or guessing the timing of fall color in the high country, knowing you subject will help you better predict the special moments in nature that reveal the spirit or essence of an animal or place.

The more you know about your subject, the better you will be at placing yourself in the situation to make the best images at the right time. It was Louis Pasteur that said, "In the field of observation, chance favors only the prepared mind." It takes time to get know a place well, and it takes even more time to understand all the habits and behaviors of the wildlife that live there. Allow yourself the luxury of time to explore. The more you observe the more you will be open to chance.

Preparation Checklist

- Charge all batteries
- Clean gear and check sensor
- Format memory cards
- Check camera settings:

 200 ISO

 aperture priority at f/8

 exposure compensation at 0 EV

 Adobe RGB color space

 RAW format
- Organize gear to be accessible
- Clean tripod and check quick-release plates
- Review custom functions (mirror lock-up)
- Study maps and guidebooks
- Have a headlamp and GPS for finding locations

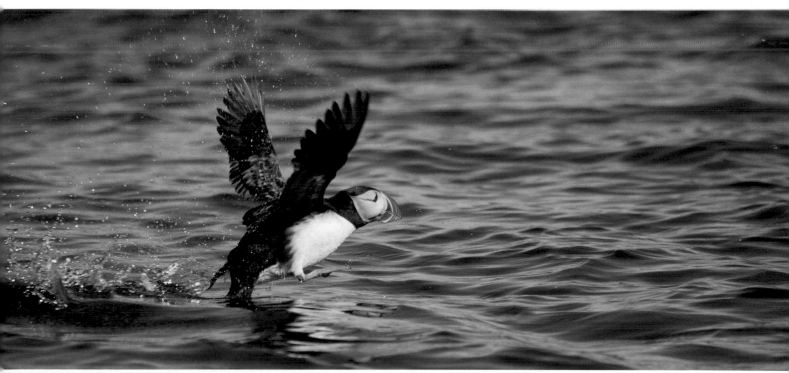

Atlantic Puffin Taking Off, Iceland

(Canon EOS 1D Mark III, Canon EF 100-400mm f/4.5-5.6L IS USM, 1/1600 second @ f/5.6, ISO 200, -0.33 EV, no filter)

Being in the moment means being ready and anticipating the action.

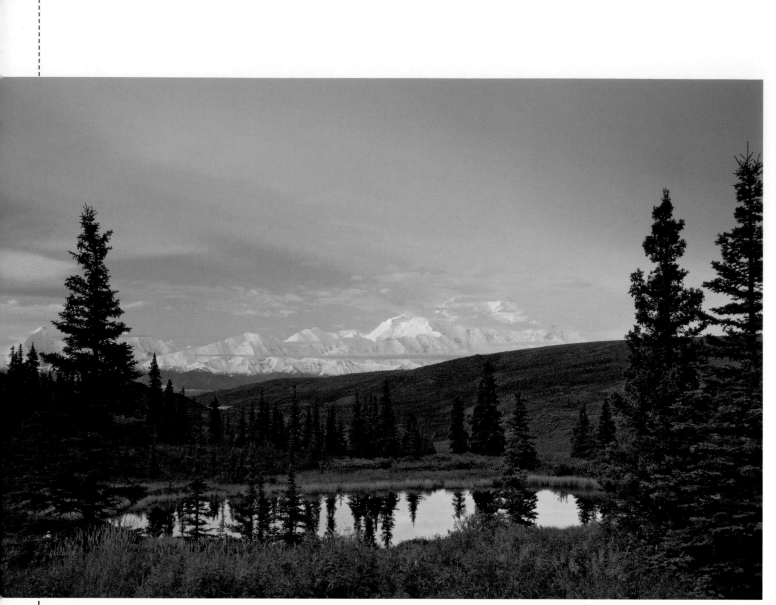

Dawn at Camp Denali, Denali National Park and Preserve, Alaska

(Canon EOS 5D Mark II, Canon EF 24-105mm f/4L IS USM, 1/50 second @ f/8, ISO 100, -0.67 EV, no filter)

Light can add a sense of moment.

Natural moments come in many forms. They can be as forceful as a brown bear pouncing on a wild salmon, or somewhat comical, like a puffin running on top of the water before take-off. Moments can also be subtle: the way a leopard pauses motionless when hunting. Even light itself can be a moment, like the soft color of sunrise creeping over the Denali tundra landscape.

Watch for Cues: Some animals tip you off as to their next behavior, so with experience you will learn some of the signs.

For example, it's well known that birds commonly "let go" before taking off. Compose the shot leaving room for the bird to fly into the frame. Before jumping, a polar bear will test the edge of the ice by pushing up and down to see if it breaks. This signals you to get ready. Compose the frame to catch the bear in mid-air when making its jump, and shoot wide if there's a chance for a reflection. Be ready; don't look away or get distracted. Miss the jump the first time and it may never happen again.

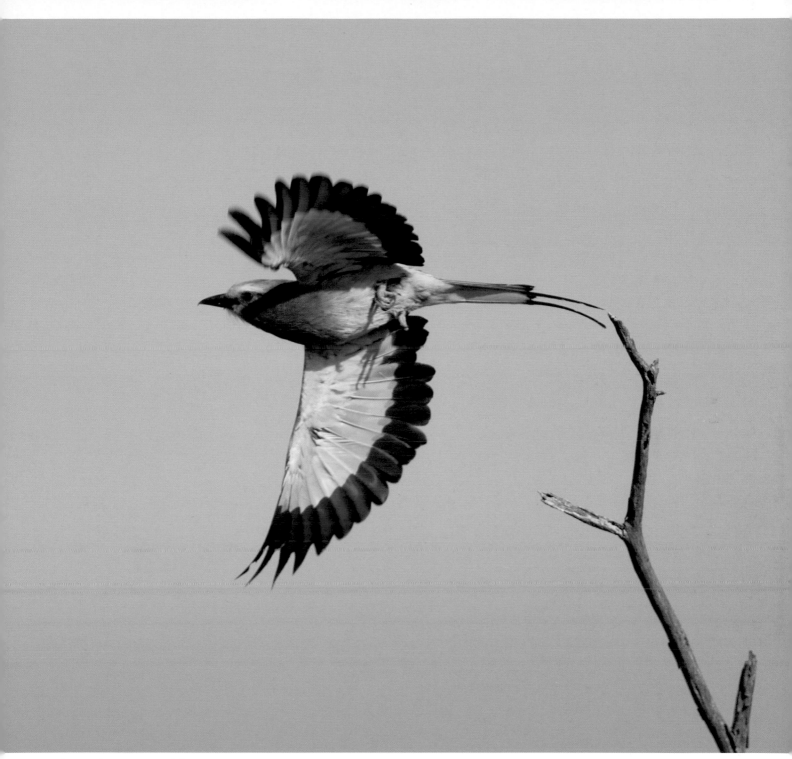

Lilac-Breasted Roller Taking Off, Lower Zambezi National Park, Zambia

(Canon EOS 1D Mark III, Canon EF 500mm f/4L IS USM w/1.4x, 1/1600 second @ f/5.6, ISO 320, +1.0 EV, no filter)

Burst mode helps capture the moment.

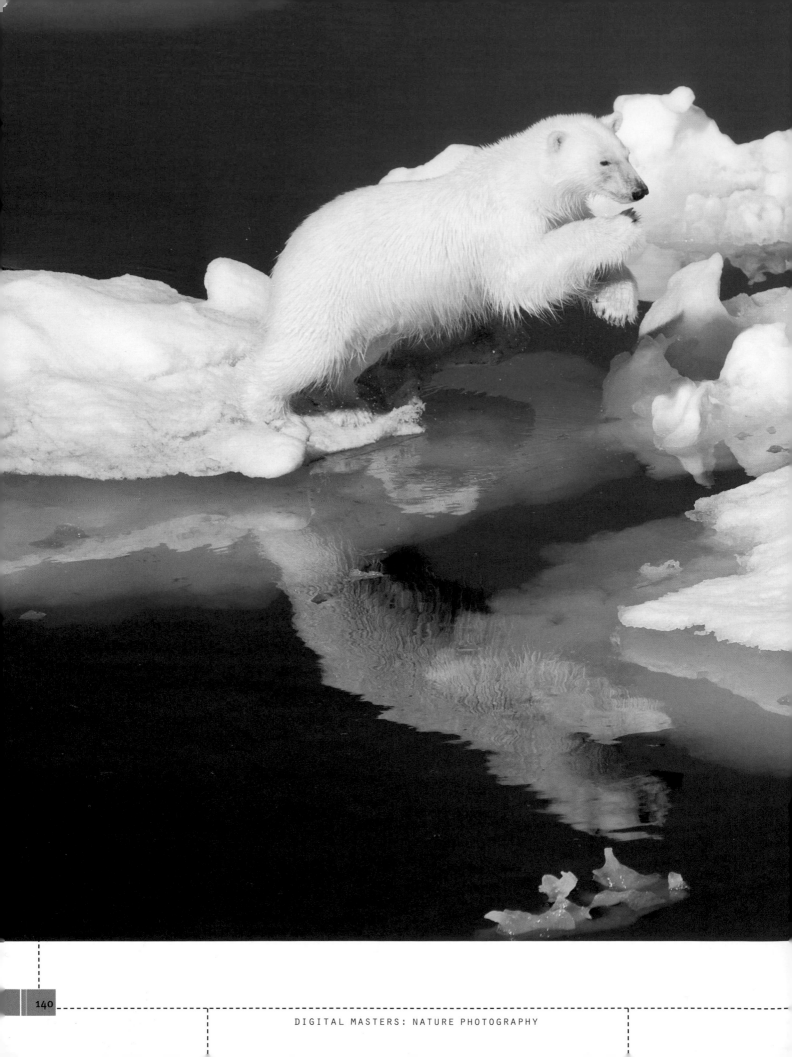

Leaping Polar Bear, Svlbard
Archipelago, Norway

(Canon EOS 1D, Canon EF
100-400mm f/4.5-5.6L IS USM,
1/1600 second @ f/5.6, ISO
200, 0.00 EV, no filter)

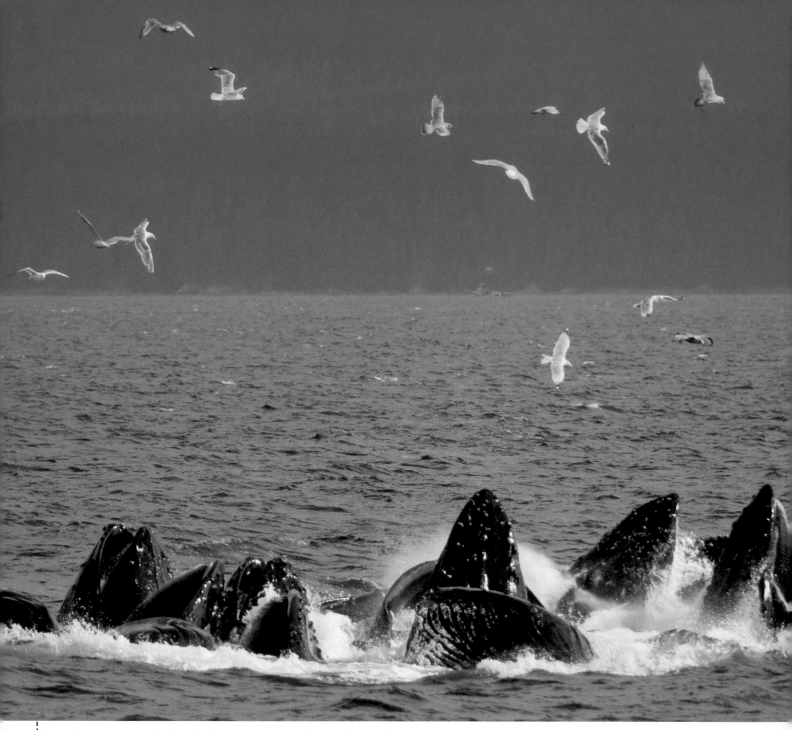

Feeding Humpback Whales, Chatham Strait, Tongass National Forest, Alaska

(Canon EOS 10D, Canon EF 100-400mm f/4.5-5.6L IS USM, 1/2500 second @ f/5.6, ISO 400, 0.00 EV, no filter)

Gathering gulls often indicate where action is going to happen.

Repetitive Behavior: The best of all worlds is when wildlife repeats a behavior giving you multiple chances to succeed, like humpback whales in southeast Alaska blowing a spiral of bubbles while feeding. This co-operative behavior called, "bubble-net feeding," often happens over and over, so it's hard to miss shot. Sometimes gulls and kittiwakes will follow the whales, feeding on scraps and giving you another way of anticipating the action.

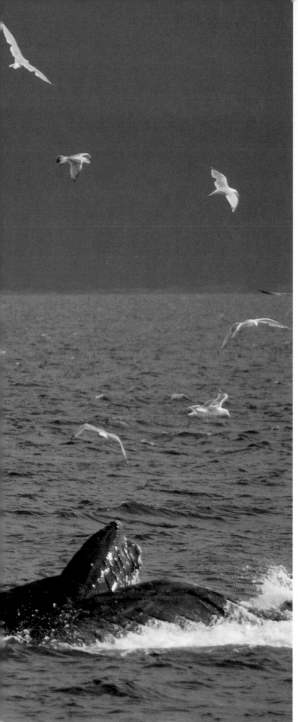

"A great photograph is a full expression of what one feels about what is being photographed in the deepest sense, and is, thereby, a true expression of what one feels about life in its entirety." – Ansel Adams

Scout Locations: It's important to explore a landscape thoroughly and search for interesting foregrounds and tight compositions that are microcosms of the larger scene. I'll often scout in the middle of the day when the sun is high, searching for compositions to return to later in the day when the light is better.

Work the Subject: Whatever the subject, work it thoughtfully. Shoot it in as many different ways as time and energy allows. If the afternoon is blessed with clouds, look for flowers and other macros subjects. Find color and fill the frame.

Feeding Humpback Whales, Chatham Strait, Tongass National Forest, Alaska

(Canon EOS 10D, Canon EF 100-400mm f/4.5-5.6L IS USM, 1/3200 second @ f/5.6, ISO 400, 0.00 EV, no filter)

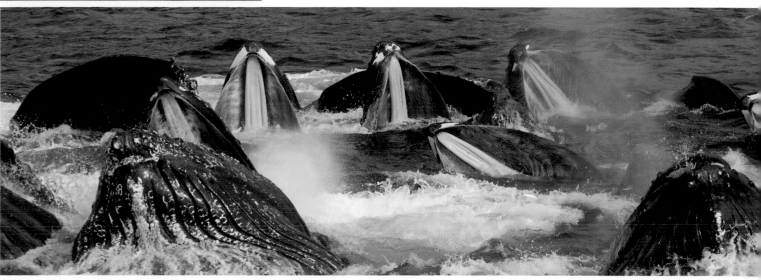

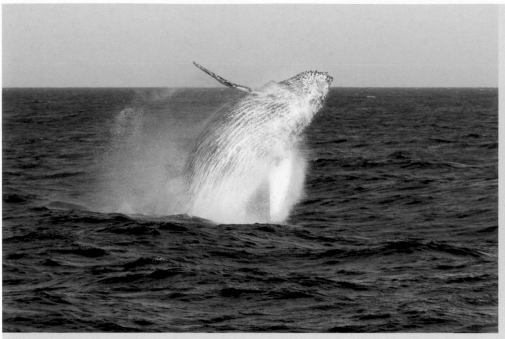

Live in the Moment

Being in the moment forces you to find a compelling reason to click the shutter at that exact instant in time, and not a few seconds later. For photographers, the moment should be about what lies within the frame that brings the image to life.

In his classic 1970's book, "Be Here Now," Ram Dass's anthem for living in the moment can be applied to nature photography. Since it's the moment that defines the image, a unique slice of time that you experience and record with your camera, then take time to learn how to live in the moment. Living in the moment is a way of life. Be present in the moment and you will become a better photographer.

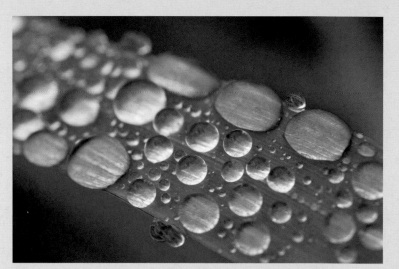

Dew Drops on Blade of Grass, Chichagof Island, Tongass National Forest, Alaska

(Canon EOS 5D Mark II, Canon EF 100mm f/2.8 Macro USM, 1/200 second @ f/8, ISO 800, -0.67 EV, no filter)

It seems that everything in nature has a moment all its own. There's something special about every bird, bear, dolphin, and whale. It can be in the way a bird flies, a bear walks, a dolphin swims, or a whale blows. It can be the light on the landscape, a bend in the river, or the cloud formations of an afternoon thunderstorm.

Each and every day of your life is different, moments never to be repeated again. If you can learn to recognize moments in whatever form they may take, then you have a bright future in photography.

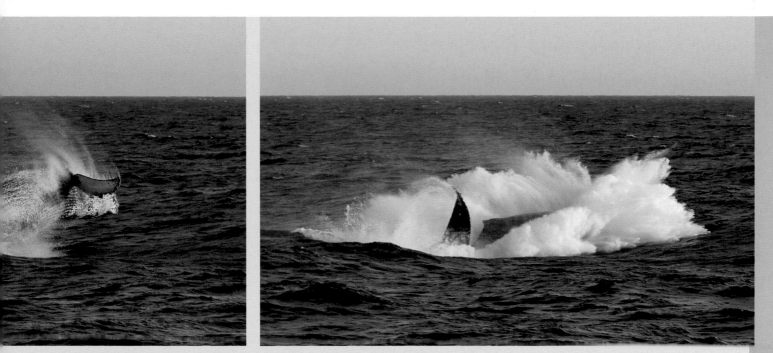

Breaching Humpback, Sea of Cortez, Baja California. Mexico

(Canon EOS 1D Mark III, Canon EF 70-200mm f/2.8L IS USM w/1.4, 1/2500 second @ f/5.6, ISO 400, -0.33 EV, no filter)

Burst mode is the best way to capture the complete sequence of a breaching humpback whale.

Rain Drops on the Pacific Ocean, Icy Strait, Alaska

(Canon EOS 1D, Canon EF 300mm f/2.8L IS USM, 1/1250 second @ f/8, ISO 100, -0.67 EV, no filter)

ANTICIPATE

The key is to recognize the potential of a situation, set up in a position for the best potential light and composition, and then anticipate the moment. This often entails framing a composition long before the animal appears or before the good light starts to hit a scene. Shoot a few test frames to refine your frame, and then wait for the moment to happen.

During the wait, think of the dream scenario. If you were to draw a storyboard of the scene, what would you want to happen? Determine the best overall position to capture the moment, and place yourself strategically. Of course, when the action starts you can always change your shooting strategy to adjust to the conditions and the opportunities that are presented.

Next, think of the technical considerations. Often it pays dividends to be ready with two camera bodies, one with the long lens mounted on a tripod, and the other with medium-zoom on a shoulder strap. If you are going for sharp images with a fast shutter speed, increase your ISO and open up your aperture a stop or two. If you anticipate showing motion in your image, lower your ISO and stop down the aperture.

Anticipating the light will help you determine your shooting mode. If the scene is consistent with no confusing backgrounds, it is usually okay to stick with aperture priority. But for shooting in more difficult conditions with variable backgrounds, consider switching to manual to avoid wild swings in light meter readings. For capturing motion blur, set the shooting mode to shutter priority and shoot at slow shutter speeds.

Storm Chasing

Anyone who has traveled with me knows that I detest clear blue skies. I get enough good weather when I'm home in New Mexico. Today's yet another perfect day, but you should have seen the clouds last week during the Balloon Fiesta. There's something about hot air balloons that bring clouds and weather. Not good for flying, but great for photographing landscapes.

When out in wild places, I prefer clouds and unsettled weather. Not that I'm hoping for a storm, as it's hard to shoot in wind and rain, and sometimes downright dangerous. The reason I like unsettled weather is that's when some of the most dramatic light happens in nature. There's usually interesting light along the edges of weather systems that can go crazy when the storm is clearing. Along coastlines, I'm hoping for storm waves and pounding surf, but you have to be careful not to get washed off the rocks by a rogue wave, or flip your boat. I certainly don't like big waves when trying to land Zodiacs on remote beaches.

I've had the good fortune to travel many times to the Southern Ocean. Crossing the legendary Drake's Passage—known to be the stormiest sea on the planet—is something not to be taken lightly. On one memorable crossing, the National Geographic Endeavour was punching some pretty good waves. I photographed the green water as the waves broke over the bow until I was green, too. When the storm broke near Elephant Island, beautiful light streamed through the clouds, spotlighting one iceberg and then the next. The calm after the storm was also an amazing time to shoot.

Storm Light on Iceberg, Southern Ocean, South Georgia

(Canon EOS 10D, Canon EF 70-200mm f/2.8L IS USM, 1/1600 second @ f/8, ISO 100, -1.0 EV, no filter)

During a recent trip to the Denali National Park and Preserve, I witnessed the mountain finally lifting its veil of clouds. Over the course of the morning it was interesting to photograph the process and observe how the light changed on the mountain as it came into view. The tundra seemed to glow as the clouds finally parted. Persistence had paid off.

Closer to home, I try to get out and shoot when storms are in the area. In the summer this means the monsoon-like thunderstorms with dramatic skies and potential for rainbows. In the fall, I hope for the first snow to come to the mountains while the aspens still have their glowing yellow leaves. In winter, I wait for the big storms, and then shoot when fresh snow clings to every branch and blankets the landscape.

As you can imagine, chasing storms is an adventure that sometimes can be too exciting. I've been chased off mountaintops by lightning, stuck in the mud after a flash flood, and lost in the dark. But to get the amazing light you have to be there in the stormy weather and be in a good location as the storm clears.

Clouds Lifting, Denali National Park and Preserve

(Canon EOS 5D Mark II, Canon EF 70-200mm f/2.8L IS USM, 1/100 second @ f/8, ISO 400, -2.0 EV, 2-stop grad-ND)

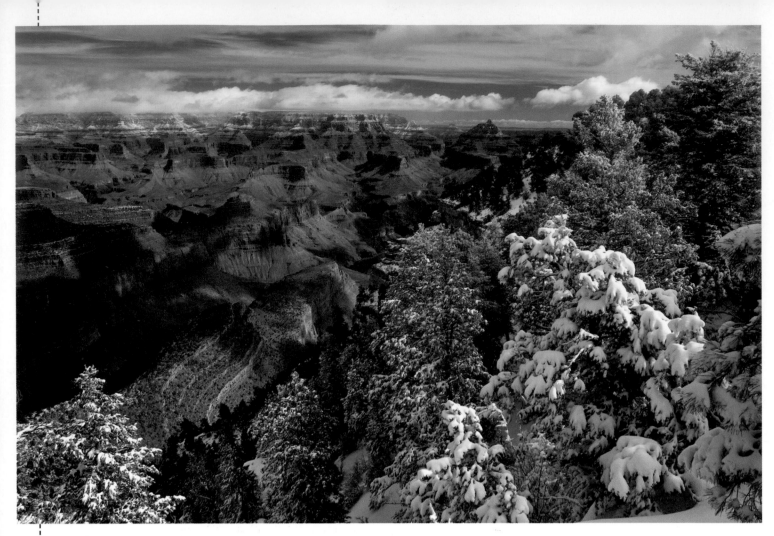

Fresh Snow Along
the South Rim, Grand
Canyon National
Park, Arizona

(Canon EOS 10D,
Canon EF 24-70mm
f/2.8L USM, 1/4 second
@ f/22, ISO 100, 0.00
EV, polarizing filter)

PRACTICE PATIENCE

Having the guts to stay to the bitter end takes your ability to capture a moment to another level. Today's digital cameras can literally shoot in the dark, so it's important to keep shooting and trying new things, even after the sun goes down.

I'm not a patient person. I may appear that way, but it's a front. I'm always thinking about the best angle and being in the right spot. Should I move, or should I stay? Is the light better over there? But once I find my spot, I'm patient to a fault.

As you develop a knack for anticipation, you will naturally become more confident about your choices of where and what to shoot, and also more patient to wait for the moment of anticipation to arrive.

There's a misconception that professional photographers know what they are doing at all times; that we can walk into any situation and, with a single click of the shutter, be done. To the contrary! The truth is, we're so paranoid about missing the shot that we work good situations to exhaustion. Sure, we may not spin our wheels as long finding a good situation, but it's always a matter of maintaining.

Once you recognize a good situation, have the patience to let the scene unfold. If it's worth one picture it's worth a giga-byte (and more). Work the situation until you can shoot no more. That's where patience comes in.

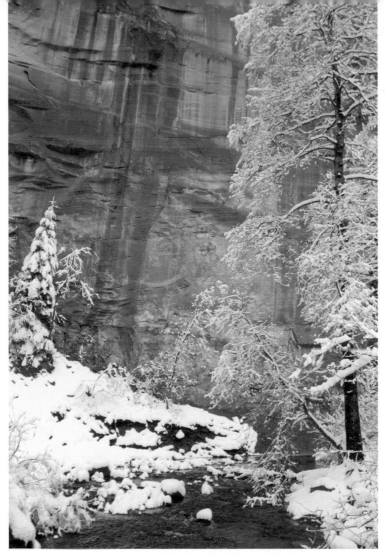

Although it sounds adventuresome and glamorous, it's not always fun waiting in the rain, hiking in the dark, or dealing with insects and the thousands of other potential discomforts in nature. Photos are not judged by the effort it takes to get them. Some days you come away with nothing. Be persistent and see your concept through. Work around the bad weather until it breaks. Practice patience and wait for the light.

Just when you think it's not happening, or you think you're done shooting, take that one extra image, or series of images. The last image you shoot could be the one and keeps you coming back to search for that next special moment to photograph.

Fresh Snow along West Fork Oak Creek, Oak Creek Canyon, Coconino National Forest, Arizona

(Canon EOS 10D, Canon EF 24-70mm f/2.8L USM, 1/30 second @ f/11, ISO 100, 0.00 EV, no filter)

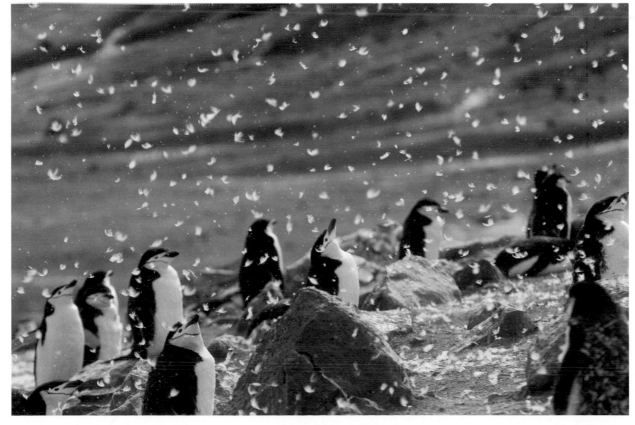

Chinstrap Penguins and Blowing Feathers, Deception Island, Antarctica

(Canon EOS 1D Mark II, Canon EF 70-200mm f/2.8L IS USM w/1.4x, 1/1250 second @ f/5.6, ISO 200, 0.00 EV, no filter)

Female Kudu Grazing,
Okavango Delta, Botswana

(Canon EOS 1D Mark III,
Canon EF 500mm f/4L IS
USM, 1/800 second @ f/5.6,
ISO 400, -0.67 EV, no filter)

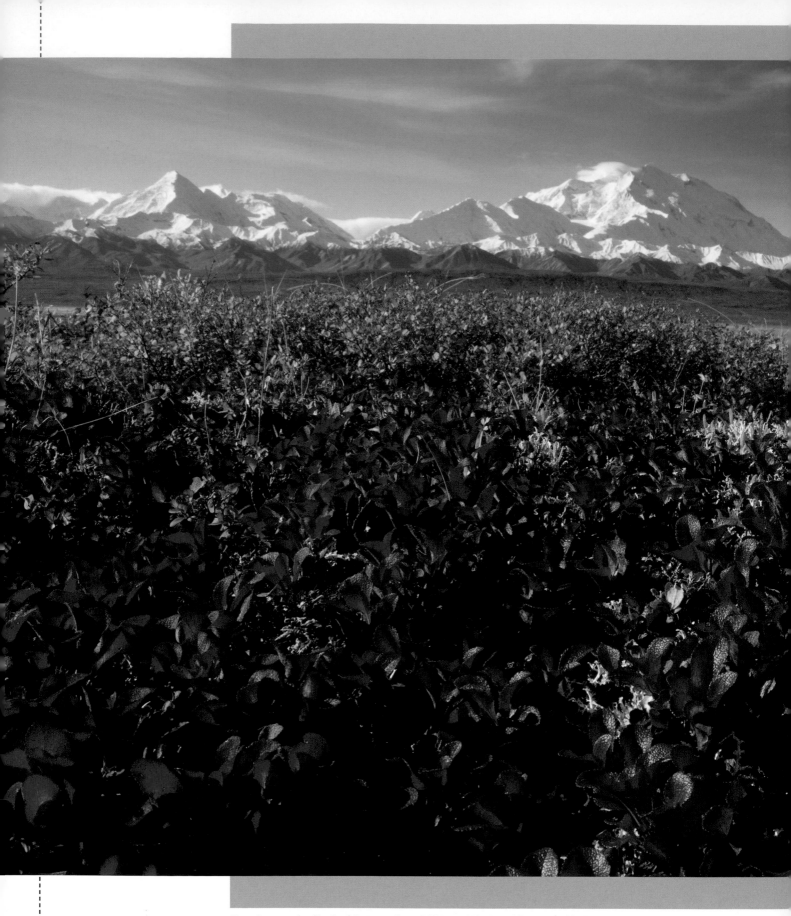

Bear Berry at the Peak of Autumn, Denali National Park and Preserve, Alaska

(Canon EOS 5D Mark II, Canon EF 24-105mm f/4L IS USM, 1/8 second @ f/22, ISO 200,
-0.33 EV, polarizing filter)

Chapter 7: Exploring Wild Landscapes

"Landscape photography is the supreme test of the photographer, and often the supreme disappointment." — Ansel Adams

It's no surprise that exploring and photographing wild landscapes is very popular among nature photographers. After all, landscapes are the easiest subjects to find, and you can often work close to your car. From expansive vistas to surprising microcosms, landscape compositions are everywhere in nature. Plus, they don't run or fly away like wildlife, making careful compositions possible—and all the more important.

Sonoran Desert Landscape, Boojum Trees and Cardon Cactus, Valle de los Cirios, Baja California, Mexico

(Canon EOS 5D Mark II, Canon EF 24-70mm f/2.8L USM, 1/250 second @ f/5.6, ISO 100, -0.67 EV, polarizer)

PREP FOR LANDSCAPES

Of all the subjects in nature, landscapes can be the most challenging. The resulting images often pale in comparison to what our eyes see and what our mind remembers. We can capture the most brilliant sunset, but find that the results are flat, empty, or repetitive. Clearly something is lost in the translation. Why is this, and what can we do to overcome it?

LEARN FROM THE MASTERS

What I learned from the masters is that you do your best work with your camera mounted on a sturdy tripod; that using a deep depth of field (DOF) with a strong foreground element creates images that are dynamic and have impact; that using the right lens is essential; and that what is not in the frame is just as important as what is. Less is certainly more in landscape photography.

TAKE THE ROAD LESS TRAVELED

To begin with, there's more to landscape photography than spectacular destinations. Even in the most scenic locations, it takes extra effort to find an interesting composition that has impact and captures a sense of the place. Stand at a popular overlook in any national park and watch how everyone jumps out of the car, walks up to the rail, and snaps the same picture. Rarely does the average photographer take the time to hike a nearby trail for a different viewpoint. There's a big difference between a snapshot and making a photograph, and most people are happy with snapshots.

Granaries at
Nankoweep Canyon,
Marble Canyon, Grand
Canyon, National Park

(Canon EOS 5D Mark
II, Canon EF 16-35mm
f/2.8L II USM, 30 sec-
onds @ f/8, ISO 800,
-0.67 EV, no filter)

KNOW WHEN TO HOLD'EM AND WHEN TO FOLD'EM

Secondly, you can't control the weather. Dramatic landscape images almost always depend on dramatic light. Despite our best intentions, sometimes we are in the right place but not at the right time. Maybe it's a perfectly clear blue-sky day with no clouds and little drama. Or perhaps clouds snuff out the light all together. Or maybe the weather is just plain socked in. You may be in a spectacular location but for whatever reason, the magic moment never materializes.

SEE LIKE THE CAMERA SEES

As I've mentioned, it's important to remember that the camera sees the world differently than our eyes. To our eyes, the landscape is vast, with endless depth and dimension. The camera, however, sees a two-dimensional world. Our eyes can also balance the light from highlight to shadow, however the camera can't handle the extremes in contrast.

VIEW THE ENTIRE SCENE

We tend to have tunnel vision when looking through the viewfinder. Our eyes focus clearly on the subject or point of interest, even a distant object, without realizing it only takes up a small portion of the frame. Obviously, the camera records what the lens sees, not our eyes. And the camera doesn't lie, what it sees is what you get. Train yourself to look at everything in the frame, and not just your focus point.

CAPTURE THE MOOD

With an infinite number of possibilities in nature, often the most interesting compositions are the less obvious ones. Take your time to work the situation and compose images that portray the mood of a place—what a place feels like, not just what it looks like.

CHANGE PERSPECTIVES

Explore the light through your viewfinder and work the subject from different points of view. Moving the camera to the left or right, or changing the camera height by just an inch or two, can make a big difference. Move the camera closer. Get low to the ground or shoot from above. Orient the camera for horizontal compositions, then try shooting vertical. Zoom in and fill the frame with a strong center of interest, or zoom out and include an interesting sky.

Giant Tree Ferns, Monteverde Cloud Forest Reserve, Costa Rica

(Canon EOS 10D, Canon EF 24-70mm f/2.8L USM, 1/250 second @ f/8, ISO 200, +0.33 EV, no filter)

Sand Dune and Ripples, Atacama Desert, Chile, Mexico

(Canon EOS 1D Mark II, Canon EF 16-35mm f/2.8L II USM, 1/15 second @ f/22, ISO 100, -0.67 EV, no filter)

Experiment with the sky; include it and then eliminate it from the frame to see the differences in the composition.

Clouds Reflecting in
Lake Myvatn, Iceland

(Canon EOS 10D,
Canon EF 16-35mm
f/2.8L II USM, 1/100
second @ f/11, ISO
100, +0.33 EV, 2-stop
grad-ND)

**Look for symmetry and
other compositional ele-
ments in the landscape.**

COMPOSE CAREFULLY

There's always a strong composition out
there somewhere—you just have to find it.
Look for patterns, reflections, and symmetry.
Include lots of sky and a sliver of the hori-
zon line, or eliminate the sky all together.
To provide yet another subject of interest
add elements of scale to your landscape
images, like a well-placed tree; look for
leading lines, like a winding road. Combine
compositional elements to make good image
even more striking.

KEEP IT SIMPLE

When photographing landscapes, strive
to portray a scene simply and with clar-
ity of subject. Well-composed landscape
photos have strong elements of interest that
lead the eye through the frame, giving the
image a feeling of depth and dimension.
When checking the composition on the
LCD screen, be on the lookout for merging
or overlapping elements that confuse the
eye. Recompose to eliminate distracting ele-
ments, or use a shallow DOF with the plane
of focus on a single element within the
frame. Your images will improve if you take
the time to check your composition using
live view. When all else fails, keep it simple.

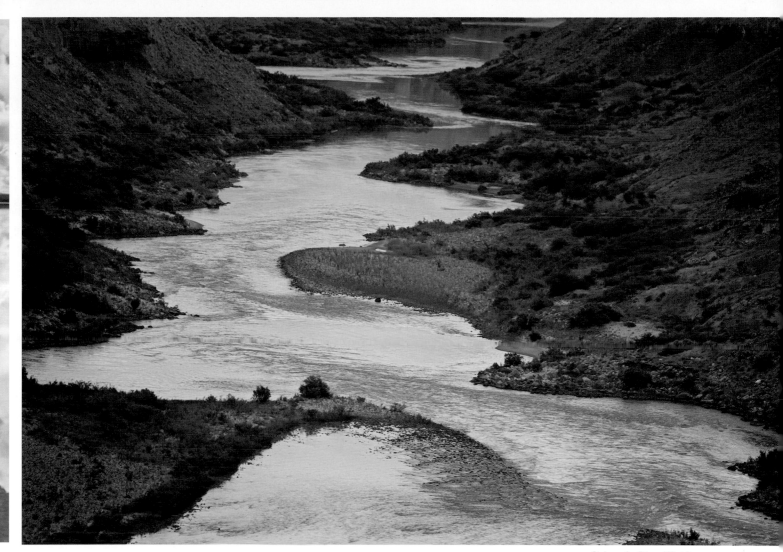

Colorado River Winding
through Marble Canyon,
Grand Canyon, National Park

(Canon EOS 5D, Canon EF
70-200mm f/2.8L IS USM,
1/250 second @ f/8, ISO 200,
-0.33 EV, no filter)

Mushroom Rock at Sunrise,
Monument Valley Tribal Park,
Arizona

(Canon EOS 5D, Canon EF
24-70mm f/2.8L USM, 1/15
second @ f/22, ISO 100, -0.67
EV, polarizing filter)

Equipment Checklist

- Sturdy tripod (preferably carbon fiber), monopod, and a bean bag
- Shutter release cable
- Two camera bodies (one for wide-angle zoom; one for long lenses)
- Wide-angles zoom for foregrounds (Canon EF 16-35mm f/2.8L II USM)
- Medium zoom for postcards (Canon EF 70-200mm f/2.8L IS USM)
- Filters: polarizer, blue-gold polarizer, grad-ND, vari-ND
- Lens hoods for flare
- Rain hood for camers and lenses
- Camera backpack with rain cover

ESSENTIAL EQUIPMENT

LOVE YOUR TRIPOD

If you are still asking yourself, "Do I need my tripod?" then you don't love your tripod. Invest in a new one today. It should be light enough to carry comfortably, sturdy enough to steady the camera, have a ballhead-style adjustment, come with a quick-release plate for ease of use, and a shoulder strap for carrying it.

From a technical standpoint, good lighting for landscapes is also low light, and therefore you will need a tripod to ensure that your images are as sharp as they need to be. Additionally, a deep DOF requires slower shutter speeds; a tripod is a necessity in these situations.

Combined with the technical logic, the real reason to carry a tripod is that it slows you down and makes you more selective in your approach. Once settled on a composition, working with a tripod also helps you become more patient. When your camera is set up and in position, you are more likely to fine-tune your compositions, check the edges, and study the frame for distracting elements.

REMOTE SHUTTER RELEASE

Some of the best compositions are easily ruined by camera shake from the physical act of pushing the shutter. This is because the best landscapes are shot in low light at a slow shutter speeds, making the camera vulnerable to movement while the shutter is open. Avoid creating camera shake by using a shutter release cable.

Hint: You can also use the camera's self-timer function to trigger the shutter button. Set the time to 2 seconds, so that every time you push the shutter button the shutter will release 2 seconds later. This method works best for shooting landscapes more than other subjects.

THE RIGHT LENS

Think about lens choice carefully. Too often we are stuck in our ways, looking at the world through our favorite lens, which usually is the one on your camera in the moment. Take the time to change lenses. To avoid changing lenses in the field, many photographers work with two camera bodies, one with a wide-angle lens attached, and one with a medium-telephoto zoom.

This also helps to minimize sensor dust because you aren't exposing the sensor to the elements. However, if you don't have two camera bodies, minimize the risk of sensor dust by following a few simple guidelines: turn the camera off before you remove a lens; leave the camera pointed down while changing lenses; and work quickly (this is where being very familiar with your equipment becomes even more important).

Wide-Angle Lenses: Wide-angles emphasize foreground elements and create a sense of space in an image. These are great lens choices for big skies and large bodies of water.

Medium Lenses: Medium lenses create images that most look like how our eyes view the world. The classic landscape photographers rely on medium lenses, in a range anywhere from 50 to 200mm. This is the postcard look, so to go one step further find composition elements that can help frame the scene, like a tree or canyon wall.

Mist and Steep Cliffs in Tracy Arm Fjord, Tongass National Forest, Alaska

(Canon EOS 10D, Canon EF 70-200mm f/2.8L IS USM, 1/500 second @ f/2.8, ISO 200, -0.33 EV, no filter)

FILTERS FOR LANDSCAPES

Filters still play an important role in digital world of nature photography, and they are especially effective when shooting landscapes. My goal in using filters is to control and modify the natural light without the final images looking filtered. Beware of temptation: It's easy to get seduced by filters and push it to far. To give yourself a choice back home in the digital darkroom, always shoot a series of shots with and without the filters.

Polarizer: Use a polarizing filter to darken blue skies, emphasize clouds, and to control reflections on water and wet vegetation, as well as bring down overly bright highlights.

Blue-Gold Polarizer: To add a touch of gold or blue to scenes with muted color, use Singh-Ray's blue-gold polarizer, then adjust the color balance in Lightroom to the desired look. This filter can definitely push the color over the top, so it's is best to shoot in RAW to have the most control.

Graduated Neutral Density (grad-ND): Balance bright skies and dark foregrounds with a grad-ND. This half-gray/half clear filter balances the light by holding back the exposures of bright skies. This helps to bring up the exposure values of the foreground relative to the sky. I find a 2-stop,

Surf Zone at Sunset, Isla Santa Catalina, Loreto Bay National Park, Baja California, Mexico

(Canon EOS 5D Mark II, Canon EF 24-105mm f/4L IS USM, 2.5 seconds @ f/22, ISO 100, -0.33 EV, blue-gold polarizer)

Example of landscape photo using Singh-Ray's blue-gold polarizer and a slow shutter speed.

Salt Pond Reflection, Isla San Jose, Loreto Bay National Park, Baja California, Mexico

(Canon EOS 5D Mark II, Canon EF 24-105mm f/4L IS USM, 1/20 second @ f/8, ISO 100, -0.67 EV, 2-stop grad-ND)

Example of reflection with graduated neutral density filter.

hard-step, grad-ND best for scenes with a distinct horizon. The soft-step grad-ND works bests for landscapes with no distinct boundary, like wildflower meadows and sweeping panoramas.

Variable Neutral Density (vari-ND): To capture motion blur at slow shutter speeds, use Singh-Ray's vari-ND, which allows you to control the amount of light passing through the lens. The vari-ND filter simplifies achieving slow shutter speeds, even on a bright day. I use it for waterfalls to create motion blur, and also for shooting waves along the coast.

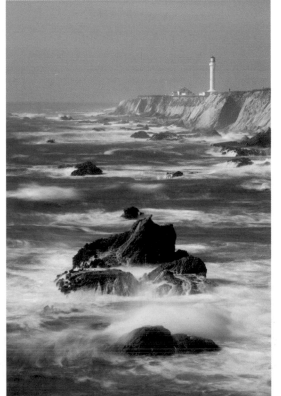

Breaking Waves near Point Arenas, Mendocino Coast, California

(Canon EOS 1D Mark II, Canon EF 70-200mm f/2.8L IS USM, 1 second @ f/22, ISO 100, -0.33 EV, vari-ND)

Tips for Shooting Landscapes

Shooting landscapes is challenging for many nature photographers. To help you get to the next level with your landscape photographs, here are a few things to keep in mind:

Use a Tripod: Using a tripod slows you down, resulting in more careful compositions. And it also steadies your camera, allowing the use of long lenses and slow shutter speeds.

Find Foreground: Strong foreground elements add depth and dimension to your landscape images. Stop down (f/22) and focus a third of the way into the frame to achieve a deep DOF.

Simplify the Frame: Less is more in landscape photography. Whenever possible, eliminate distracting elements. Create a feeling of space by including lots of sky or focus on reflections in the water.

Choose the Right Lens: Wide-angle lenses emphasize the foreground. Longer lenses help isolate details and compress the perspective, making distant objects appear larger.

Find the Light: Landscape photographers can't be impatient. Go for the gold by getting up early and staying out light. Embrace stormy weather and be there when the light breaks. Always be on the look out for dramatic light.

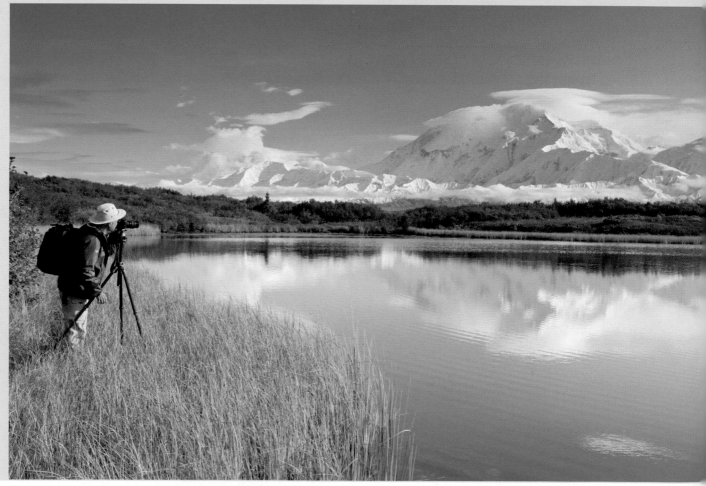

Photographer at Reflection Pond, Denali National Park and Preserve, Alaska

(Canon EOS 5D Mark II, Canon EF 24-70mm f/2.8L USM, 1/60 second @ f/8, ISO 100, 0.00 EV, polarizer, 2-stop grad-ND)

SHOOTING LANDSCAPES

CHASE THE LIGHT

The more you know about a place and how the light reveals the landscape, the better you'll be at finding good situations for making strong images. Allow yourself the time to explore a landscape so that you can discover some of its hidden secrets.

Scout Before the Light Hits:
It takes time to find the right place to make a good landscape photograph. Landscape photographers are usually hikers at heart, and a well-chosen trail can lead to amazing landscapes and wonderful photo opportunities. Scout for locations during the middle of the day—when the midday light is worst for landscape photography—and look for potential subjects and compositions. Then, be in position when the light is good.

Time it Right:
Landscape photography is a constant search for good light, and time of day is the key factor. Early and late in the day the light is soft and balanced, allowing the colorful hues of the landscape to glow. Once the sun is up, the light quickly turns harsh, contrasty, and washes out colors, unless there are clouds to direct and filter the light. The dedicated landscape photographer in search of dramatic light gets up early and stays out late, shooting at first light and finishing long after sunset when the last of the twilight has faded.

Clearing Storm, The Towers, Torres del Paine National Park, Chile

(Canon EOS 5D, Canon EF 70-200mm f/2.8L IS USM, 1/3200 second @ f/2.8, ISO 100, +0.33 EV, no filter)

Stormy Light:
Dramatic light also occurs with advancing and clearing storms, so it's important to seek out stormy weather and wait for the storm light. Weather elements—clouds, rain, fog, mist, and snow—add mood to landscape images.

I've spent many long hours and even days in the tent or camper waiting for a break in the weather. While waiting for the dramatic light that accompanies a clearing storm, I'll work subjects that conditions allow, like close-ups and details. Don't be afraid to return to the same place again and again. Professionals are in the right place at the right time because they are persistent. If you are seriously interested in landscapes, you can't be a fair-weather shooter. Chase the storms and your landscapes images will improve dramatically.

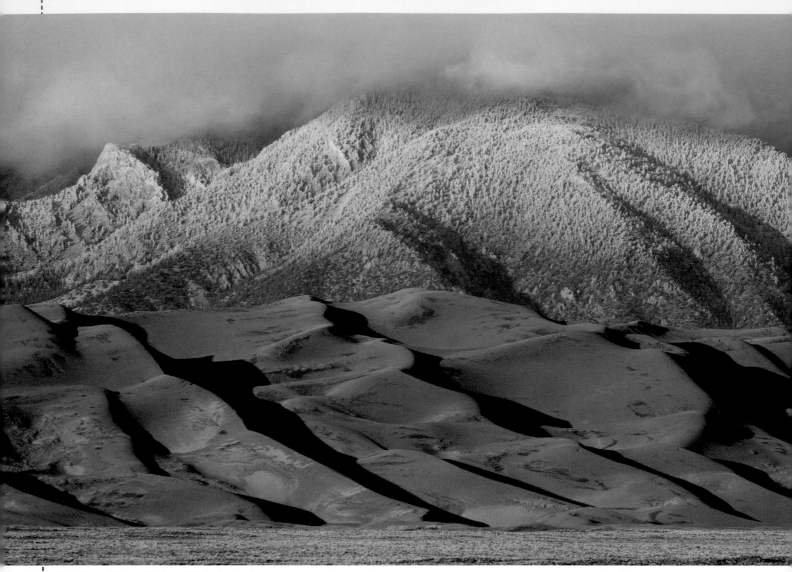

Great Sand Dunes National Park, Colorado

(Canon EOS 5D, Canon EF 70-200mm f/2.8L IS USM, 1/320 second @ f/8, ISO 100, 0.00 EV, no filter)

Choose Sidelight: Sidelight creates the interplay between light and shadow, enhances textures and forms, and imparts a feeling of depth and dimension to the scene. The lower the sun is in the sky, the deeper and longer the shadows. The low angle of the sun in late fall and winter also provides nice sidelight situations. The Great Sand Dunes in southern Colorado would appear dimensionless without sidelight defining each ridge and swale.

Choose Backlight: Backlight can be very dramatic light, adding a radiant glow to plants and flowers and giving a highly-defined form to foreground objects, especially when shot slightly underexposed as silhouettes. I especially like shooting desert scenes backlight for the pleasing rim lighting it imparts on cactus spines. Enhance landscape silhouettes by metering for the light source; then recompose your image and shoot.

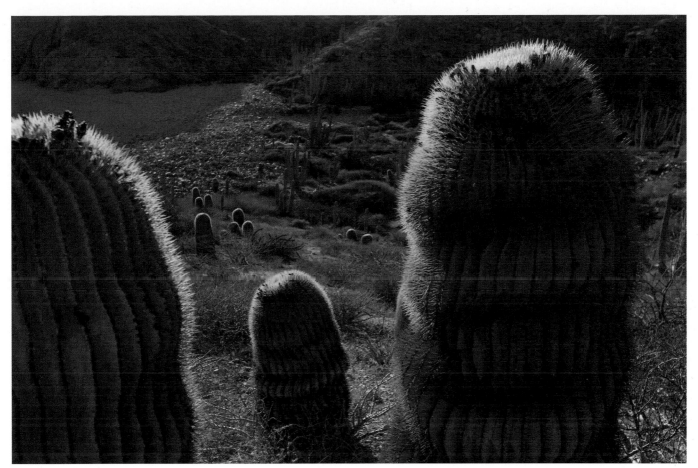

Golden Cottonwoods along the Chama River, New Mexico

(Canon EOS 5D, Canon EF 24-70mm f/2.8L USM, 1/40 second @ f/11, ISO 200, -0.67 EV, no filter)

Choose Diffused Light: Clouds, those big diffusion filters in the sky, are great for landscapes, and especially details of landscapes. Overcast or cloudy light conditions are perfect for shooting scenes that don't include the sky, like under the forest canopy and in deep canyons. Cloudy light casts a warm, saturated look, bringing out color and emphasizing detail. To help enhance the effect, try shooting JPEGs with cloudy white balance, or try processing your RAW images with a cloudy white balance.

Rhododendrons in Bloom, Redwood National Park, California

(Canon EOS 5D, Canon EF 16-35mm f/2.8L II USM, 1/60 second @ f/5.6, ISO 200, -0.33 EV, no filter)

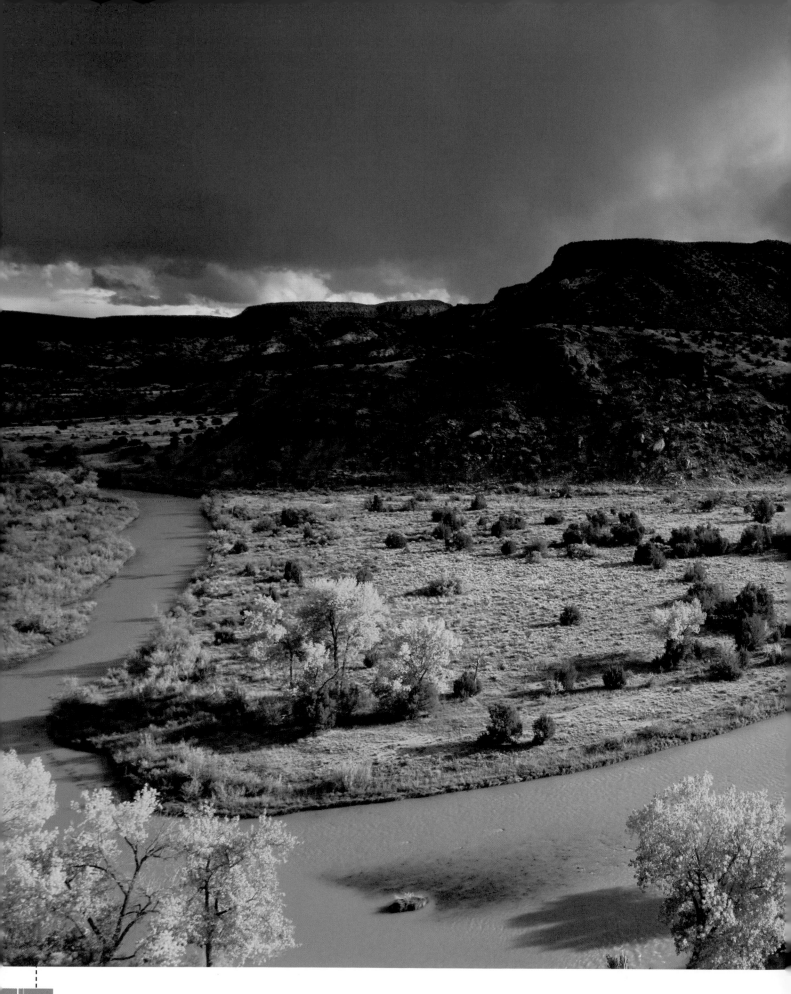

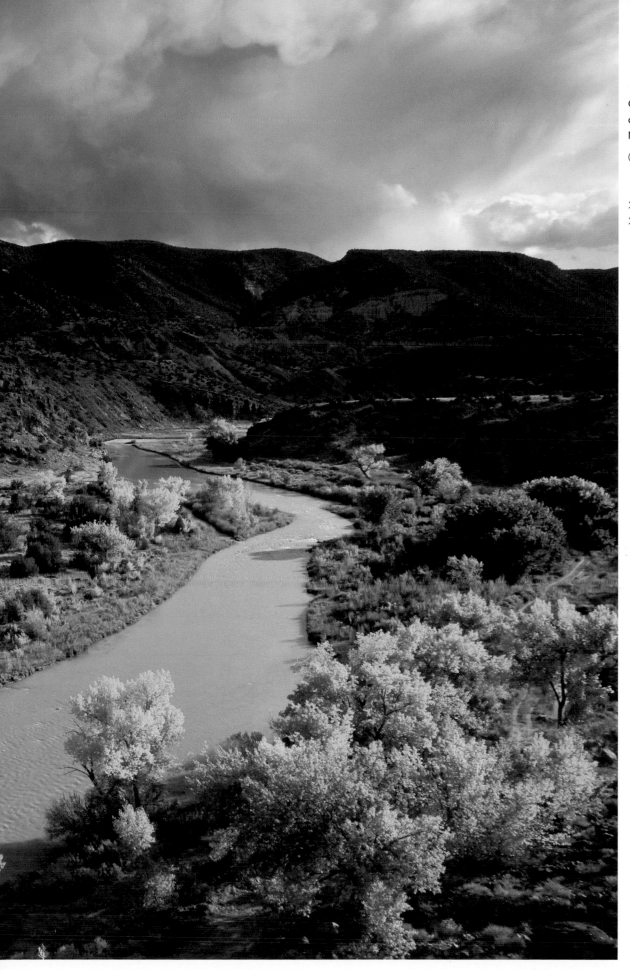

Golden Cottonwoods along the Chama River, New Mexico

(Canon EOS 7D, Canon EF 16-35mm f/2.8L II USM, 1/40 second @ f/11, ISO 200, -0.67 EV, polarizer, 2-stop grad-ND)

CONTROL
DEPTH OF FIELD

Landscape photographs with depth and dimension generally have a strong foreground and a deep DOF, with near and far elements all in sharp focus. Foreground elements add a sense of balance to an overall grand landscape, and a deep DOF takes the viewer's eye further into the scene. A shallow DOF can focus the viewer's attention down to smaller elements of the whole composition. The DOF you choose is a creative choice, but there are important technical aspects to keep in mind for either situation.

Focus: Remember to focus about a one-third of the way into the frame—the approximate hyper-focal distance—in order to achieve the deepest DOF possible with your camera's optics. By having foreground elements sharp, the eye moves through the frame toward middle and background layers.

Enhance Depth: Elements that cut diagonally across the foreground help create the effect depth. For this reason, I'm constantly on the search for sculpted and balanced rocks, flowers, tree trunks or branches, reflections and flowing water, or just about anything that adds foreground interest and depth to the scene.

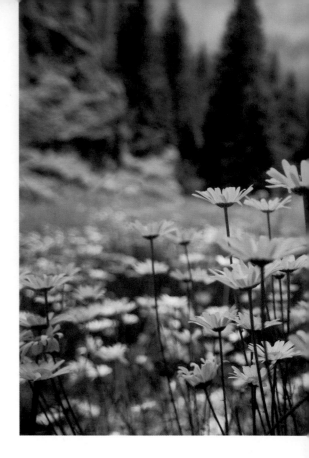

Beware of Camera Shake

Stopping down for a deep DOF (f/16 or f/22) usually requires a relatively slow shutter speed, any where from a 1/15 to several seconds, making camera shake a critical issue. In addition to having your camera mounted on a sturdy tripod and using a remote cable release, use your camera's mirror lockup function: this prevents the mirror from shaking the camera as the shutter is released.

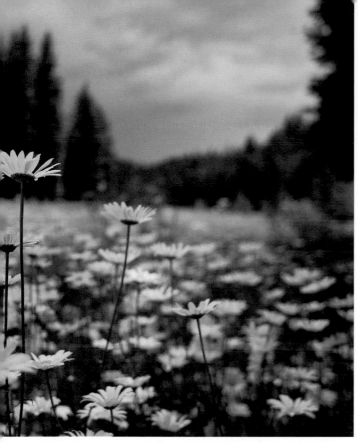

Summer Wildflowers, Valle Grande, Jemez Mountains, New Mexico

(Canon EOS 5D Mark II, Canon EF 16-35mm f/2.8L II USM, 1/2000 second @ f/2.8, ISO 100, -0.67 EV, no filter)

The shallow DOF makes this an interesting composition; the flowers are the obvious focus, and the blurred background hints at the extent of the landscape.

Cascades in Havasu Canyon, Grand Canyon National Park, Arizona

(Canon EOS 5D Mark II, Canon EF 16-35mm f/2.8L II USM, 1/2 second @ f/16, ISO 100, +0.33 EV, vari-ND)

A deep DOF and motion blur can create a dynamic landscape composition.

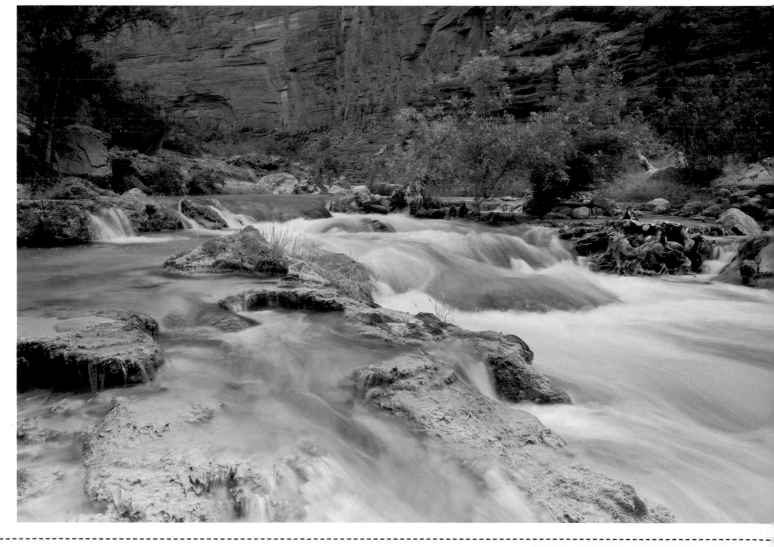

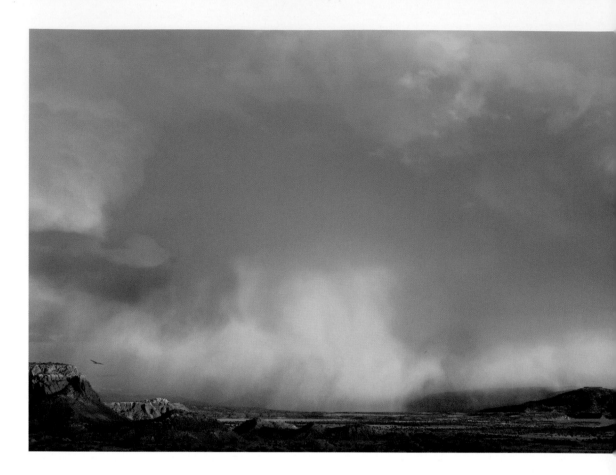

SPECIAL
LANDSCAPE IMAGES

PANORAMIC

Some landscapes lend themselves to making panoramic images, that is, photos that have a wide aspect ratio, generally being as least twice as long as the image is high.

In the film world, the Fuji 6 X 17 and Hasselblad X-PAN (35mm) panoramic cameras have been state of the art for some time. The exciting news is that, in the digital world, you no longer have to carry a specialized panoramic camera to create stunning panoramic images. The process can be done with computer software, and it's very easy.

Manual Shooting Mode: To create a digital panoramic, shoot a series of three or more frames. Ideally, set your camera on manual to keep the exposure consistent in every frame. Also, don't to use a polarizer; it can create inconsistencies in blue skies.

Overlap Each Frame by 1/3: Once you've settled on a composition worthy of a panoramic, shoot a sequence being sure to overlap each frame by about 1/3. You can be very exact—using your camera on a level tripod—or you can do the quick and dirty handheld shots. For best results, I highly suggest using a tripod, especially if you are new to shooting panoramics. (That said, I've handheld many pano sequences when things happen too fast, such as a momentary view of a gorgeous bank of clouds over a sprawling vista.)

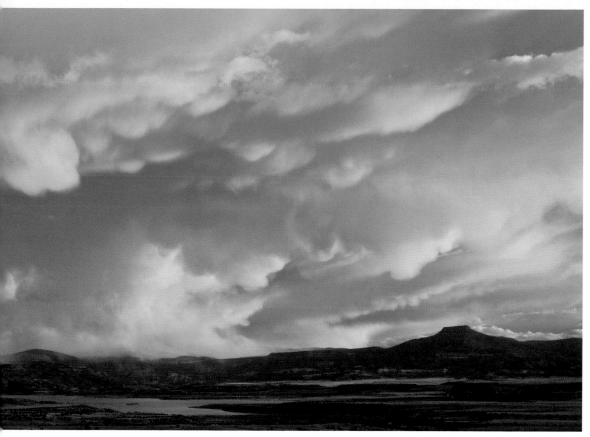

Clouds over Ghost Ranch, New Mexico

(Canon EOS 5D Mark II, Canon EF 24-105mm f/4L IS USM, 1/125 second @ f/8, ISO 100, -0.33 EV, gold-blue polarizer)

This example shows a panoramic image stitched together from three vertical frames.

Shoot Bookend Images: The hard part of shooting panoramic images is remembering why you took so many pictures of the same thing when editing later. To cue myself at the start of the sequence, I first shoot a blank picture of the sky, then the panoramic sequence images, and then a blank image at the end of the sequence. When I'm editing and see a sequence of images between blank skies, I'll know there's a panoramic to be made.

Select the Best Sequence: I select the best sequence of images to process as a panoramic. In Lightroom, I begin by working on the first image of the sequence, doing basic adjustments, then syncing those adjustments with the rest of the sequence. It's important that each image is processed in the same way so there is no variation in color balance, brightness, or saturation. After I tweak, I then export the images to a file on my desktop.

Stitch the Images: The final step in the process is accomplished in Photoshop or any other application that has a "photo stitching" application. In Bridge, I select the images to be stitched together, and then go to Tools > Photoshop > Photomerge. Select the "perspective" layout and hit OK. The software does the rest and the image opens in Photoshop when it's done.

Once the merging of images is complete, crop to the desired size. Sometimes I just crop to specific panoramic aspect ratios, but other times I crop according to what works well with the composition of the particular image. I finish the process by flattening the image and fine-tuning basic adjustments.

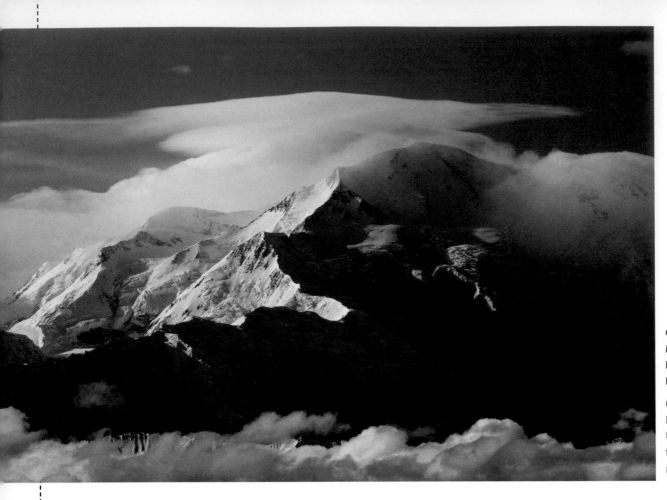

Clearing Storm on
Mt. McKinley, Denali
National Park and
Preserve, Alaska

(Canon EOS 5D, Canon
EF 70-200mm f/2.8L IS
USM, 1/250 second @
f/8, ISO 100, -0.33 EV,
polarizer)

BLACK AND WHITE

Sometimes I enjoy seeing in black and white. Black and white alters your reality and the way you look at the world, but in a good way. By removing color from the equation, the search for images becomes all about the interplay between light and shadow. In certain situations, "bad" light becomes "good" light when seeing in black and white.

To have full control over the final image, shoot RAW files so that you have the color data to work with. But to get instant feedback, set your camera's LCD to black and white. Even though you are viewing the image in black and white, the camera is actually still recording in color in the RAW file, so all the information is retained.

When shooting landscapes with black-and-white conversions in mind, look for shapes and patterns, and use sidelight to reveal textures. I use a polarizing filter to darken skies and enhance storm clouds. Summer thunderstorms are always great subjects for black and white landscapes.

Convert to Grayscale: My approach to making conversions is to start with Lightroom's presets, and then tweak as needed on an image-by-image basis. I find that the "High Contrast" or "Low Contrast" presets are a good starting point. Some images lend themselves to the "Antique Light" or "Sepia" presets. Experiment and have fun!

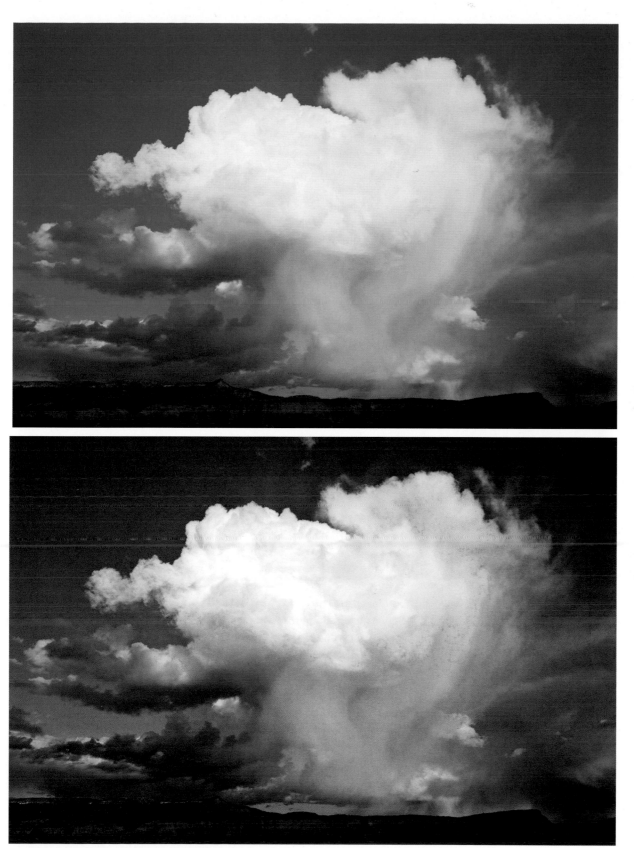

Thunderhead over Ghost Ranch, New Mexico

(Canon EOS 7D, Canon EF 16-35mm f/2.8L II USM, 1/125 second @ f/8, ISO 200, +0.67 EV, polarizer)

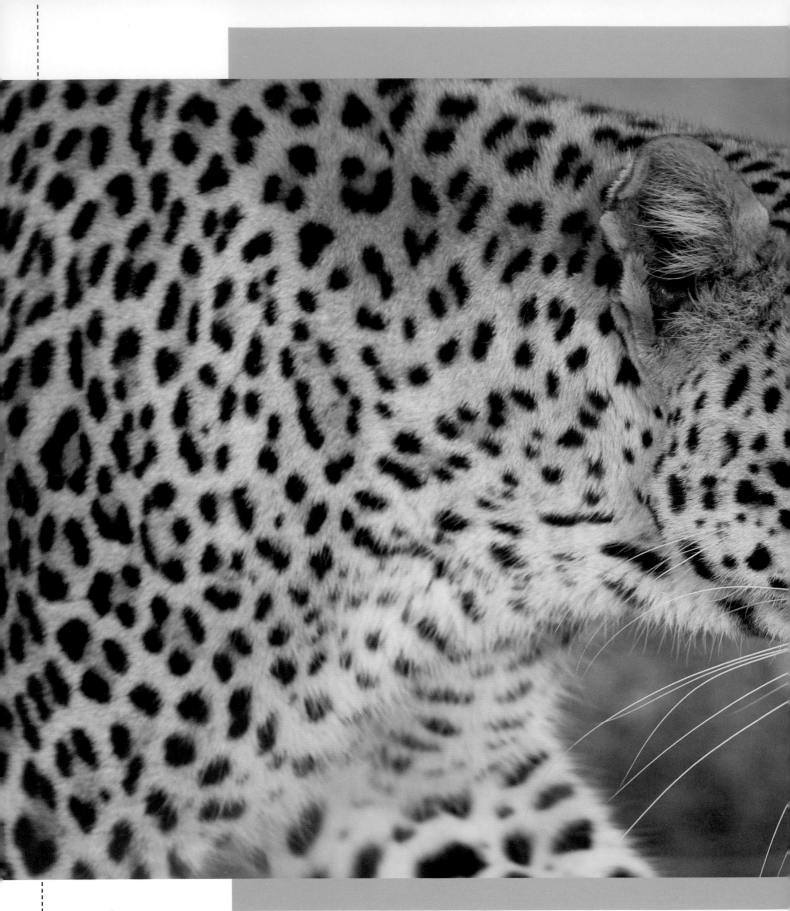

Leopard on the Prowl, Lower Zambezi National Park, Zambia, Africa

(Canon EOS 1D Mark III, Canon EF 500mm f/4L IS USM w/1.4x, 1/320 second @ f/5.6, ISO 400, -0.33 EV, no filter)

When photographing moving animals, it's important to get the eye in sharp focus.

Chapter 8: Wildlife

"I have discovered photography. Now I can kill myself. I have nothing else to learn." – Pablo Picasso

Photographing animals in the wild is one of the most thrilling experiences for a nature photographer. It's the long romanticized notion of traveling to the world's wild places in search of the next great animal encounter. There's the freedom of being on a ship at sea, the uncertainty of searching for animals in their natural environment, and the adrenaline rush with the first sighting. Add to this the challenge of being in position at the right instant to click the shutter, and you've got a recipe for high adventure.

PREP FOR WILDLIFE

Few things in life can compare with the pure excitement of being in Africa on safari photographing elephants, giraffes, and lions, or plying through the Arctic pack ice in search of walrus and polar bears in Svalbard (except maybe photographing penguins by the thousands in Antarctica, or being among giant whales and playful dolphins in Baja California!). I've been extremely fortunate over the years to return again and again to these wild places to spend time in the company of wildlife—a humbling experience.

It wasn't until I started working with Lindblad Expeditions aboard their fleet of ocean-going expedition ships that I found myself in world-class wildlife situations. Like a kid leaving home for the first time, I left the landscapes of the southwest behind to travel to these exotic places. They were new to me and inhabited by animals I had never seen before. It was mind blowing.

That was over 20 years ago, when I was still using medium-format film. As a landscape photographer at the time, I had a lot to learn about shooting wildlife. Without the long glass of my 35mm colleagues, I learned how important it was to photograph the animal within the landscape, providing context and a sense of place. This hands-on training shaped my wildlife photography.

KNOW THE RISKS

Then there's the risk of being in the wild in potentially dangerous situations. Although not all wildlife poses risks to the photographer, certain locations have hidden dangers, such as loose rocks along bird cliffs or photographing marine mammals in rough water along rocky shores from small boats. It's important to understand the risks before you go; consider hiring an assistant or local guide who knows the area well.

RESEARCH, RESEARCH, RESEARCH

No matter whom you travel with or how you get there, you still need to plan your trip carefully. Research all there is to know about the animal's environment and life history. Spend an hour or two on the Internet and you'll have the basics on where on earth to find your animal of interest, when to go, and options for getting there. Then research books and magazines to see what kind of images have already been made. It can be discouraging at first realizing the coverage that already exists, but it is also inspiring to know that these wild places still exist, and that soon you will be there.

Many wild animals are worth going to the ends of the earth for. To photograph polar bears, you've got to go north. For penguins in the wild, head south (it's surprising how many people get this confused!). The more you know about the animals in question, the more likely you'll be able to recognize good situations for making images.

PREPARE, PRACTICE, AND PATIENCE

As with other photographic disciplines, getting to the next level with your wildlife photography entails practice, preparation, and experience. It takes time to observe how animals live. There are big differences between simply taking pictures of animals and shooting true wildlife photography.

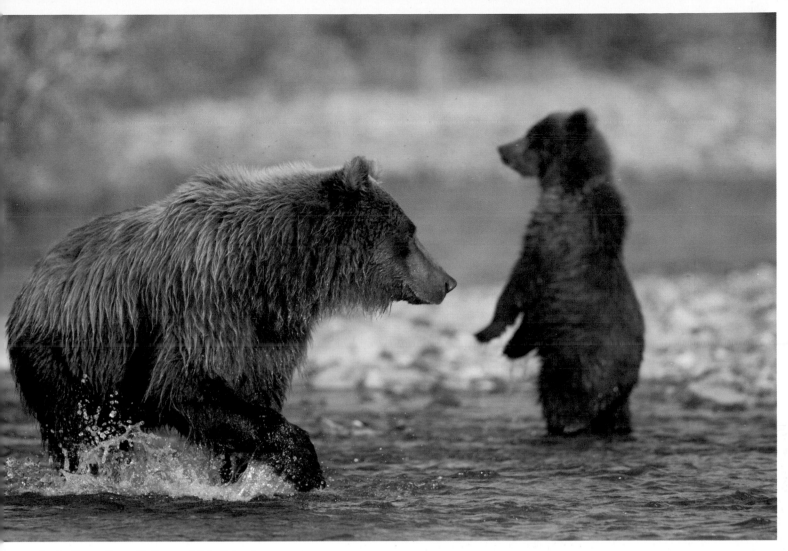

Alaska Brown Bears, Mother and Cub, Katmai
National Park and Preserve, Alaska

(Canon EOS 1D Mark III, Canon EF 500mm f/4 IS USM
w/1.4x, 1/1250 second @ f/5.6, ISO 400, -0.33 EV, no filter)

Sometimes when using a long lens, you have to
choose which animal you want to focus on.

Not everyone has the time or the resources
to get the world's wild places, but you also
have a choice in how you approach your
own wildlife photography. You can start
photographing the wild birds in your own
backyard and go from there.

What follows will help in your search for
wildlife in the wild and your quest for mak-
ing images that have impact and meaning,
whether capturing wild moments in your
backyard or in the world's wild places.

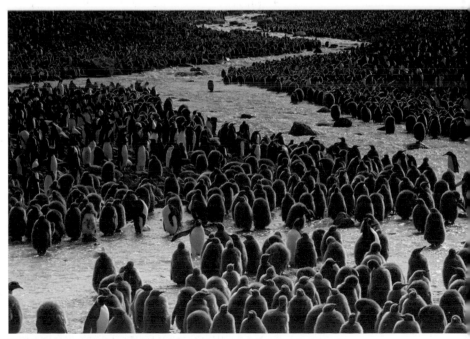

King Penguins along Meltwater Stream, St. Andrews Bay, South Georgia

(Canon EOS 1D Mark II, Canon EF 70-200mm f/2.8L IS USM, 1/500 second
@ f/8, ISO 400, -0.66 EV, grad-ND)

ESSENTIAL EQUIPMENT

Before taking the plunge into wildlife photography, know what you're getting yourself into. Serious wildlife photography demands the best equipment: an arsenal of D-SLR cameras and lenses, a sturdy tripod for holding them steady, and a big backpack and strong back for carrying it all.

THE DIGITAL ADVANTAGE

Advances in the digital technology have opened up opportunities for wildlife photographers like never before. The high ISO capabilities and quality of today's digital images in low-light situations is astounding. In fact, just within the time frame of writing this book, the maximum attainable ISO has increased from 25,000 to over 100,000. We can now shoot in situations we never dreamed possible back in the film days. We are truly entering the golden age of digital photography.

Photographer and Espanola Mockingbird, Galapagos Archipelago, Ecuador

(Canon EOS 1D Mark II, Canon EF 24-70mm f/2.8L USM, 1/1250 second @ f/5.6, ISO 100, -0.33 EV, no filter)

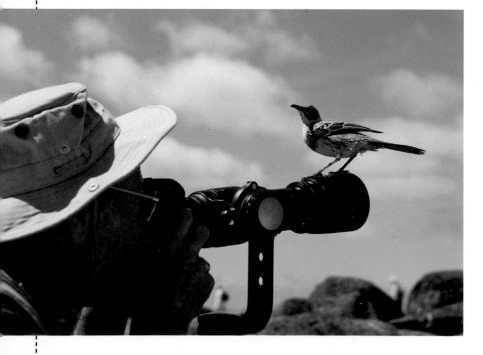

With memory cards getting larger, faster, and cheaper, we can also shoot large sequences of images. This is especially important when the action is fast and furious. Film used to hold me back, not wanting to get stuck at the end of a roll when the action happened. Now, when I get down to 50 shots or less, I switch cards. Shooting non-stop creates new challenges of time management and storage issues, but I'm willing to deal with these concerns in exchange for the freedom of creating amazing imagery.

Safari Vehicle and Elephant Crossing the Road, Ngorongoro Crater, Tanzania

(Canon EOS 1D Mark II, Canon EF 70-200mm f/2.8L IS USM, 1/2000 second @ f/2.8, ISO 400, 0.00 EV, no filter)

D-SLRS

D-SLRs are the camera of choice for wildlife work because:

- Advanced autofocus capabilities
- Instantaneous shutter
- Ever-inreasing buffer capacities thta allow continuous shooting of high-resolution JPEG and RAW images at burst rates approaching 10 frames per second (fps)
- Shooting in continuous drive mode with a rapid burst rate
- Higher-quality images
- Accept a range of specialized lenses
- Excellent ISO capabilities for low-light situations

LENSES

It's essential to have image stabilized (IS) or vibration reductio (VR) lenses for working from moving boats and vehicles.

- 70-200mm f/2.8
- 100-400mm f/4.5-5.6
- 500mm f/4 with the 1.4x extender
- 300mm f/2.8 with the 1.4x extender
- Wide-angle zoom lens for those unexpected close encounters

Equipment Checklist

- Sturdy tripod (preferably carbon fiber), monopod, and a bean-bag
- Gimble head (Wimberly-style) for long lenses
- Two camera bodies (one for wide-angle zooms; one for long lenses)
- Wide-angle zooms (16-35mm f/2.8; 24-105mm f/4)
- Medium zoom (70-200mm f/2.8)
- Long telephoto zoom (100-400mm f/4.5-5.6)
- Long telephoto fixed (300mm f/2.8, 500mm f/4)
- Tele-extenders (1.4x)
- Rain hood for cameras and lenses
- Camera backpack with rain cover

BRING THE ARSENAL

There's the hard work involved with preparation and logistics of getting yourself and your equipment to the location, as well as the issue of what equipment to pack and schlep. My answer is always the same, "Bring only what you can carry, but bring the arsenal." Depending on the location, you may also need to protect your gear from salt water, sand, and inclement weather. A good camera backpack and protective dry bag is essential for some of the more rugged destinations. Your success as a wildlife photographer depends on being prepared with the essential equipment and knowing how to use it.

Galapagos Tortoise in Wetland, Santa Cruz Island, Galapagos National Park, Ecuador

(Canon EOS 1D Mark II, Canon EF 24-70mm f/2.8L USM, 1/160 second @ f/5.6, ISO 100, -0.67 EV, no filter)

Young Male Elephant,
Ndarakwai Reserve,
Tanzania, Africa

(Canon EOS 5D, Canon
EF 300mm f/2.8L IS USM,
1/250 second @ f/8, ISO
200, -0.33 EV, no filter)

Shooting Tips: Wildlife

- Use a tripod
- Check and set the ISO
- Check and set the shooting mode
- Check and set the f/stop (in aperture priority)
- Check and set the exposure compensation (EV)
- Set single-spot focus for portraits and slow moving animals
- Set pattern focus for fast moving animals
- Use continuous focus (servo)
- Use continuous drive (burst mode)
- Increase ISO for sharp images
- Decrease ISO for motion blur

GETTING CLOSE TO WILDLIFE

GET LOCAL

You don't have to go to far-flung places or climb the highest mountain to find wildlife to photograph. Your own adventures can start at home with backyard animals. Start small, photographing birds, squirrels, or rabbits. Maybe set up a birdfeeder by a window or create a blind. As you gain experience, expand your universe to include local parks or wildlife refuges.

I would rather see aspiring wildlife photographers spend time learning in nature rather than going to a zoo or visiting a farm, but controlled environments are good places to start observing animal behavior. Have a curious mind and develop the patience to wait for spontaneous moments to happen.

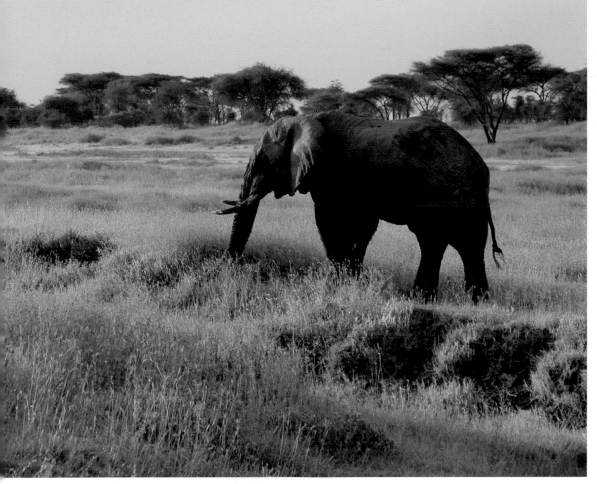

Elephants Walking Through the Grass, Ngorongoro Crater, Tanzania

(Canon EOS 40D, Canon EF 70-200mm f/2.8L IS USM w/1.4x, 1/2000 second @ f/2.8, ISO 400, 0.00 EV, no filter)

Photographing Polar Bears, Svalbard Archipelago, Norway

(Canon EOS 40D, Canon EF 100-400mm f/4.5-5.6L IS USM, 1/1250 second @ f/5.6, ISO 200, -0.33 EV, no filter)

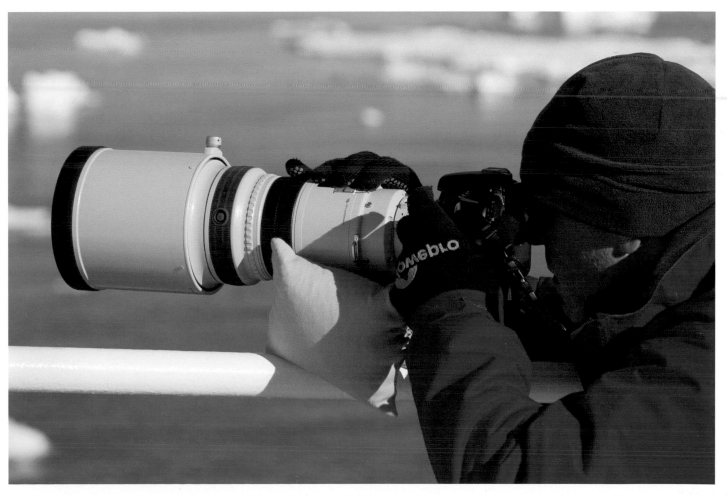

WILD MOMENTS

It was Sam Abel who said, "If you're not having any experiences, you're probably not taking pictures." Not surprisingly, the key element in wildlife photography is focused on the experience and the moment—being there, being observant, and clicking the shutter at the right instant. After all, what experience can put you more in the moment than being with a wild animal in its natural habitat?

Light and composition are important elements for making wildlife images that have impact and meaning, but as you would expect with animals, capturing a sense of the moment trumps everything.

SURRENDER CONTROL

It's important to realize that you are not in control of the situation when photographing wildlife. Life suddenly becomes very real when in the presence of wild animals, particularly with large game and predators. It raises the stakes knowing there's something out there that could cause you serious harm. Always remember you are a visitor in their natural environment, and that the animals play by their own rules.

I learned the hard way that to become a good wildlife photographer you have to develop a feel for being around animals, that you have to wait until they put their guard down, and it's always better if the animals come to you. It was overwhelming to be among wild animals. Sensory overload can take over, making it hard to know what to shoot, let alone remember how to use the camera.

One such overwhelming experience occurred when a gray whale calf approached our boat in San Ignacio Lagoon. Amazingly, gray whales want to be touched, as if they have forgiven mankind for almost hunting them to extinction, and this calf approached with

nothing but good intentions. At a certain point I just stopped shooting, as I could not resist reaching out and touching this friendly whale.

Another overwhelming experience is snorkeling with sea lions, as they jet past you blowing bubbles as they go by. They literally swim circles around you, making your head spin. Moments like these force you to either concentrate on making photos or surrendering to the experience. I've shot lots of frames of empty water before giving up and enjoying the show. Of course, this is easier once you've already got the shot!

EMBRACE SERENDIPITY

Any number of things must come together for a great wildlife photo to be made. It all starts with being there for the sighting to occur, and then being ready to capture the moment in whatever form it takes. Once the scene is set, it's up to the animal to exhibit a gesture, an interesting behavior, or, with luck, interact with other animals. It's the animals that decide the fate of the wildlife photographer.

That's where you must let serendipity play its role, which means more than being just plain lucky. Serendipity, by one definition, "is the natural gift for making useful discoveries by accident." To be a successful wildlife photographer you must learn how to develop that natural gift for being there when "accidents" happen. Knowing where to find wild animals, being patient waiting for accidental discoveries to unfold, and then being in the moment photographing them without disturbing their natural behavior are all keys to capturing successful wildlife images.

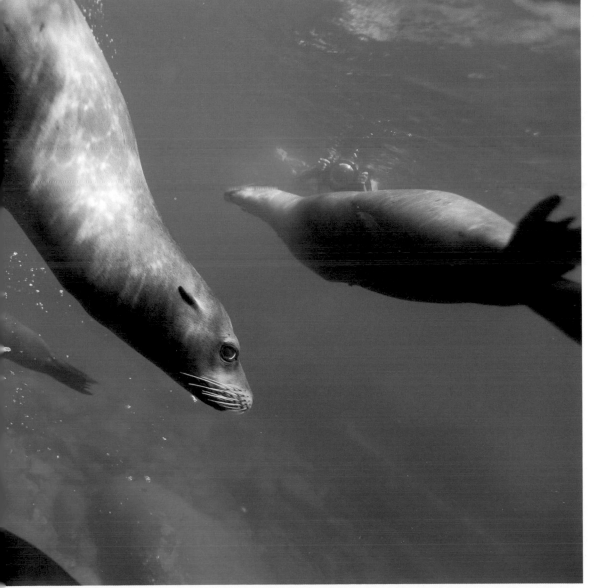

California Sea Lions Darting Underwater, Los Islotes, Espiritu Santo Archipelago National Park, Gulf of California, Mexico

(Canon EOS 5D, Canon EF 16-35mm f/2.8L II USM, 1/1000 second @ f/2.8, ISO 400, -0.67 EV, Ikelite dome port)

WORKSHOPS AND EXPEDITIONS

Take a workshop with a local wildlife photographer, or book a one-on-one session. Once you know tricks of the trade, then it's time to branch out and take a road trip to Yellowstone or reward yourself with a once-in-a-lifetime photo expedition to another continent.

Few of us have the resources to head out into the wilds for months at a time. Going with professionals on a workshop or photo expedition helps to focus your time by taking you straight to the source, and offers the peace of mind that you're with experts that have experience in these situations. There's also the safety factor of being with a group should something unforeseen occur.

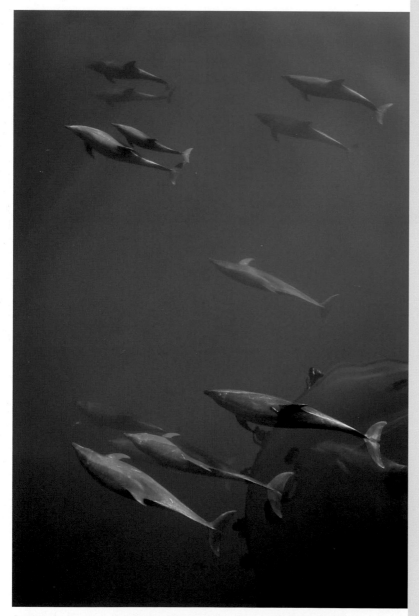

Bottlenose Dolphins Bow-Riding, Sea of Cortez, Baja California, Mexico

(Canon EOS 5D Mark II, Canon EF 24-70mm f/2.8L USM w/1.4x, 1/250 second @ f/8, ISO 400, -0.67 EV, polarizer)

Great Voyages: Ship-Based Expeditions

There are a number of wild places in the world that are best visited by making ocean-going expeditions on small passenger ships. Among the best are destinations like Antarctica and South Georgia, Baja California and the Sea of Cortez, Alaska's Inside Passage, the Galapagos Islands, and Norway's Svalbard Archipelago. All of these geographies share spectacular scenery with abundant wildlife.

The great thing about traveling by ship is that you can unpack for the duration of the voyage. It's a relaxing and effortless way to travel, as the ship takes you to new places every day. On photo expeditions, the ship serves as a platform for photography, and it's high adventure getting out on the water and close to wildlife in the inflatable Zodiacs.

Another great thing about ship-based travel is that you can bring your entire photographic arsenal: wide-angle to medium and long telephotos, extra camera bodies, you name it. (Weight is only an issue if you have to fly to the port of embarkation, and it's usually worth it to pay the oversize baggage fee.) I travel with a tripod for going ashore and a monopod for shooting on deck. I also travel with a bean neck support that doubles as a beanbag camera support on the ship's rail. You can also bring your laptop for downloading and reviewing your work as you go.

A ship-based photo expedition will help your photography grow by leaps and bounds. Each day is a new adventure, and sometimes you are even back on board in time for cocktail hour!

National Geographic Endeavour Framed through an Ice Arch, Antarctica

(Canon EOS 5D Mark II, Canon EF 70-200mm f/2.8L IS USM, 1/800 second
@ f/5.6, ISO 200, +0.67 EV, no filter)

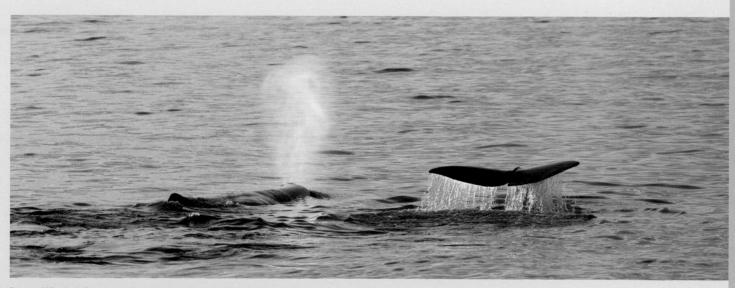

Sperm Whales, San Ignacio Lagoon, Baja California, Mexico

(Canon EOS 5D, Canon EF 300mm f/2.8L USM, 1/1250 second
@ f/8, ISO 400, -0.67 EV, no filter)

Playful Penguins

On an expedition to the south (for penguins!) aboard the National Geographic Endeavour, we were ashore along the Antarctic Peninsula in an area where icebergs are regularly grounded by tides and currents. Adelie penguins were using one iceberg in particular as a jungle gym, jumping around and pushing each other. There were about a dozen penguins, and it was clear they were playing. They would climb to the top, push each other off a ledge, and appear to fly.

I set up low to the ground to shoot their antics against a patch of blue sky behind the iceberg. This behavior happened over and over, as one penguin after another leapt off the ledge, with a little encouragement from his friends. There was plenty of light for a fast shutter speed (1/2000 second) to freeze the action at f/8.

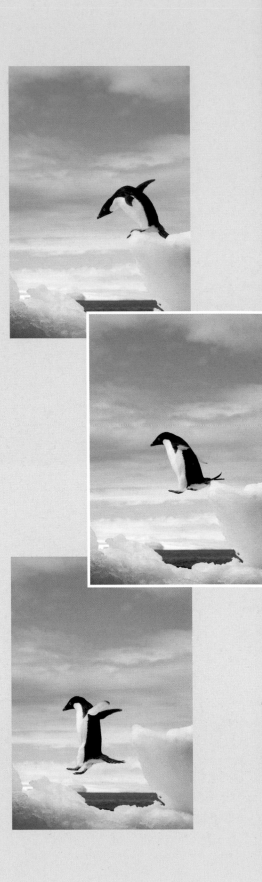

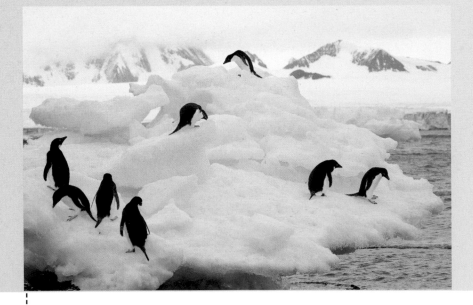

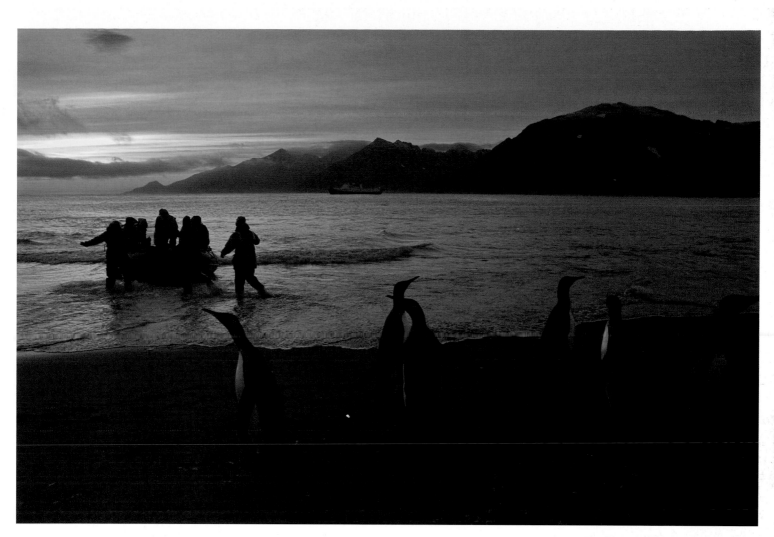

King Penguins Greet a Wet Landing at St. Andrews Bay, South Georgia

(Canon EOS 5D Mark II, Canon EF 24-70mm f/2.8L USM, 1/125 second @ f/2.8, ISO 400, 0.00 EV, no filter)

GET UP EARLY

Wildlife is most active early in the day, so getting up at the crack of dawn is essential. The wake-up call comes at the uncivilized hour of 3:45 A.M. It seems early even for a sunrise landing on the sub-Antarctic island of South Georgia, located in the Southern Ocean, 54° south of the equator. I don my thermal layers and rain gear, pulling on rubber boots for a guaranteed wet landing. By the time we hit the beach, the dawn sky is glowing pink, and it's time to get to work.

We are here at this hour because the regal king penguins are also coming ashore, bounding through the surf in bunches. There are photo opportunities in every direction. There's the symmetry of penguins lined up like bowling pins against the ice-caped mountains on the skyline, reflections off the water as the surf is pulled back out to sea, and the opportunity for motion blur at slow shutter speeds as the animals struggle through the waves to get ashore. I work the situation every way I know how. After awhile the light changes from pink to golden, then is snuffed out altogether by clouds, but not before spending two hours of some of the best photo opportunities ever.

King Penguins at Sunrise, St. Andrews Bay,
South Georgia

(Canon EOS 5D, Canon EF 24-70mm
f/2.8L USM, 1/500 second @ f/8, ISO 200,
0.00 EV, no filter)

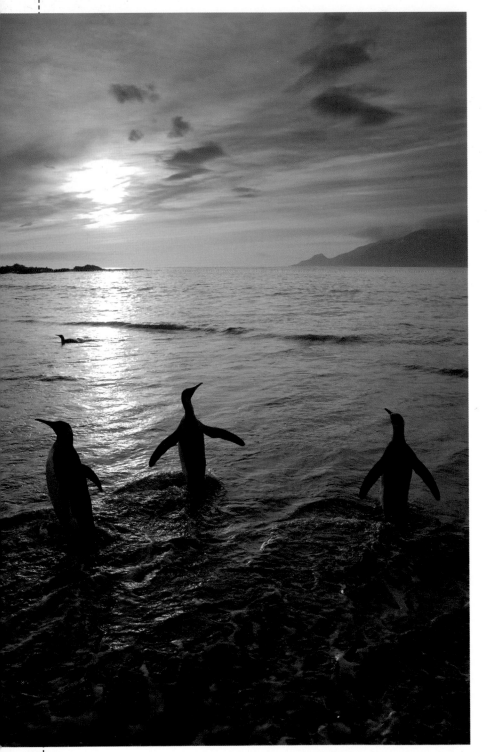

Zodiac and Humpback
Whale, Antarctica

(Canon EOS 5D, Canon
EF 24-70mm f/2.8L USM,
1/1250 second @ f/8, ISO
200, -0.67 EV, no filter)

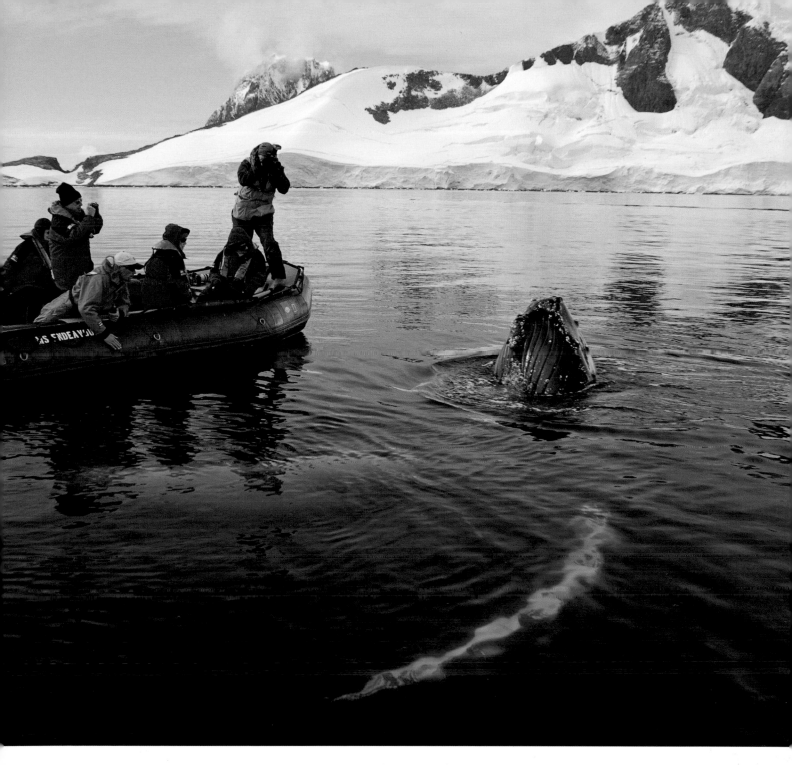

BE PERSISTENT

It takes dedication to see a project through. This step may not be for everyone. It's far easier to be a casual wildlife photographer, making the most of the easy opportunities during your travels, and there's nothing wrong with taking it easy and not making wildlife photography and major thing in your life. Sometimes, however, you might need to get to a location well before sunrise, and stay long after twilight. If you are dedicated and stick it out until the bitter end (the die-hards know who they are), at least you know you didn't miss the moment. It just didn't happen, for whatever reason.

BE INVISIBLE

Years ago, I was in Costa Rica staked out near a resplendent quetzal's nest, a beautiful green bird with a long red tail that inhabits the cloud forests in Central America. I was hiding in a makeshift blind, using a camouflage rain poncho wrapped around my tripod. I patiently huddled in the grass with my film camera and 300mm f/2.8 lens, photographing a pair of quetzals as they prepared their nest for the season's offspring. The poncho worked great as a blind and the birds ignored my presence.

Blinds: I mentioned blinds above, and many wildlife refuges have permanent blinds and viewing platforms that are open to the public at certain times of year (usually when the migratory birds are present). The key is to be set up in the blinds or on the platforms before sunrise. Then, stay put until the early light is gone or the action is over. There are also a number of one-person portable blinds on the market that are easily transportable to remote locations.

Vehicles: You may be surprised to learn that a lot of great wildlife photography is done from vehicles. Animals don't seem threatened by vehicles, and if sit you quietly and avoid sudden movements, they will ignore the vehicle all together. But get out of the car, and the game changes—animals view humans on the ground as predators, so the birds fly and the deer run. And the lions may eat you!

In Africa, Land Rovers are the modus operandi for getting out in the bush in search of wildlife. Closer to home, there are also many national parks and wildlife refuges where you can observe and photograph animals from your own vehicle. In Denali National Park, professional photographers can enter a lottery to secure their own road permit for photographing, and great wildlife sightings happen daily from the shuttle buses driving the park road out to Wonder Lake. In New Mexico, the Bosque del Apache Wildlife Refuge is another great place to photograph birds from your own vehicle.

Boats: As with working from a vehicle, boats and other small craft pose no recognizable threat to wildlife. Working on the expedition ships, I get to spend a lot of time in Zodiacs—small, rugged inflatable craft designed by the French and made famous by Jacques Cousteau. Zodiacs are essential for getting water-level views of marine life and wildlife along the shore. Kayaks, canoes, and other small boats can also provide stable platforms for photography on the water. And put on that life jacket!

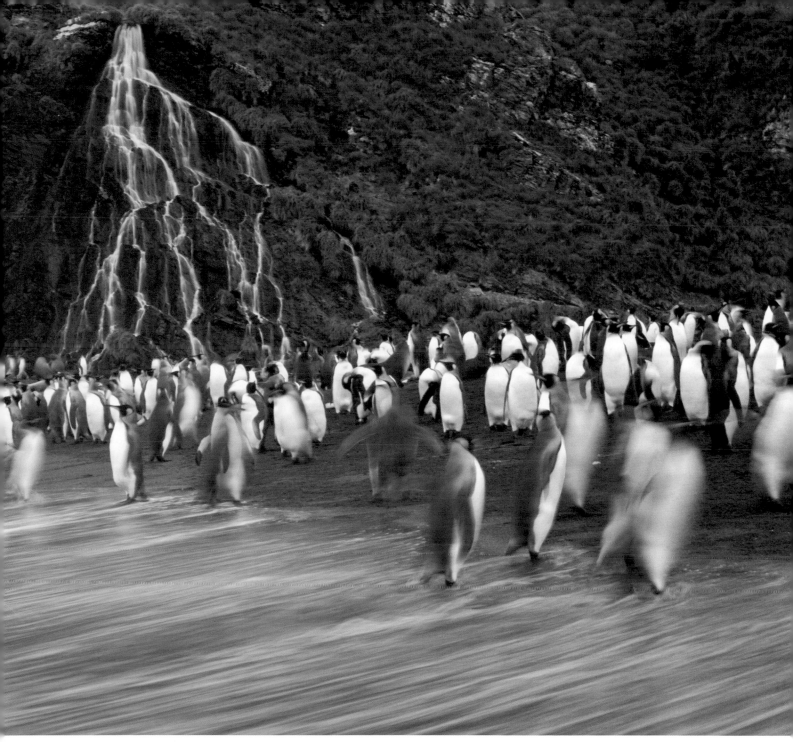

Stalking: Out in the field and on your own, there's an art to not being seen that involves staying low, moving very slowly, and remaining silent. Always approach wildlife into the wind to avoid giving away your scent. Wear dark or drab clothing to blend in with the surroundings. Pay attention to the animal's behavior; often body language will let you know if the animal is nervous or agitated. Walk a few feet, stop, and observe the animal's behavior. If the animal is relaxed, move a little closer. Be constantly mindful, respecting the animal at all times while trying not to alter or influence its behavior. The best situations are always when the animals come to you.

King Penguins in the Surf, South Georgia

(Canon EOS 5D, Canon EF 70-200mm f/2.8L IS USM, 1/4 second @ f/22, ISO 100, -0.67 EV, no filter)

With a tripod and a slow shutter speed, I captured the motion of flowing water and the penguins' movement.

Chestnut-Mandibled Toucan, Tortuguero National Park, Costa Rica

(Canon EOS 1D Mark II, Canon EF 70-200mm f/2.8L IS USM, 1/640 second @ f/8, ISO 200, -0.33 EV, no filter)

RESPECT THE GUIDELINES

Be sure to follow any local wildlife watching guidelines. Visitor guidelines in Antarctica suggest the closest approach at 15 feet (5 meters) for penguins. That's plenty close for full-frame shots with most telephoto zooms. Want a wide-angle point of view? Simply sit down and wait: the penguins may get curious and approach you. Luckily, many animals don't pay attention to guidelines or follow the rules.

Weddell Seal Relaxing, Paulet Island, Antarctica

(Canon EOS 5D, Canon EF 70-200mm f/2.8L IS USM w/1.4x, 1/250 second @ f/5.6, ISO 320, -0.33 EV, no filter)

Spiny-Tailed Iguana Eating a Cardon Cactus Blossom, Isla San Esteban, Baja California, Mexico

(Canon EOS 40D, Canon EF 100-400mm f/4.5-5.6L IS USM, 1/1400 second @ f/5.6, ISO 200, +0.33 EV, no filter)

IMAGES WITH IMPACT

Wildlife photography varies greatly from landscape photography. With landscapes, we take the time to compose the shot because that one shot should ideally capture the essence of the place. But wildlife is a different story; living animals are interesting and dynamic subjects, and you can't always translate the "full picture" of their life with just one well-composed shot. (And not many animals stay still long enough for the time it takes to compose that shot!) Wildlife photos need visual variety. To give your viewer the full story, it's important to shoot wildlife situations in many different ways. Establishing shots, environmental portraits, behavioral studies, and full-frame compositions all have their place.

THE ESTABLISHING SHOT

The establishing shot sets or "establishes" the scene and helps to introduce the animal and its surroundings. In wildlife photography, a well-composed establishing shot should provide an important sense of place, and tell the viewer something about the environment where the animals live. A good establishing shot is usually a wide view of the entire scene, and includes the animal in the composition as an element of scale. Ideally, this should be a thoughtful inclusion that shows a piece of the animal's reality, but take a few "safety shots" just in case.

Note: The "safety shot" is a backup image; you might fire off a few frames before getting into position, not knowing if the animals are going to present you with a better look. Safety shots are usually hurried and not well composed; hopefully they are the frames you delete later if a wildlife sighting develops into a good encounter.

I'm always on the lookout for a strong establishing shot. Look at any wildlife spread in a magazine and you will see that a good establishing shot is often the lead photo that sets the stage for telling a story with the images that follow. The story can document the life history of an animal, or illustrate the delicate balance and struggle for survival.

Amazing shots of action, interesting behavior, and full-frame headshots can follow, but the stage is set with a strong establishing shot, where the animal is shown in its natural habitat and you feel like you're there.

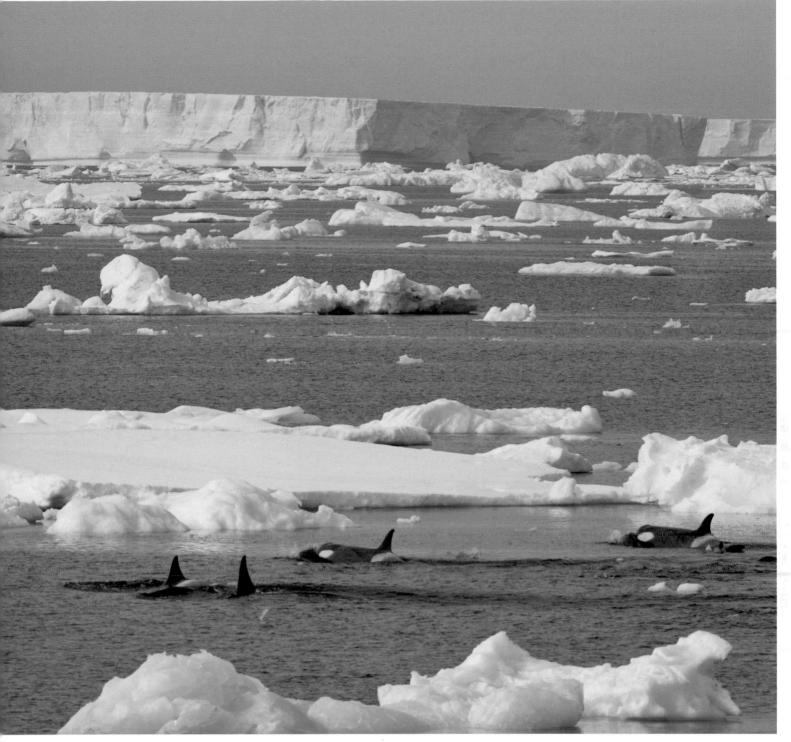

Killer Whales Navigate Pack Ice, Weddell Sea, Antarctica

(Canon EOS 1D Mark II, Canon EF 300mm f/2.8L IS USM, 1/1600 second @ f/8, ISO 200, -0.33 EV, no filter)

While on an expedition photographing polar bears in Svalbard, a good situation presented itself. As the polar bears came into view, to our surprise there was not just one, but three bears walking across the pack ice. The National Geographic Explorer nosed along the ice edge; hoping for a close approach, I mounted my long 500mm f/4 telephoto on a monopod, a good setup for shooting from the ship's deck. But these bears were heading slightly away from us now, so I switched to handholding the camera with my favorite lens, the Canon EF 70-200mm f/2.8 medium telephoto zoom. Whispering to myself, "spacing and separation," I anticipated what I thought would be the best composition. I was pre-visualizing a strong establishing shot for this arctic expedition, one that looks as cold through the viewfinder, as it feels here in the wind standing on the bow.

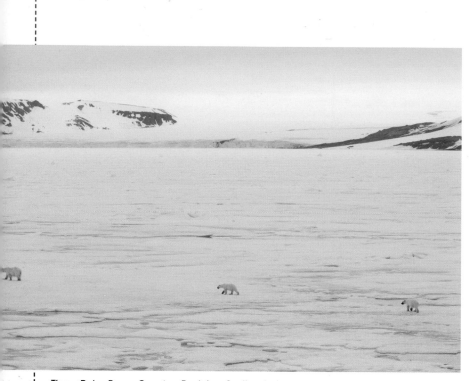

Three Polar Bears Crossing Pack Ice, Svalbard

(Canon EOS 5D Mark II, Canon EF 70-200mm f/2.8L IS USM, 1/640
second @ f/8, ISO 320, +1.33 EV, no filter)

ENVIRONMENTAL PORTRAITS

If the establishing shot sets the scene, then a successful environmental portrait zeroes in on the animal's way of life and how it relates to its environment. A good environmental portrait is a timeless image that captures a bit of the essence of the animal and the way it lives. A leopard framed through the brush, or a giant tortoise wallowing in the mud make strong visual statements about the animal and how it interacts its surroundings.

My experience with medium-format trained me to look for ways to photograph animals in their natural habitat by forcing me to slow down and think about each shot. Often we are so intent on getting full-frame shots that we forget to back off and include elements of their surroundings to show where the animals live.

Years ago I was camped high in Colorado's Never Summer Range working on the guidebook, "Hiking Colorado's Geology." Darting back and forth among the boulders where gerbil-like creatures, called pikas. The pika's alarm cry—a sharp "eeeek!"—echoed through the valley. I camped among them for a couple of days, fascinated by their antics and strong sense of purpose.

As the bears continued their pace across the ice, it happened. The lead bear slowed down and the other two caught up. I placed them in the lower third of the frame to show the magnitude of the landscape, and minimized the gray clouds on the skyline to make the scene as white as possible. I wanted to communicate the cold, barren feel of their habitat. I shot a series of frames from horizontal to vertical, and overlapped frames with panoramic stitches in mind.

When a good situation presents itself, I try to cover all bases: full-frame close-ups, details, and wide-angle points of view; but always on the lookout for that poetic establishing shot that captures the feeling of being there.

Sitting among the boulders with my digital camera and 300mm f/2.8 lens on a tripod, I photographed their frenetic activity. It took some time until they ignored me altogether and went about their business. After tracking one pika for a couple of hours, the stubborn little guy finally paused on a rock with a mouthful of grass. He cocked his head sideways and stared right into the lens, making sure I got the shot before scurrying off and getting back to business.

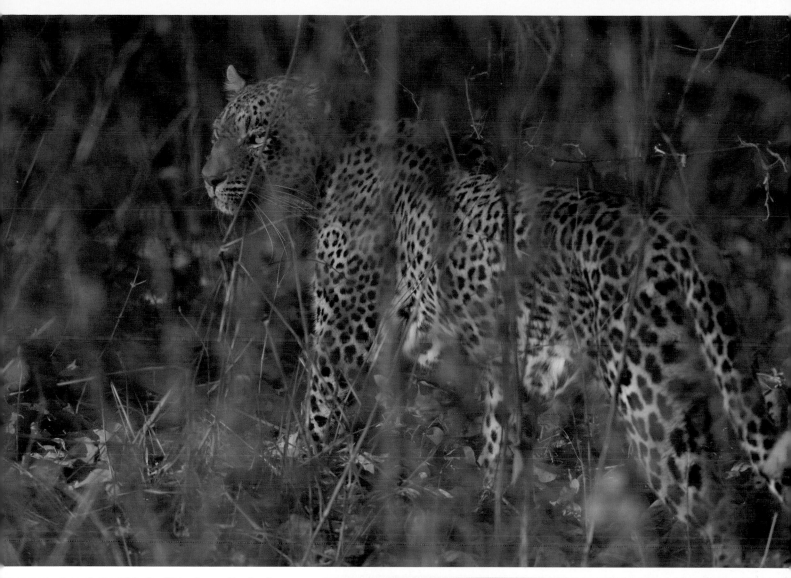

Leopard in the Grass, Lower Zambezi National Park, Zambia, Africa

(Canon EOS 1D Mark III, Canon EF 500mm f/4 IS USM, 1/640 second @ f/5.6, ISO 400, -0.67 EV, no filter)

It turns out that pikas (also called coneys) are cousins of the rabbit, and spend all summer collecting hay, drying the hay in stacks, then stashing the dry hay beneath the boulders in the talus slopes. They don't hibernate during the winter, instead living underground among their haystacks for warmth, insulation, and food. Little did that pika know that he positioned himself perfectly for a very telling environmental portrait about how pikas live among boulders.

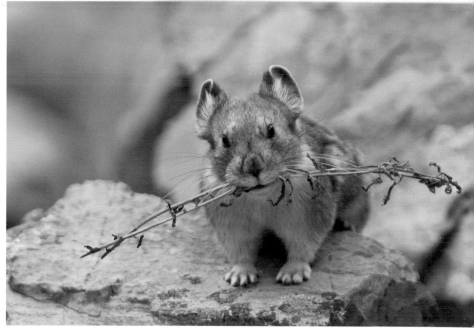

Pika with a Mouthful, Never Summer Range, Colorado

(Canon EOS 10D, Canon EF 70-200mm f/2.8L IS USM w/1.4x, 1/640 second @ f/5.6, ISO 400, -0.67 EV, no filter)

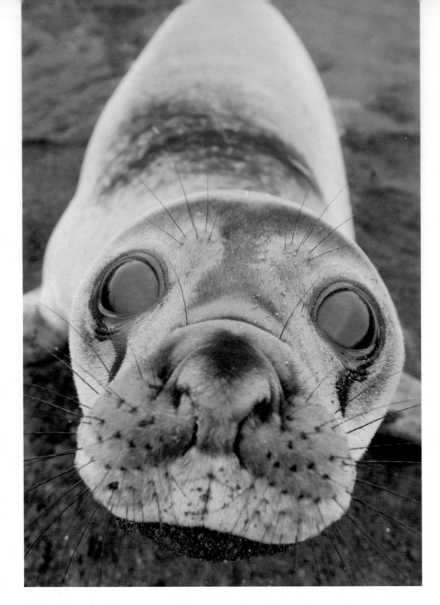

Oakum Boy, St. Andrews Bay, South Georgia

(Canon EOS 1D Mark II, Canon EF 70-200mm f/2.8L IS USM, 1/80 second @ f/5.6, ISO 100, 0.00 EV, no filter)

Curious Pup, Southern Elephant Seal, St. Andrews Bay, South Georgia

(Canon EOS 1D, Canon EF 16-35mm f/2.8L II USM, 1/250 second @ f/5.6, ISO 200, 0.00 EV, no filter)

FILL THE FRAME

Now that I've convinced you how important it is to include establishing shots and environmental portraits in your visual narrative, it's time to zoom in and create wildlife images with impact. That's right: fill the frame. After all, it's the in-your-face, full frame shots that usually get the most attention and the most "oohs" and "aahs" in a slide show.

Filling the frame with your compositions creates a strong center of interest that demands the viewer's attention. Especially in wildlife photography, a full frame shot that includes the eye of the animal leaves no doubt where the viewer should look. There's a power and an impact that looser compositions just can't convey.

Focus on the Eye: It's important to focus on the animal's eye when you are shooting full-frame compositions. If you get the eye tack sharp, focus can fall off on the rest of the animal without distracting from the impact of the image. To accomplish this I set a single focal point in my viewfinder and aim with that point to lock on the eye. If it's necessary, I move the single focal point around in the frame to avoid the bull's eye syndrome that happens when the focus point is in the center.

Shoot from a Low Angle: It's also important to gain a low vantage point, preferably at or below the eye level of the animal you're photographing. The low camera angle imparts a feeling of power. Also watch for distracting backgrounds. If you can't eliminate the distracting elements, use a shallow DOF to throw the background out of focus.

Use Long Lenses: Sometimes even though I can get close to the wildlife, I'll actually back up and use a longer focal lengths for the shallow DOF and compressed perspective. And then I will zoom in even tighter, eliminating the background altogether. Use a long focal-length lens to make the animals appear larger in the frame, especially if you can't get physically close.

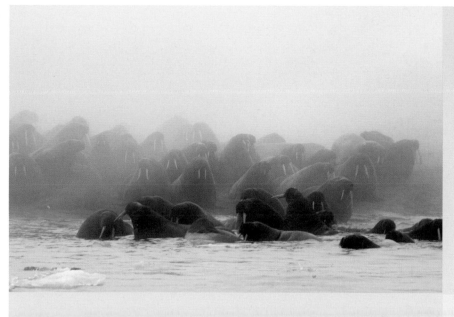

One of the best walrus encounters I've ever experienced illustrates the impact of filling the frame when photographing wildlife.

It had been foggy for days in Norway's Svalbard Archipelago, making it difficult to find wildlife. We were at Cape Lee, where walrus are known to haul out on shore. As we navigated through the fog, we shut off the engines and paddled closer to shore.

It didn't take long to confirm that the walrus were home; even though we couldn't see them we could hear their snorts, and there's no way to miss their smell. As we drifted closer we finally saw the walrus hauled out on shore—over 50 animals huddled together. I zoomed in with my beloved 70-200mm f/2.8 medium telephoto, filling the frame from edge-to-edge with walrus and the repetition of their heads and tusks disappearing into the foggy background. In wide-angle views of the same scene the walrus were lost in the fog.

A few of the walrus were also in the water and started to approach the Zodiacs. One by one these large marine mammals poked their heads up making eye contact. They were definitely checking us out but made no threatening gestures (walrus are known to attack small boats without warning). Out of nowhere, four heads surfaced not far from the boat. Without hesitation I filled the frame with walrus faces, then zoomed in on the closet animal just as it puckered its lips at water level (see page 20 for this image).

The fog had been somewhat of a blessing in disguise, forcing me to zoom in for tight compositions and simplify the frames with the soft gray background. The diffuse light also helped capture the color and rough texture of the walrus' skin.

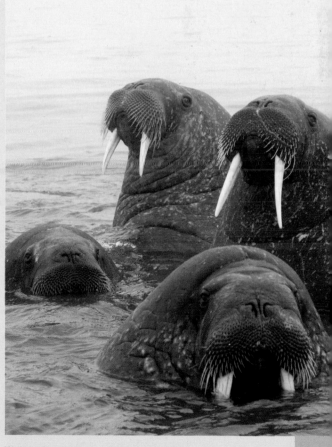

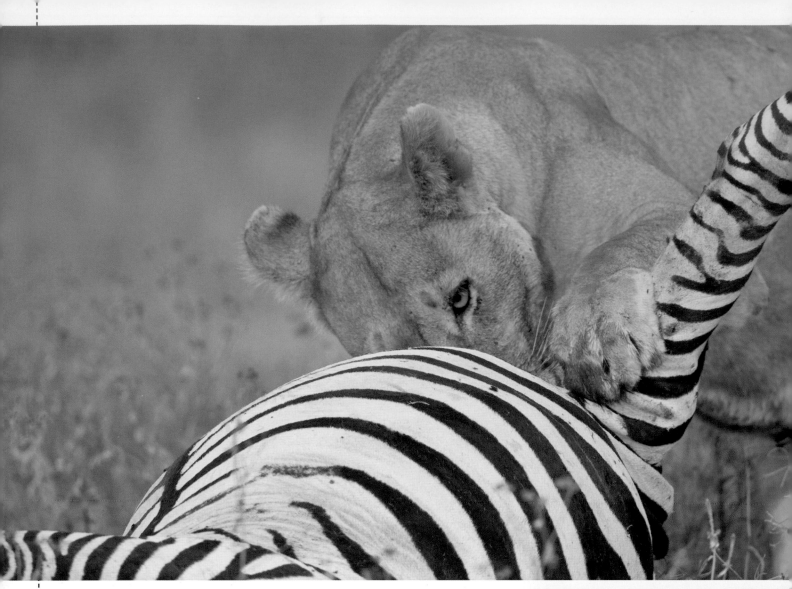

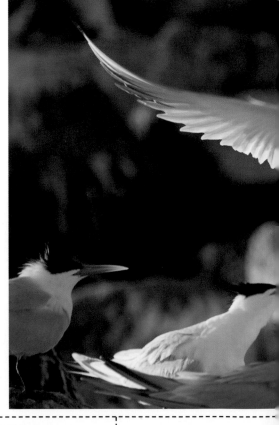

African Lion with Kill,
Lake Ndutu, Serengeti
National Park, Tanzania

(Canon EOS 1D Mark III,
Canon EF 500mm f/4 IS
USM w/1.4x, 1/250 sec-
ond @ f/5.6, ISO 400,
0.00 EV, no filter)

WILD BEHAVIOR

While great wildlife portraits are a worthy goal, behavior tops the list of all the things to look for when photographing wildlife. Whether it's a lion with its kill, elegant terns courting, or mating scarlet macaws, capturing wildlife behavior and interaction between animals is the "Holy Grail" for wildlife photographers. The pursuit of wildlife behavior will test your mettle as a wildlife photographer. To do it well takes plenty of time, dedication, and patience. But like all worthy pursuits in photography, the rewards are worth the effort. A strong sequence of behavioral images is an important contribution in educating people about the animal's lifestyle and threats to its environment, as well as an impressive series in your image collection.

As discussed throughout this chapter, having knowledge of the animals you are photographing will help put you in good situations, as well as prepare you for what type of behavior to look for. What happens next is up to you and the animals in question.

Be Prepared: In the moment of truth, you must be one with your camera; this is no time to get caught up in the technical game. What will set you apart as a good wildlife photographer is going through your mental checklist before the action starts. Use a mindful approach when setting up for the shot. Tweak the composition to simplify the frame by avoiding distracting elements. Pay attention to the f/stop and envision the DOF you want. Assess the light conditions with shutter speed in mind, increasing the ISO as necessary for making sharp images (or not, if you're going for motion blur). Set the shooting mode to aperture priority or switch to manual—whatever makes you most comfortable. If you are looking to blur the action, switch to shutter priority. If there's time, make a couple of test shots and review the histogram, adjusting the exposure compensation to avoid blowing out any highlights.

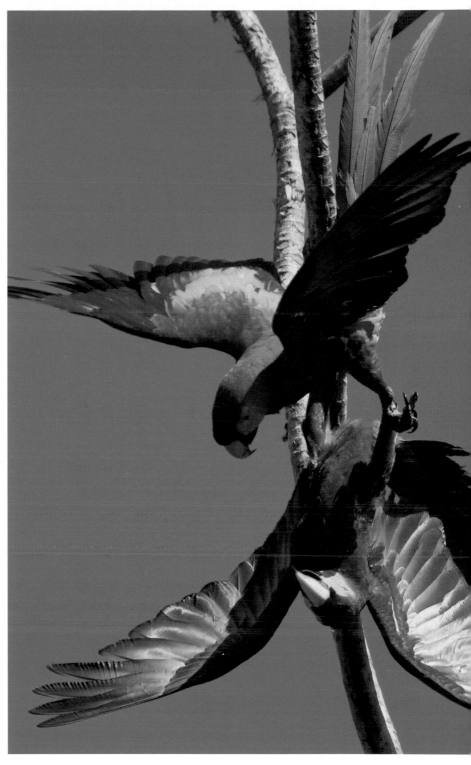

Scarlet Macaws Mating, Corcovado National Park, Costa Rica

(Canon EOS 1D Mark II, Canon EF 300mm f/2.8L IS USM w/2x, 1/2500 second @ f/5.6, ISO 200, -0.67 EV, no filter)

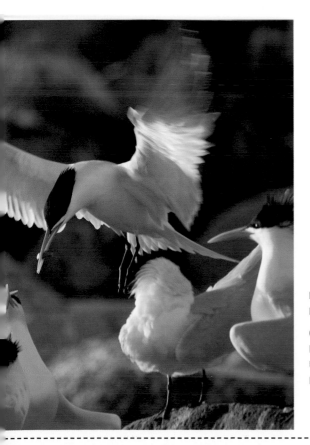

Elegant Terns Courting, Isla Rasa, Baja California, Mexico

(Canon EOS 1D Mark III, Canon EF 100-400mm f/4.5-5.6L IS USM, 1/640 second @ f/5.6, ISO 320, -1.0 EV, no filter)

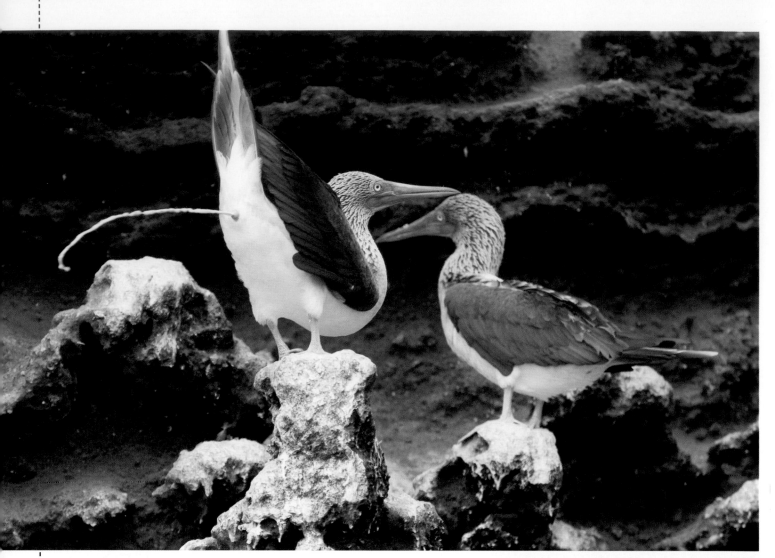

Blue-Footed Booby
Lets Go, Galapagos
Archipelago, Ecuador

(Canon EOS 1D Mark III,
Canon EF 70-200mm
f/2.8L IS USM w/1.4x,
1/400 second @ f/5.6, ISO
400, -0.67 EV, no filter)

Freeze the Action: One way to shoot behavior is with a fast shutter speed to freeze the action. A howler monkey jumping between trees in the canopy, a humpback whale splashing with its fluke (a behavior called tail lobbing), dolphins leaping, or a gull dropping a clam on the rocks all require a fast shutter speed of 1/1500 second or more. A general rule for fast moving action is, if you see it in the viewfinder, you've probably missed the shot—the shutter must be open during those key moments.

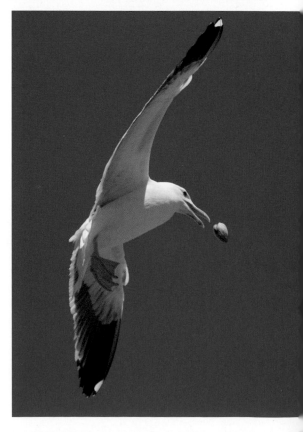

Yellow-Footed Gull, Sea of Cortez, Baja
California, Mexico

(Canon EOS 1D Mark III, Canon EF 100-
400mm f/4.5-5.6L IS USM, 1/1600 sec-
ond @ f/8, ISO 400, 0.00 EV, no filter)

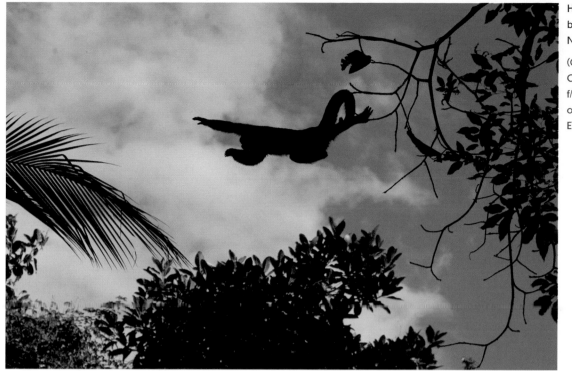

Howler Monkey Jumping between Trees, Corcovado National Park, Costa Rica

(Canon EOS 1D Mark II, Canon EF 70-200mm f/2.8L IS USM, 1/2500 second @ f/5.6, ISO 400, -0.67 EV, no filter)

Lava Heron Fishing, Galapagos Archipelago, Ecuador

(Canon EOS 1D Mark II, Canon EF 70-200mm f/2.8L IS USM, 1/800 second @ f/4, ISO 200, -0.33 EV, no filter)

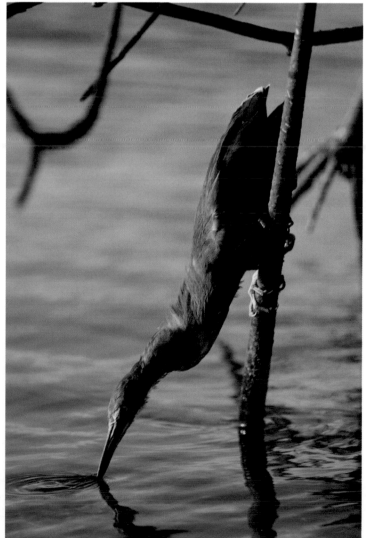

Continuous Drive and Focus:
No, not you—your camera! To capture the moment, it's important to shoot the sequence using continuous drive or burst mode. My camera is almost always set for continuous focus tracking, so the camera focuses constantly while I follow the action. I habitually check my settings and am always ready for action. The sequence of a lava heron in Galapagos fishing from the mangrove roots is a perfect example. A moment like this happens too quickly to get the shot by pure chance. You can't always make up for it by just blasting away hoping to get lucky; anticipate and pick your moments carefully, shooting in short bursts. The last thing you want is to have your camera pause while the buffer is full because you held the shutter button down. That's the digital equivalent to being out of film when the moment happens.

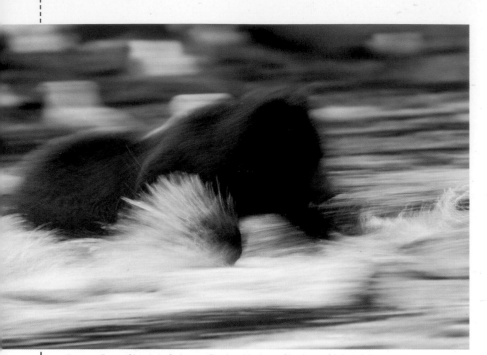

Brown Bear Chasing Salmon, Pavlov Harbor, Chichagof Island, Tongass National Forest, Alaska

(Canon EOS 1D Mark II, Canon EF 100-400mm f/4.5-5.6L IS USM, 1/15 second @ f/8, ISO 100, 0.00 EV, no filter)

Motion Blur: Another effective way to capture behavior and action is by showing a sense of movement using slower shutter speeds. To accomplish this, set your ISO to its lowest value and switch to shutter priority. This allows you to select the desired shutter speed, while the camera sets the f/stop according to the available light conditions. Be sure that the light is low enough for your desired shutter speed. If it's too bright the camera may not be able to shoot at 1/15 of a second, for example, and may require the use of a neutral-density filter to lessen the light coming through the lens.

I particularly like to pan with flying birds to show motion in the wings. You have to be willing shoot a lot of frames and continually adjust your technique after peeking at the results on your camera's LCD screen. There's a fine line between artistic blur and just plain blurry, so take the time to get it right. "Almost" doesn't count when it comes to wildlife photography.

Killer Whale Surfacing, Stephan's Passage, Southeast Alaska

(Canon EOS 1D Mark II, Canon EF 70-200mm f/2.8L IS USM, 1/60 second @ f/5.6, ISO 200, -0.67 EV, polarizer)

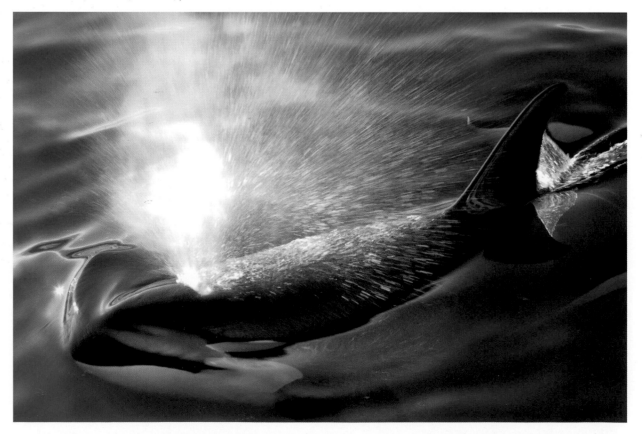

Lone Leaping
Bottlenose Dolphin,
Sea of Cortez, Baja
California, Mexico

(Canon EOS 1D
Mark II, Canon
EF 300mm f/2.8L
IS USM w/1.4x,
1/1600 second @
f/8, ISO 400, 0.00
EV, no filter)

POWER IN NUMBERS

I pay attention to animal groups when photographing wildlife, keying into odd numbers and animals in interesting arrangements. I'll look for two animals interacting, or an isolated animal off by itself. I often joke that one is lonely, two is cute, and three is dynamic. But, as with most humor, there's an element of truth.

One is Lonely: One animal out in the landscape provides scale for an establishing shot—a lone caribou against a mountain backdrop or a solitary polar bear crossing pack ice. With just one animal in the frame, the landscape feels larger. The animal can appear lonely, lost, or vulnerable, like a single penguin heading out into white space, or one bottlenose dolphin leaping in the distance. Shooting a single animal up close imparts an emotional connection and a feeling of intimacy, especially when making eye contact. For tight shots, focus on the closer eye.

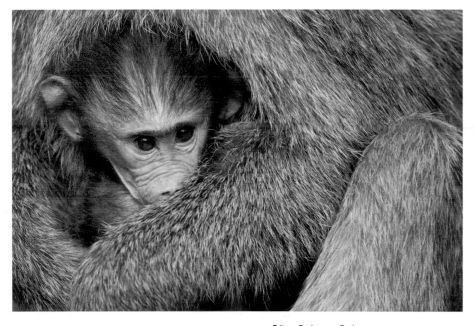

Olive Baboon Baby,
Ngorongoro Crater, Tanzania

(Canon EOS 40D, Canon EF
70-200mm f/2.8L IS USM,
1/500 second @ f/5.6, ISO
200, -0.33 EV, no filter)

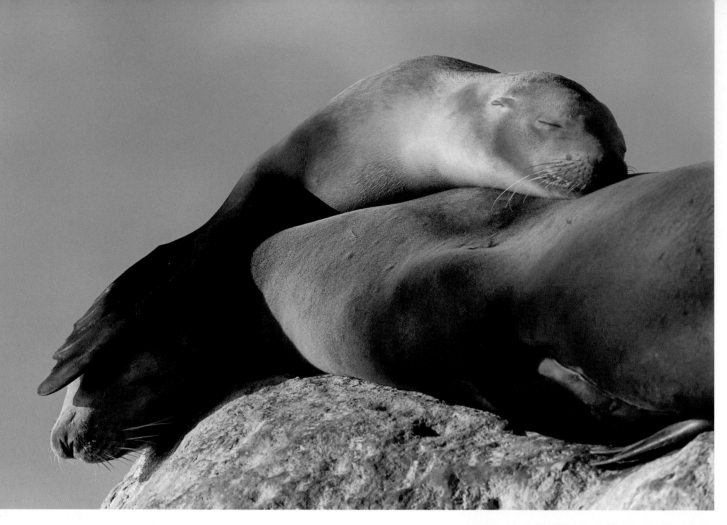

Sea Lion Siesta,
Mother and Pup, Los
Islotes, Espiritu Santa
Archipelago National
Park, Baja California,
Mexico

(Canon EOS 10D,
Canon EF 300mm
f/2.8L IS USM, 1/800
second @ f/5.6, ISO
400, -0.33 EV, no filter)

Two is Cute: Two animals can impart a feeling of togetherness and companionship. Wildlife pairs make cute couples, especially if they appear to be touching, whether sea lions sleeping together, a baby monkey on mom's back, or an adult penguin with a chick. Animal pairs sometimes exhibit courting behavior, imparting a feeling of romance or love. Interactions between two animals can be fleeting, so it's critical to be observant. To improve your success rate, pre-focus on an active pair of animals and be ready click the shutter. Especially with advanced compact cameras, pre-focusing minimizes shutter lag.

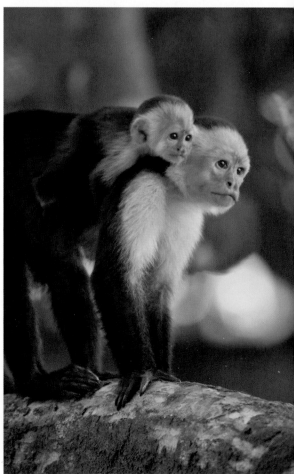

White-Faced Capuchin, Mother and Baby, Corcovado National Park, Costa Rica

(Canon EOS 1D Mark II, Canon EF 300mm f/2.8L IS USM w/2x, 1/100 second @ f/5.6, ISO 800, -0.67 EV, no filter)

Three Guanacos, Torres del Paine
National Park, Chile

(Canon EOS 10D, Canon EF 70-200mm
f/2.8L IS USM w/1.4x, 1/400 second @
f/5.6, ISO 200, -0.67 EV, no filter)

Three is Dynamic: And then are
three—guanacos looking in the same direc-
tion, sandhill cranes taking off, vervet
monkeys looking at the camera, three baby
turtles heading out to sea, three penguins in
the surf. I look to photograph three animals
more than any other number because of the
"rule of odds." The rule of odds suggests that
odd numbers create a dynamic image that is
aesthetically appealing. Odd numbers create
patterns and symmetry in your compositions,
and three animals can form a triangle—a
geometrical shape that draws the viewer's
eye into the photo.

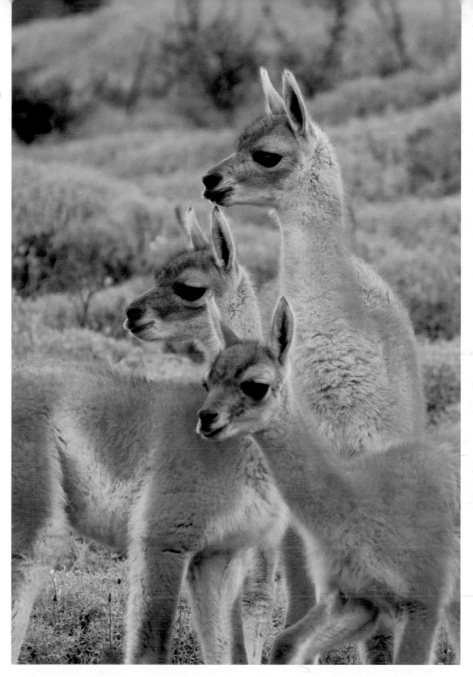

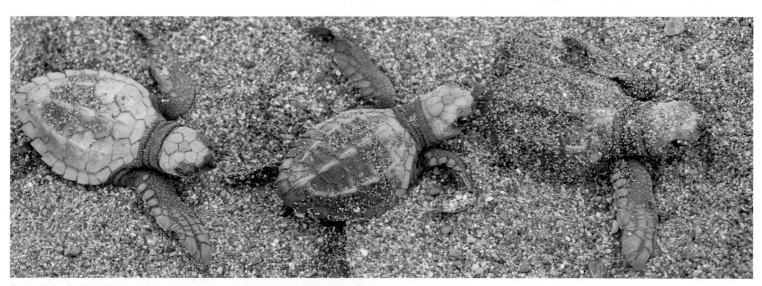

Three Baby Turtles Heading Out to Sea, Corcovado National Park, Costa Rica

(Canon EOS 1D Mark II, Canon EF 100mm f/2.8 USM Macro, 1/200 second @ f/8, ISO 200, -0.67 EV, no filter)

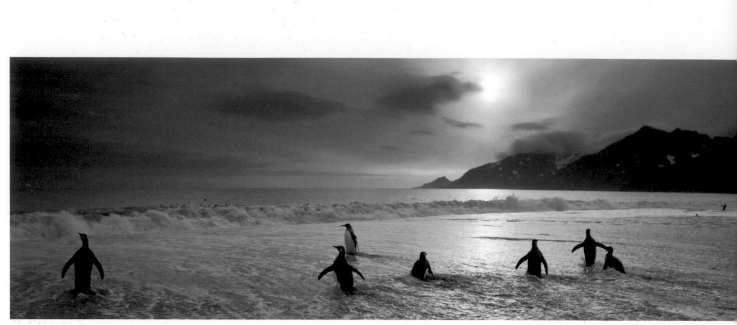

King Penguins in the Surf, St. Andrews Bay, South Georgia

(Canon EOS 5D, Canon EF 24-70mm f/2.8L USM, 1/500 second @ f/5.6, ISO 320, -0.67 EV, no filter)

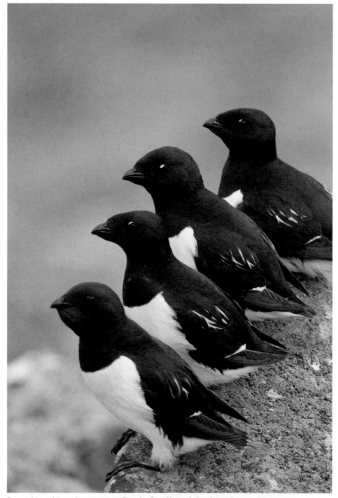

Dovekies Lined up on a Rock, Svalbard Archipelago, Norway

(Canon EOS 1D Mark II, Canon EF 300mm f/2.8L IS USM w/2x,
1/160 second @ f/8, ISO 200, 0.00 EV, no filter)

Four or More: Shooting groups of animals can be the most challenging of all. It's easy for groups to appear unorganized and cluttered. I get around this by looking for patterns or pleasing clusters of animals within the larger group, like picking out a tight arrangement of zebras, or a grouping of dovekies lined up on a rock. It also works to look for behavior and interactions between animals within the groups, like lions snarling at each other as they share a kill.

When shooting groups, I find it very effective to take a low vantage point, setting up my tripod low to the ground, or lying down and bracing my camera with my elbows. By getting low, I can frame the animals against the skyline. This is particularly effective when shooting penguins—they are curious and often approach closely.

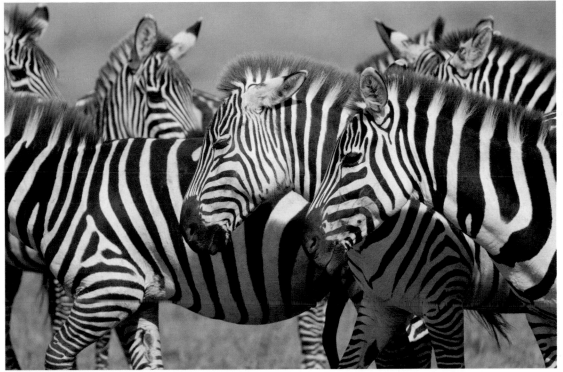

Zebras, Serengeti National Park, Tanzania

(Canon EOS 1D Mark III, Canon EF 500mm f/4 IS USM w/1.4x, 1/1600 second @ f/5.6, ISO 200, 0.00 EV, no filter)

Lions Sharing a Kill, Lower Zambezi Naitonal Park, Zambia

(Canon EOS 1D Mark III, Canon EF 500mm f/4L IS USM, 1/1250 second @ f/8, ISO 400, -0.67 EV, no filter)

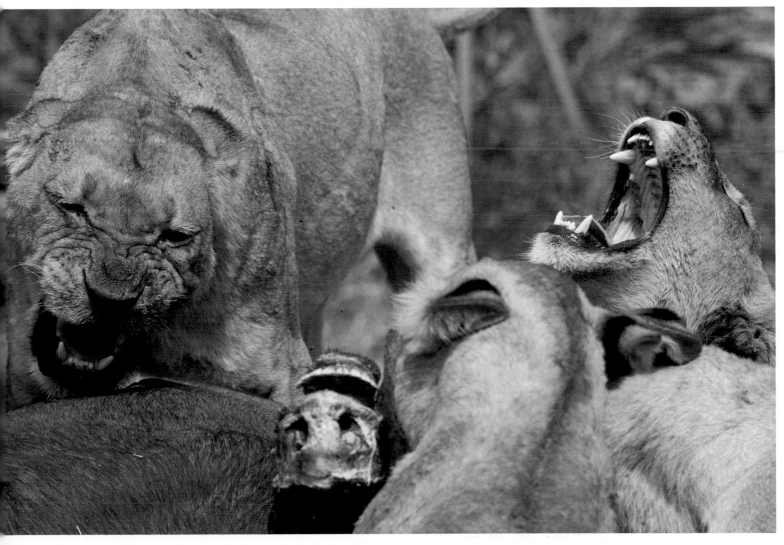

Close-Up Detail, Sacred Datura flower, Grand Canyon National Park, Arizona

(Canon EOS 1D Mark II, Canon EF 100mm f/2.8 Macro USM, 1/250 second @ f/22, ISO 200, +0.67 EV, no filter)

Chapter 9: The Macro World

"There is nothing worse than a brilliant image of a fuzzy concept." – Ansel Adams

Are you drawn to flowers on the forest floor, raindrops on a feather, or the intimate details of a single saxifrage flower? Welcome to the macro world. There's an entire universe waiting for nature photographers with curious minds willing to explore the little things close up.

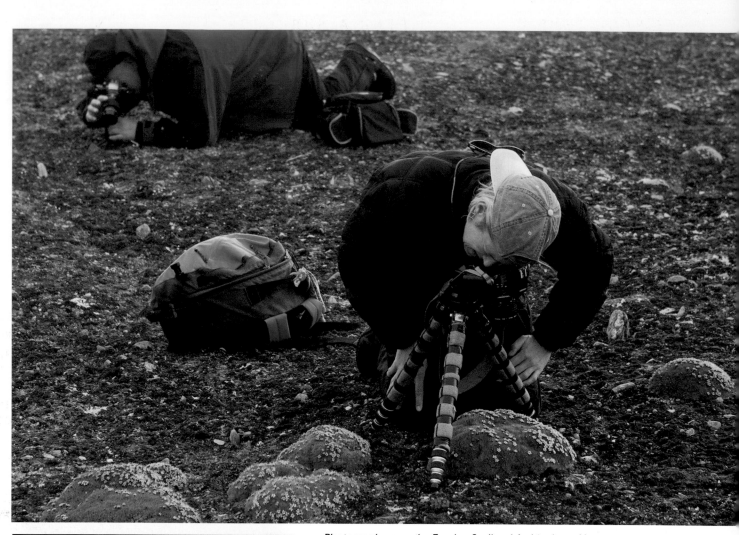

Photographers on the Tundra, Svalbard Archipelago, Norway

(Canon EOS 1D Mark II, Canon EF 24-70mm f/2.8L USM, 1/60 second @ f/5.6, ISO 200, +0.33 EV, no filter)

PREP FOR MACRO

I smile remembering Arctic photo expeditions with photographers on their hands and knees, spread across the tundra. They were there for over an hour, and still less than 100 yards from the landing point. The tundra is a fascinating microcosm, full of miniature wildflowers and willow trees only inches tall. Interesting subjects and patterns occur on many different scales in nature—even in your own backyard—and once you start down that rabbit hole there's no turning back.

Blue Columbine, San Juan Mountains, Colorado

(Canon EOD 10D, Canon EF 24-70mm f/2.8L USM, 1/125 second @ f/5.6, ISO 200, +0.22 EV, no filter)

TAKE YOUR TIME

Close-up work takes time and can't be rushed, mainly because the element of precision plays a huge role in macro photography. While you can sometimes get away with laziness and bad habits when you shoot landscapes, this is not the case with macro. Magnifying an image means magnifying its imperfections. A sloppy approach results in soft or out-of-focus images that usually end up being deleted.

Macro photography demands good technique, a few essential pieces of equipment, and a keen eye for composition. Like everything in nature photography, it also requires a great deal of time and patience, especially if there's a breeze blowing (wind is the enemy in macro work).

FIND A SUBJECT

Finding a subject for your macro photography is no problem—just walk out your back door. In fact, anytime you take your camera out to shoot, whether you are shooting a breathtaking landscape or trailing bears in Alaska, you can find a wealth of macro subjects. Flowers, tree bark, insects, moss, and shells all make for fantastic macro subjects. There are a few things to look for that will set your macro shots apart: contrasting colors, like a red blossom against green leaves; similar objects in various sizes, such as fall leaves on the forest floor; and variations in textures, such as raindrops on a feather.

Raindrops on Glaucous Gull Feather, Svalbard Archipelago, Norway

(Canon EOS 10D, Canon EF 100mm f/2.8 Macro USM, 1/80 second @ f/8, ISO 200, +0.33 EV, no filter)

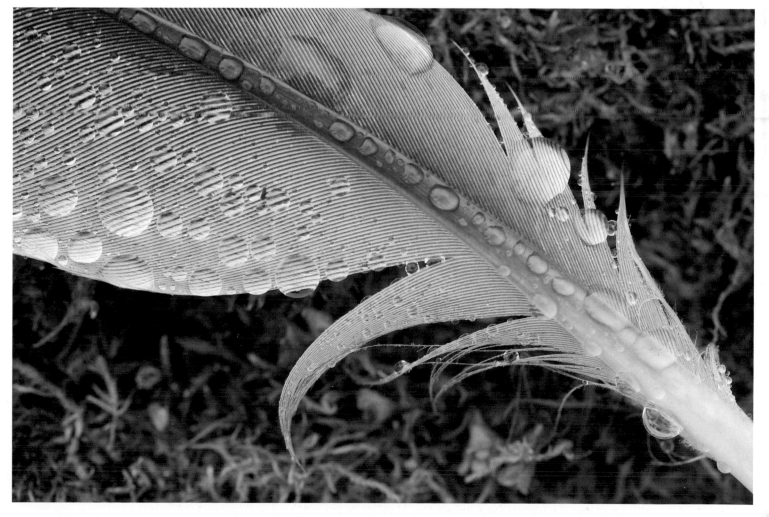

Poison Dart Frog,
La Selva Biological
Station, Costa Rica

(Canon EOS 10D,
Canon EF 100mm
f/2.8 Macro USM, 1/80
second @ f/8, ISO 200,
0.00 EV, fill flash)

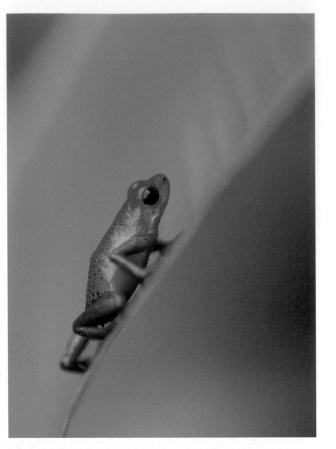

MINIMIZE MOVEMENT

This is one of the most important aspects for successful macro photography: minimize movement in your photo. Everything in macro photography is smaller—including the amount of light. Less light means slower shutter speeds, so subject and/or camera movement can be a real issue. Minimizing camera movement is easy: put that camera on a tripod! But if you are shooting in an open area, even the slightest breeze can make a great composition into a mediocre image. Minimize subject movement as much as possible—create a wind block with a tent, or use your body to shield the subject from any breeze (and don't breath too hard when you push the shutter button!). Also, fill flash is a good way to freeze subject movement when you don't have as much control, such as shooting a lizard, insect, or any other animal that moves independently.

Orange Crustose Lichen on Marble Boulder, Svalbard Archipelago, Norway

(Canon EOS 5D, Canon EF 24-105mm f/4L IS USM, 1/250 second @ f/8, ISO 400, -0.33 EV, no filter)

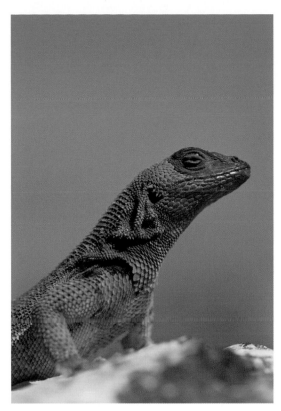

Lava Lizard, Espanola Island, Galapagos Archipelago, Ecuador

(Canon EOS 5D, Canon EF 100mm f/2.8 Macro USM, 1/1600 second @ f/5.6, ISO 200, 0.00 EV, no filter)

STUDY THE LIGHT

To begin with, making close-up images is more about the quality of light and compositional elements than about the moment itself. The first thing I do when approaching a macro subject is to study the light, taking into account both the quality (soft or harsh) and the direction. I can position myself to control the angle of light that I want in the image. Also remember that there is less light striking the sensor plane because the camera is closer to the subject, requiring slower shutter speeds. The closer you focus, the less light there is to work with.

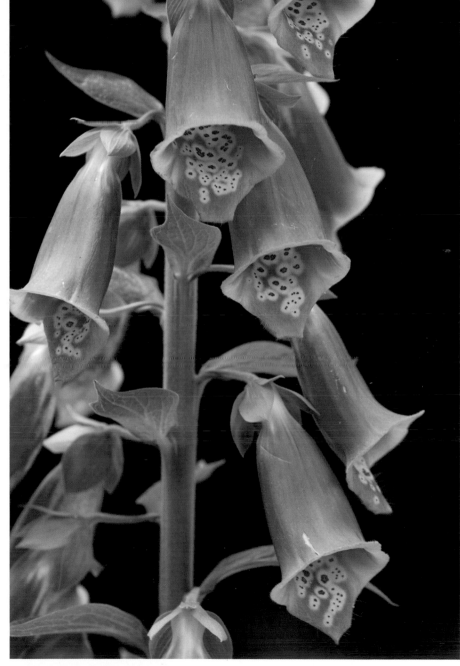

Foxglove, Tongass National Forest, Alaska

(Canon EOS 10D, Canon EF 100mm f/2.8 Macro USM, 1/10 second @ f/5.6, ISO 200, 0.00 EV, no filter)

FIND AN ANGLE

Work the subject to find an interesting composition. This involves deciding the exact position of the camera, how high or low, and how close. As with all nature photography, the same compositional guidelines apply—look for leading lines, find a strong center of interest, and compose with clean backgrounds. When in doubt, get even closer and use the limited DOF to help simply the frame.

LOOK FOR MOMENTS

If while going through the process of approaching a macro subject there's an opportunity to capture a moment, shoot it. The moment is still what puts an image over the top. You may be lucky enough to have a butterfly show up right on cue. Capture the moment with wings out and the resulting image is far more interesting and dynamic. If you can manage to add a sense of moment to your close-up composition, maybe you'll create a masterpiece.

BE PRECISE

Shooting close-up images demands more precision and accuracy than other branches of nature photography because of the inherent shallow DOF, making subject selection and where you focus of critical importance. The closer your camera is to the focal plane, the less DOF you have to work with, making it a challenge to get all parts of macro subjects in sharp focus.

Glasswing Butterfly, Monte Verde Cloud Forest Preserve, Costa Rica

(Canon EOS 1D Mark II, Canon EF 100mm f/2.8 Macro USM, 1/100 second @ f/2.8, ISO 200, -0.67 EV, no filter)

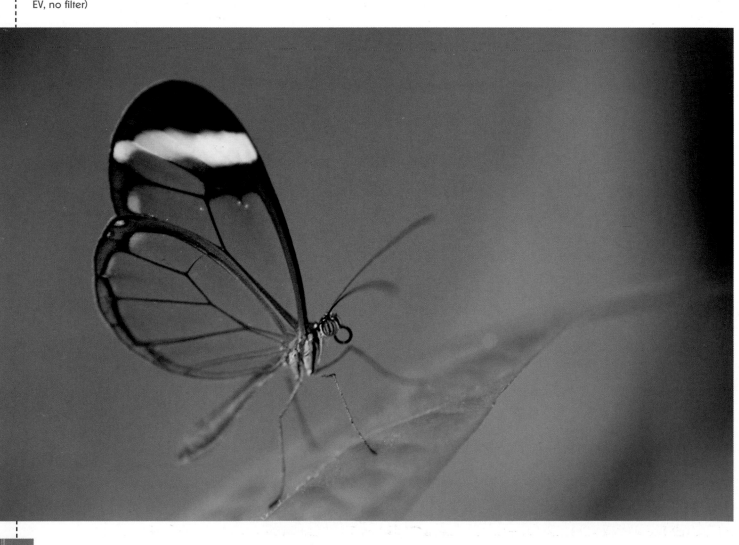

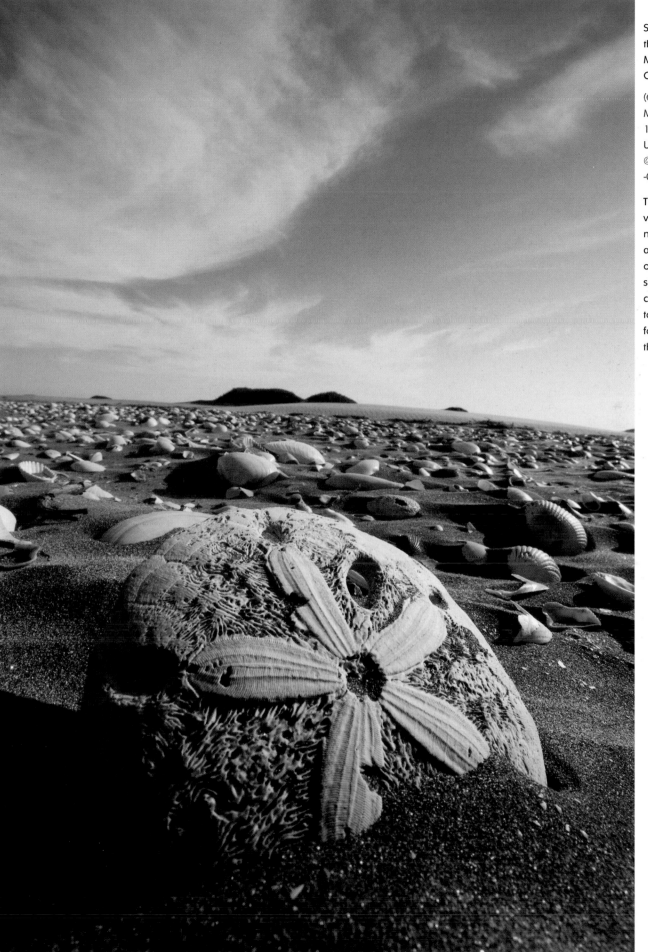

Sand Dollar on the Beach, Isla Magdalena, Baja California, Mexico

(Canon EOS 1D Mark II, Canon EF 16-35mm f/2.8L II USM, 1/125 second @ f/22, ISO 200, -0.33 EV, no filter)

This is how live view can help you nail the shot. I balanced the camera on a foreground shell and paid careful attention to the plane of focus to maximize the DOF.

ESSENTIAL EQUIPMENT

The great thing about macro photography is that you don't need a ton of equipment to make good images. This is not like shooting wildlife where you need an arsenal of cameras and long lenses. Macro photography requires only a digital camera with the ability to focus closely and magnify the subject. This can be accomplished with either an advanced digital camera with macro capabilities, or a D-SLR with a dedicated macro lens. What could be simpler? You can always go all out with extension tubes, close-up lenses, and flash attachments—and don't forget your tripod!—but there are ways to achieve the good results with less equipment.

CAMERAS

Advanced Digital Cameras: The popularity of advanced digital cameras is growing with each new generation and improvement in image quality. Because of the spontaneity factor and ease of use, I also carry one and consider it important equipment, especially for macro work.

- Macro mode allows for close focusing

- Compatible with special lens attachments for macro

- Amazing depth of field (DOF) at close focusing distances

- Live view allows you to compose and nail critical focus

- Foldout LCD screen for ease of camera placement

Equipment Checklist

- Sturdy tripod
- Camera with macro lens or macro mode
- Shutter release cable
- Diffusion disc (or "portable cloud")
- Reflector
- Polarizing filter
- Off-camera flash
- Knee pads
- Hip waders

Hip Waders, Arctic Tundra, Svalbard Archipelago, Norway

(Canon EOS 1D Mark II, Canon EF 100mm f/2.8 Macro USM, 1/60 second @ f/11, ISO 200, -0.67 EV, no filter)

Advanced Digital Camera in Macro Mode, Alaska

(Canon EOS 1D Mark II, Canon EF 24-70mm f/2.8L USM, 1/60 second @ f/5.6, ISO 200, +0.33 EV, no filter)

D-SLRs

The advantages of using a D-SLR for shooting macro work are the availability of accessories.

• Shutter release cables

• Extension tubes (beware of chromatic aberration)

• Off-camera flashes

• Close-up lens attachments

• Tele-extenders (1.4x, 1.7x, and 2x)

• Dedicated macro lens (55-180mm range)

• Shooting close-ups with a D-SLR can be accomplished in a variety of ways:

• Live view for composing and focusing

• Fold-out LCD screens for getting down and dirty

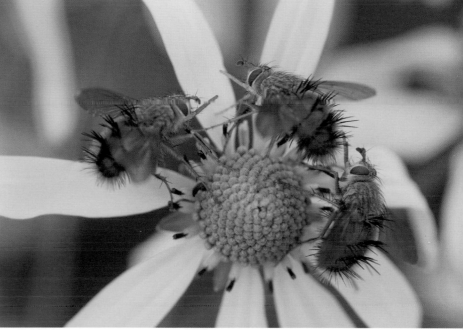

Bees on Yellow Sunflower, Jemez Mountains, New Mexico

(Canon EOS 1D Mark II, Canon EF 100mm f/2.8 Macro USM, 1/320 second @ f/5.6, ISO 400, -0.33 EV, no filter)

Chromatic Aberration, Blue Fringing along the Edges, caused by an Extension Tube paired with a 24-105mm zoom.

(Canon EOS 5D, Canon EF 24-105mm f/4L IS USM w/ extension tube, 1/1600 second @ f/5.6, ISO 400, -1.0 EV, no filter)

Nootka Rose, Tongass National Forest, Alaska

(Canon EOS 10D, Canon EF 100mm f/2.8 Macro
USM, 1/15 second @ f/8, ISO 200, -0.33 EV, no filter)

LENSES

Macro: My workhorse lens is the Canon
EF 100mm f/2.8 macro, which becomes a
140-160mm macro with the cropping factor
of APS-size sensors, perfect for close-ups at
a reasonable working distance for everything
from flowers to lizards and butterflies.

Wide Angle: Wide-angle lenses empha-
size the foreground and what's closest to the
lens, creating a different point of view and
a more intimate perspective. This produces
interesting results when the lens is almost
level to the ground and right up on a fore-
ground element. In the right situation, this
can result in framing the foreground against
the sky. Using the smallest aperture (f/22)
achieves the deepest depth of field (DOF).

Fiddlehead Sword Fern, Tongass National Forest, Alaska

(Canon EOS 10D, Canon EF 100mm f/2.8 Macro USM, 1/15 sec-
ond @ f/3.5, ISO 200, -0.33 EV, no filter)

An example of the close-focusing capabilities of a macro lens.

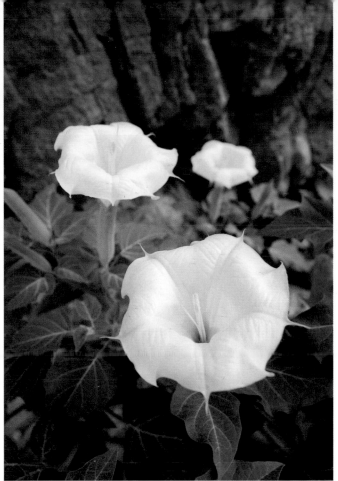

Sacred Datura Flowers, Grand Canyon National Park, Arizona

(Canon EOS 1D Mark II, Canon EF 16-35mm f/2.8L II USM, 1/125 second @ f/5.6, ISO 200, -0.33 EV, no filter)

Mountain Avens, Svalbard Archipelago, Norway

(Canon EOS 1D Mark II, Canon EF 16-35mm f/2.8L II USM, 1/160 second @ f/22, ISO 200, 0.00 EV, no filter)

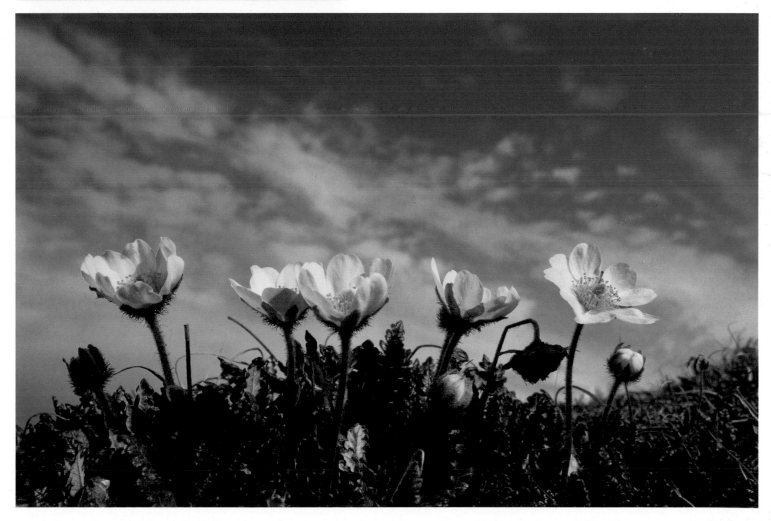

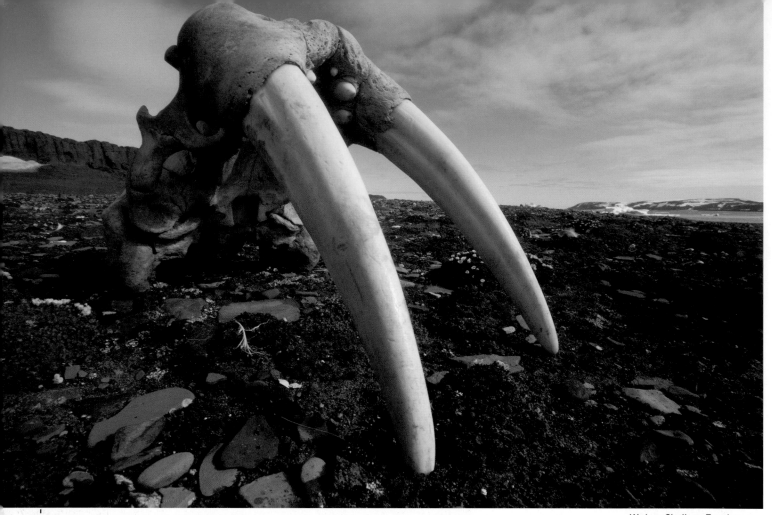

Walrus Skull on Tundra, Svalbard Archipelago, Norway

(Canon EOS 5D Mark II, Canon EF 16-35mm f/2.8L II USM, 1/60 second @ f/22, ISO 200, -0.33 EV, no filter)

Heliconia Butterfly, Monte Verde Cloud Forest Preserve, Costa Rica

(Canon EOS 1D Mark II, Canon EF 70-200mm f/2.8L IS USM w/1.4x, 1/250 second @ f/2.8, ISO 200, 0.00 EV, no filter)

Telephoto: Telephoto lenses allow you to get a tight shot of a far-away subject, and this comes in handy when shooting macro shots of subjects that might fly or run away. Additionally, telephotos compress perspective; paired with a shallow DOF, a compressed perspective throws the background out of focus to make the subject really pop.

Moss Champion,
Arctic Tundra, Svalbard
Archipelago, Norway

(Canon EOS 5D Mark
II, Canon EF 16-35mm
f/2.8L II USM, 1/60 sec-
ond @ f/8, ISO 200, 0.00
EV, no filter)

LIGHT MODIFIERS

Quality of light is important for making strong close-up compositions. Shooting close-ups deals with small areas of coverage, so it's possible to control or modify the light and make it to your liking.

Diffusers: I carry a "portable cloud," in the form of a diffusion disc, which is simply a translucent portable reflector. On harsh sunny days, it's sometimes necessary to deploy the "cloud" to soften the light. The diffusion disc creates the perfect diffuse light for macro work. Some dedicated macro photographers carry diffuse tents, portable enclosures that diffuse the light while also blocking the wind. You can find other solutions—anything translucent that diffuses the light without changing the color balance will work nicely—like a white sheet.

Reflectors: A reflector can add light into a composition. This can have a nice effect when working in shadow areas, or filling in uneven, dappled light where sunlight is filtered through trees. The benefit is that the reflector can add the same light as the ambient light, or you can use a colored reflector to give the subject a tinted light.

Devil's Club, Tongass
National Forest, Alaska

(Canon EOS 5D Mark
II, Canon EF 100mm
f/2.8 Macro USM, 1/160
second @ f/5.6, ISO 800,
0.00 EV, no filter)

Devil's Club, Tongass
National Forest, Alaska

(Canon EOS 5D Mark
II, Canon EF 100mm
f/2.8 Macro USM, 1/250
second @ f/5.6, ISO 800,
-0.67 EV, polarizing filter)

SHOOTING MACRO COMPOSITIONS

In the macro world, there are an infinite number of opportunities to create images that are both striking and unique. As you explore the macro world, you'll find that close-up photography requires a slightly different approach to the technical aspects of photography.

Polarizing Filter: It may surprise you that a polarizing filter is helpful in macro photography. The polarizer effectively cuts reflections off wet leaves or other surfaces, minimizing blown highlights and keeping colors saturated. Give it a try, especially when working in the rain or right after it stops. Keep in mind that a polarizing filter cuts the light by up to 2 stops, so if you are handholding the camera, bump up the ISO as necessary for sharp images. (But I recommend not handholding a macro shot, especially at close distances.)

Off-Camera Flash: Flash can be an important tool for macro photography for several reasons. First, an accessory flash unit is a portable light source, so no matter where you go or what the light conditions may be, you can bring your own light. Second, flash is easily modifiable; you can diffuse it, make it stronger or weaker simply by moving it, and can angle it for any kind of light direction you want. Third, and most importantly for macro photography, flash makes sharp images. Because it is so fast—from 1/1000 to 1/10000 second duration—it can freeze subject or camera movement. One downside is that flash is not a natural-looking light, but that is easily corrected if you shoot JPEG and change the white balance, or shoot RAW and adjust the white balance in post-processing, or if you use a colored gel to modify the flash's light.

Shooting Tips: Macro Photography

- Use your tripod!
- Use a macro lens/macro mode
- Focus manually (turn off autofocus)
- Simplify the background with shallow DOF
- Use maximum aperture (f/22) for close details
- Increase ISO for faster shutter speed
- Use a cable/remote release
- Use the mirror lock-up function
- Use a polarizing filter to cut reflections
- Work in diffuse light or deploy the "portable cloud"

MODIFY THE LIGHT

One great thing about macro photography is that if you don't like the light, you can modify it to act the way you want.

Determine the Angle: You can determine the angle of light hitting your subject simply by changing your position. For example, if you want to shoot sidelight, then orient yourself so the sun is at an angle to the subject; for a backlight situation,

shoot into the sun. Flowers glow when lit from behind and sidelight creates interesting shadows and also adds a catch light in a lizard's eye.

Create a Cloud: Cloudy conditions are perfect for photographing things up close and personal. This light quality is soft and forgiving, bringing the tonal range in line with what your camera can handle. If you

are looking for diffused light on bright sunny day, diffuse the sun with your own portable cloud—a diffusion disc. (You can also use a reflector to add a bit of extra light if you need it.)

Use Fill Flash: Being mostly a natural light photographer, I only use flash in certain situations. Typically I'm looking just to add a little pop of fill-flash to augment the natural light. To accomplish this I set my accessory flash on "slow sync" and dial down the flash output to around -2. Other times I may choose to override the ambient light, using the flash at full strength at the camera's sync speed (e.g. 1/200 sec). Full flash overrides the ambient light and creates a dark background so that the subject stands out.

To control the position and angle of the flash relative to the subject, I almost always use an off-camera flash, either wireless or connected with a sync chord. If you often use flash in your macro work, consider an after-market dedicated flash bracket for positioning the flash.

Poison Dart Frog, La Selva
Biological Station, Costa Rica

(Canon EOS 1D Mark II,
Canon EF 100mm f/2.8
Macro USM, 1/80 second
@ f/8, ISO 800, -1.0 EV, no
filter, fill flash)

Poison Dart Frog, La Selva
Biological Station, Costa Rica

(Canon EOS 1D Mark II, Canon
EF 100mm f/2.8 Macro USM,
1/200 second @ f/8, ISO 400,
0.00 EV, no filter, fill flash)

Fill flash is an easy way to create a dark background and make the subject stand out.

Asters in Wildflower
Meadow, Jemez
Mountains, New Mexico

(Canon EOS 1D Mark
II, Canon EF 100mm
f/2.8 Macro USM, 1/320
second @ f/5.6, ISO 100,
0.00 EV, no filter)

FIND FOCUS
AT CLOSE RANGE

Macro photography will challenge your understanding of focus. This is fundamental because one of the primary creative controls you have in macro photography is choosing what part of a subject you want to be in sharp focus; this is a function of the camera to subject distance, the DOF, and the orientation of the subject relative to the focus plane.

Camera to Subject Distance:
The guiding principle here is that the closer you are to the focal plane, the shallower the DOF will be. The closer you get to the subject with your camera, the less you can keep in focus. When working at close distances to your subject, the margin for focus is much, much smaller. Use a tripod so you can more precisely change how close or far you are from the subject in order to maintain good focus.

Depth of Field:
As you get closer to the subject, the effective DOF decreases down to fractions of an inch, even at apertures that create a deeper DOF, such as f/22. Thus it becomes critical to focus on the part of the subject you want to appear in sharp focus. If your center of interest is sharp, then what lies beyond can fall out of focus to become a pleasing mix of form and color.

To help get to the feel for just how shallow the DOF really is, try this small assignment: Focus your lens on a flower and shoot a sequence of images from the maximum aperture (f/2.8 or f/4) to the minimum aperture (f/22 or f/32). Move the camera closer, recompose the photo, and shoot the sequence again. (This is not possible on advanced compact cameras since the minimum aperture is commonly f/8, but try the assignment anyway to see how the DOF varies across your camera's range of apertures.)

You'll make a couple of important discoveries when you review these images. The first discovery is how shallow the DOF really is when you are shooting so close to the subject. The second discovery is just how critical focus becomes working with such a narrow range of acceptable focus. Even at f/22, what is in sharp focus falls off very quickly in front and behind the focal plane.

It's also important to understand that sharpness decreases as you stop the lens down past f/16 due to diffraction in the lens barrel, so you're not necessarily gaining sharpness with smaller and smaller apertures. Use apertures in the medium range (f/8 – f/16) to create the deepest DOF with the best image quality.

Indian Paintbrush and Purple Asters, Route National Forest, Colorado

(Canon EOS 10D, Canon EF 24-70mm f/2.8L USM, 1/20 second @ f/8, ISO 200, +0.33 EV, no filter)

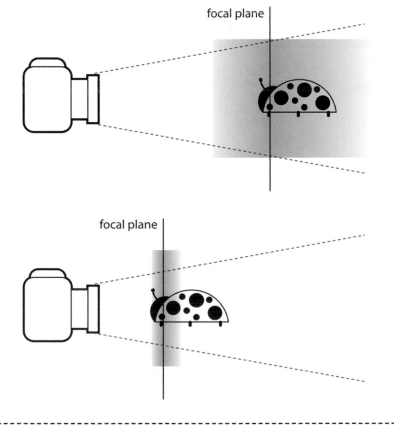

As the camera gets physically closer to the subject—specifically the plane of focus—the effective DOF decreases dramatically. The orange shading represents the DOF, which lies 1/3 in front of the focal plane and 2/3 behind.

Mud Cracks and Pebbles, Petrified Forest National Park, Arizona

(Canon EOS 1D Mark II, Canon EF 100mm f/2.8 Macro USM, 1/250 second @ f/22, ISO 200, +0.33 EV, no filter)

A close-up illustrating sharp focus at f/22.

Plane of Focus: When shooting extreme close-ups, what is in focus occurs at the same distance from the camera across the image. Technically speaking, the subjects—or the portions of those subjects—that are in focus lie on the plane of focus, which is parallel with the sensor plane (or the back of your camera).

This is not as technical as it sounds. The guiding principle here is that objects that are on the focal plane will be in sharp focus. What is in focus plays a key role in macro compositions, since the viewer's eye tends to go to the sharpest part of the photo. Therefore, the plane of focus and where you place the focus point are important considerations in macro work

Use the plane of focus to your advantage by choosing subjects within your composition that lie along a similar plane, then setting up with the back of the camera roughly parallel to the subjects you want to be in focus. In practice, if a row of flowers lies the same distance from the camera, then all the flowers should be in focus. How "deep" the focus will be from the front of the flower to the back depends on the depth of field and the camera to subject distance.

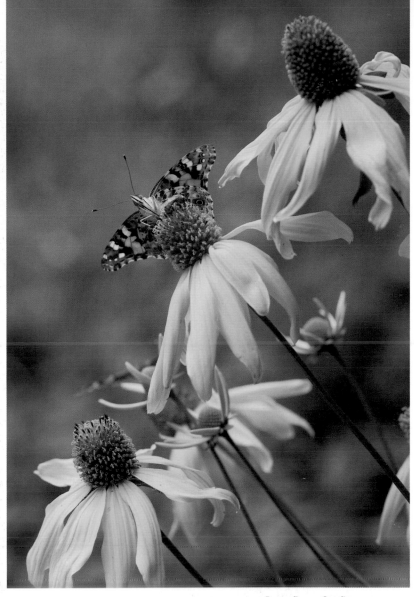

Butterfly on Sunflowers, Jemez Mountains, New Mexico

(Canon EOS 1D Mark II, Canon EF 100mm f/2.8 Macro USM, 1/640 second @ f/5.6, ISO 200, 0.00 EV, no filter)

This example shows a shallow DOF with the flowers and butterfly in focus because they lie on the plane of focus.

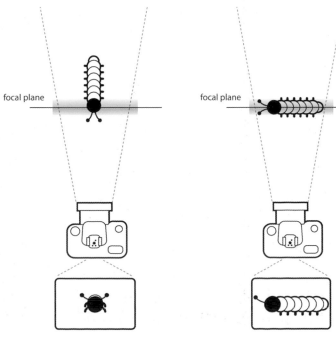

At close shooting ranges, only the areas of the subject that are along the focal plane will appear sharp in the image.

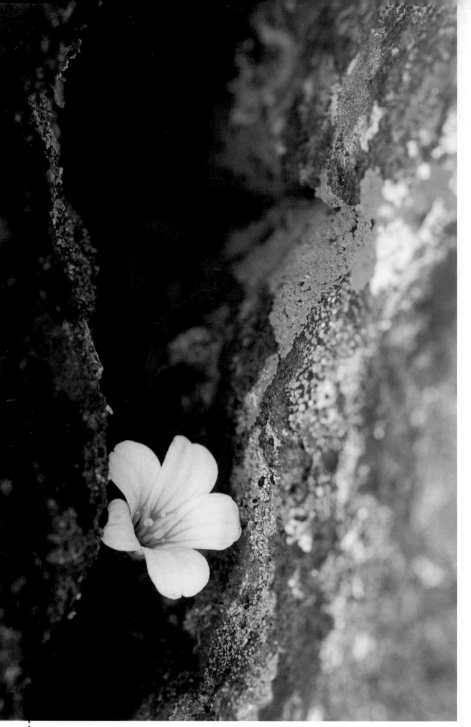

Focus Point: Where you place the focus point is the final step in setting up a macro shot. The interplay of what is in or out of focus can make for interesting design elements and splashes of color. In practice, the best way to approach nailing the focus point is by using manual focus. Macro subjects often have many different levels of possible focus that can confuse the autofocus feature. Focusing manually allows you to be in total control of the focus point.

Critical focus is achieved by positioning the camera for the intended composition, then refining focus with slight movements of the camera while twisting the manual focus ring back and forth to zero in exactly where the focus point needs to be. Never assume you nailed the focus the first time—shoot every subsequent image the same way without re-focusing. Also, shoot multiple images of the same composition while varying both the focal point (to shift the focal plane), and the f/stop (to vary the DOF).

Arctic Chickweed, Arctic Tundra, Svalbard Archipelago, Norway

(Canon EOS 1D Mark II, Canon EF 100mm f/2.8 Macro USM, 1/25 second @ f/8, ISO 200, -0.67 EV, no filter)

Rain Drops on Moss, Arctic Tundra, Svalbard Archipelago, Norway

(Canon EOS 1D Mark II, Canon EF 100mm f/2.8 Macro USM, 1/60 second @ f/11, ISO 200, -0.67 EV, no filter)

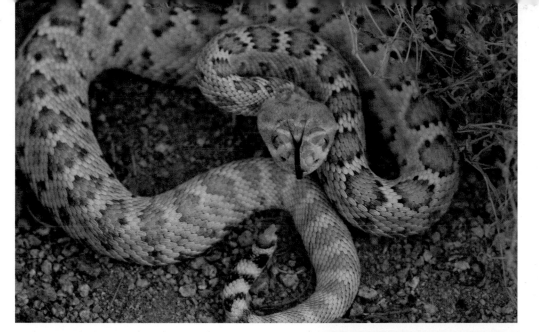

Barrel Cactus in Bloom, Isla San Esteban, Baja California, Mexico

(Canon EOS 1D Mark II, Canon EF 100mm f/2.8 Macro USM, 1/320 second @ f/8, ISO 100, -0.67 EV, no filter)

Rattleless Rattlesnake, Isla Santa Catalina, Loreto Bay National Park, Baja California, Mexico

(Canon EOS 1D Mark II, Canon EF 100mm f/2.8 Macro USM, 1/125 second @ f/8, ISO 200, -0.67 EV, no filter)

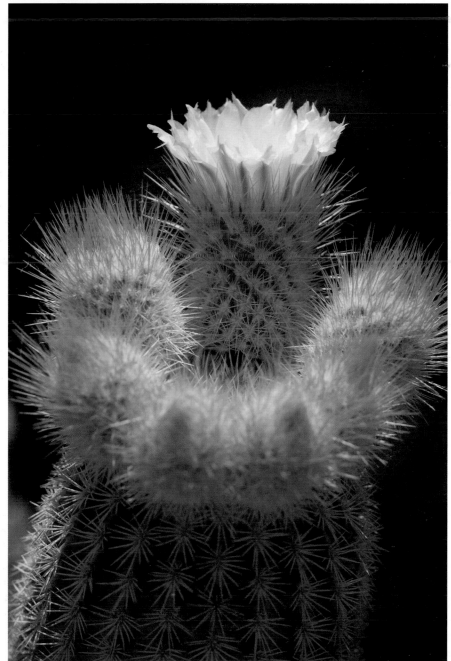

Macro Study of Coral Skeleton, Baja California, Mexico

(Canon EOS 1D Mark II, Canon EF 24-70mm f/2.8L USM, 1/2000 second @ f/2.8, ISO 100, -0.33 EV, no filter)

INDEX